Strindberg

Strindberg

PAINTER AND PHOTOGRAPHER

YALE UNIVERSITY PRESS • NEW HAVEN AND LONDON
PUBLISHED IN ASSOCIATION WITH
THE NATIONALMUSEUM, STOCKHOLM

NATIONALMUSEUM, STOCKHOLM	9 February – 13 May 2001
STATENS MUSEUM FOR KUNST, COPENHAGEN	9 June – 16 September 2001
MUSÉE D'ORSAY, PARIS	15 October 2001 – 27 January 2002

EXHIBITION COMMITTEE	Torsten Gunnarsson, Per Hedström, Göran Söderström
EXHIBITION DIRECTOR	Per Hedström
SECRETARY	Inger Tengqvist
ARCHITECT	Henrik Widenheim
CATALOGUE EDITOR	Per Hedström
CD-GUIDE	Lena Holger
INFORMATION	Agneta Karlström and Lena Munther
MARKETING	Birgitta Plånborg
GRAPHIC DESIGN	Arne Öström
TRANSLATION	Nancy Adler, Roger Tanner and Laurie Thompson

JACKET
August Strindberg, Detail of *The Vita Märrn Seamark II*, 1892, OIL ON CANVAS, 60X47 CM, NATIONALMUSEUM, STOCKHOLM, NM 6980.

PRINTING
Printed by Berlings Skogs AB, Trelleborg 2001

The Swedish Institute has generously supported the exhibition at Musée d'Orsay in Paris.

Library of Congress Cataloging-in-Publication Data
Strindberg: painter and photographer/Per Hedström ... [et al.].
 p. cm.
 Includes bibliographical references and index.
 ISBN 0-300-09187-7 (cloth: alk. paper)
 1. Strindberg, August, 1849-1912–Criticism and interpretation. 2. Strindberg, August, 1849-1912–Knowledge–Photography. I. Hedström, Per, 1963– II. Strindberg, August, 1849-1912.

ND793.S85 S77 2001
760'.092–dc21 2001033329

CONTENTS

Foreword 7
OLLE GRANATH

Strindberg as a Pictorial Artist – *a survey* 9
PER HEDSTRÖM

Strindberg: The Gersau Photographs 103
AGNETA LALANDER AND ERIK HÖÖK

Dreaming Materialized
– *on August Strindberg's photographic experiments* 117
DOUGLAS FEUK

Strindberg in the Artists' Community of Paris 131
GÖRAN SÖDERSTRÖM

Strindberg, Carl Larsson and the Frescoes Lining the Main Staircase of
the National Museum 149
GÖRAN SÖDERSTRÖM

New Directions in Art! Or the Role of Chance in Artistic Creation 177
AUGUST STRINDBERG

Chronology 183

Exhibited Objects 186

Notes 192

Bibliography 192

LENDERS

Albert Bonniers förlag
Bonniers porträttsamling, Nedre Manilla, Stockholm
Carl Eldhs Ateljémusem, Stockholm
Folkhems konstsamling
Göteborgs Konstmuseum
Göteborgs Universitetsbibliotek
Kalmar Konstmuseum
Kungliga Biblioteket, Stockholm
Malmö Konstmuseum
Moderna Museet, Stockholm
Munch-museet Oslo kommune Kunstsamlingene
Musée d'Orsay, Paris
Nordiska museet, Stockholm
Norsk Folkemuseum, Oslo
Prins Eugens Waldemarsudde, Stockholm
Statens Museum for Kunst, Köpenhamn
Strindbergsmuseet, Stockholm
Strindbergssällskapet, Stockholm
Thielska Galleriet, Stockholm
Uppsala universitetsbibliotek
Örebro Konsthall, Örebro stads- och länsbibliotek
Örebro Stads- och länsbibliotek

And Private Lenders

Foreword

Forty years ago, in 1960, there was renewed interest in Strindberg as a pictorial artist both in Sweden and throughout Europe. In Stockholm, students reading art history at what was soon to become Stockholm University opened an art gallery, "The Observatorium", with an exhibition of his work. The driving force behind it was Göran Söderström, who has also placed his expertise at the disposal of the current exhibition.

A few months later the Musée National d'Art Moderne in Paris hosted an exhibition sponsored by the Council of Europe entitled "Les sources du XXième siècle", subtitled "Les Arts en Europe 1884–1914". Strindberg was represented there by four works. This sparked off a series of exhibitions about him all over Europe, which in turn led to comprehensive writings on the great dramatist as a pictorial artist. In 1963 it was the turn of the Modern Museum in Stockholm, and by that time Strindberg was established throughout Europe as a significant pioneer of modernism. This image was reinforced by his remarkable essay "The New Arts! Or the Role of Chance in Artistic Creation", written in French and published in France; a notable document especially in view of the fact that in his art criticism August Strindberg's attitude towards painting was actually quite conservative. An exchange of letters with Gauguin where Strindberg declines an invitation to write an introduction to a catalogue of the French painter's work is well known, but his refusal was so brilliant and interestingly worded that Gauguin turned it into an excellent preface after all.

Bearing in mind the above outline of all those European exhibitions, it is an especial pleasure to note that the Musée d'Orsay in Paris has once again generously opened its doors to a Scandinavian artist from the turn of the last century. It is also gratifying that Copenhagen, which was a second home to Strindberg for a while, will play host to the exhibition as well, at the Statens Museum For Kunst (The National Art Gallery).

The Nationalmuseum in Stockholm would like to extend its heartfelt thanks to all those private individuals and institutions who have loaned works for this exhibition. Especial gratitude is due to the Nordic Museum, the Royal Library and the Strindberg Museum, all of which have contributed a large number of items from their extensive Strindberg collections. Many thanks also to Göran Söderström, who is still the undisputed authority on August Strindberg as a pictorial artist. His expertise has been the very foundation of the exhibition. We are also grateful to the Swedish Institute, who have made it possible to produce an English version of the catalogue.

STOCKHOLM I NOVEMBER 2000

Olle Granath
DIRECTOR, NATIONALMUSEUM, STOCKHOLM

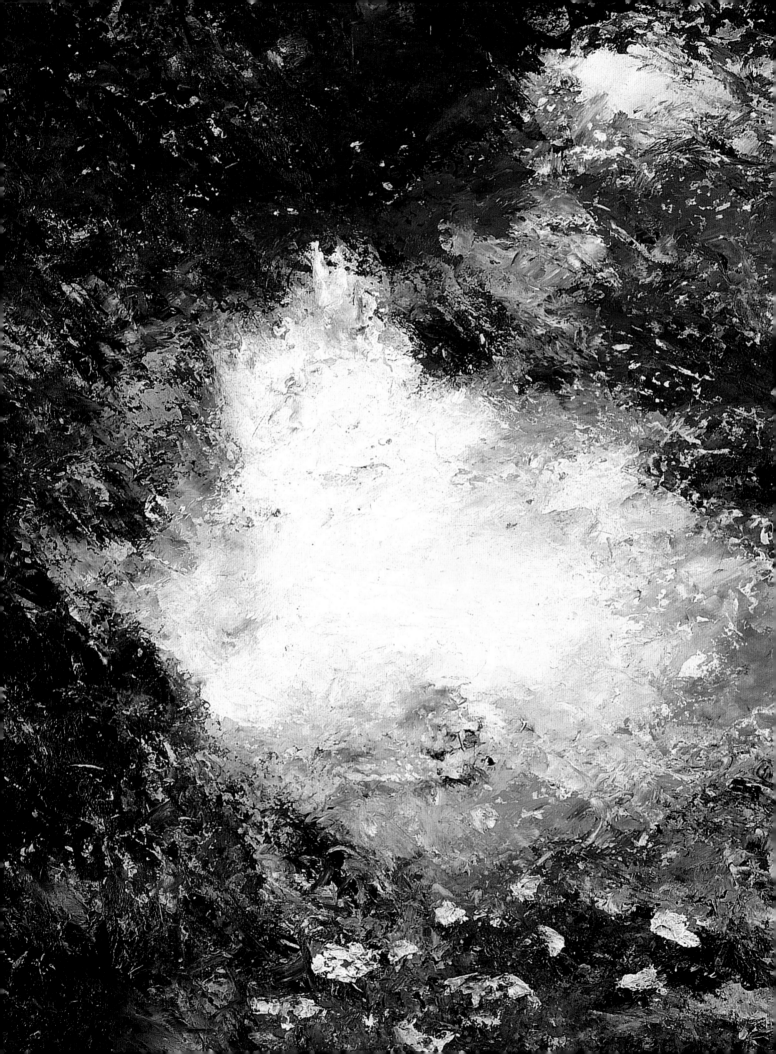

Strindberg as a Pictorial Artist

A Survey

One of Strindberg's greatest assets as an author was his ability to depict visual experiences, to create pictures out of words. He developed a metaphorical language which still fascinates his readers by means of its tangibility and symbolic force. A good example of the range of variation possessed by his imagery is the vast number of words he used for colours. The precision and breadth of Strindberg's way of "painting with words", to use his own expression, might seem to be in sharp contrast with his paintings.

Strindberg the painter restricted himself to a very narrow field. He painted exclusively landscapes, which were predominantly coastlines and sea views, and often repeated his compositions. Moreover, Strindberg's paintings frequently betray the artist's lack of formal training. At one point in his autobiographical novel *Tjänstekvinnans son* (Son of a Servant), he asserted that painting could be a blunt instrument. As a young man he had witnessed a shipwreck in the Stockholm archipelago, and wanted to give formal expression to the experience: "The whole scene was so new and picturesque that he felt the urge to give it artistic form, but paint and paintbrushes were inadequate for the task and he was forced to take up his pen." As we shall see, however, writing and painting meant two different things as far as Strindberg was concerned, and both forms of expression were important. His standing as an artist has improved over the last forty years.

Why has his painting attracted so much attention? Jan Myrdal maintained recently that the reason is because Strindberg was famous, he did not produce many pictures, and their style is uniform and easy to recognize. As a result, Myrdal claims, they are now worth a lot of money, and so are popular with art dealers. It is true of course that he holds the Swedish record for

PER HEDSTRÖM

Detail of *Wonderland*, 1894,

art auction prices – his painting *Underlandet* (Wonderland) was sold for almost SEK 23 million in 1990. Nevertheless, although there may well be a grain of truth in Myrdal's claim, one has to say that it is not only art dealers who have expressed an interest in his painting. There is no doubt that the most important reason for the attention he has received is that even as a painter, he has managed to create something totally original.

The literature on Strindberg as a painter and photographer has become extensive over the years, even if it only constitutes a tiny proportion of secondary literature on Strindberg as a whole. The pioneering work is Gunnel Sylvan's long article "August Strindberg som målare" (August Strindberg as a Painter), which was published in *Tidskrift för Konstvetenskap* (Journal of Art History) in 1948; but the most profound and comprehensive research into the subject is Göran Söderström's doctoral thesis *Strindberg och bildkonsten* (Strindberg and Pictorial Art) and his contribution to the anthology *Strindbergs måleri* (Strindberg's Painting), both first published in 1972. They remain the standard works regarding Strindberg's own painting, and his relationships with the world of art and artists. The pioneering work on his activities as a photographer was done in the 1960s by Per Hemmingsson, whose book *August Strindberg som fotograf* (August Strindberg as a Photographer) first appeared in 1963.

Although there were occasional exhibitions of Strindberg's paintings in the 1920s and 1940s, the crucial breakthrough came in connection with a series of exhibitions in Sweden and elsewhere in Europe during the first half of the 1960s. Since then, Strindberg the painter has featured in many exhibitions, often in association with other Scandinavian artists from the turn of the last century.

Judgements on Strindberg's paintings have varied over the years, as the dominant trends in art have changed. In the 1890s he was sometimes perceived as an Impressionist, a verdict that would hardly occur to anyone nowadays. After that the label most often attached to Strindberg's paintings was Expressionist. At the beginning of the 1960s his work began to be seen as presaging the Abstract Expressionism and action painting so fashionable at the time.

The last twenty years have produced a multifaceted view of Strindberg as a pictorial artist. Greater emphasis has been placed on the relationship between his painting and photography, his interest in the occult and his romantically based scientific activities. The Expressionistic aspects have been toned down, which is is no doubt associated with the fact that the term Expressionism has become more negative in its implications in the post-modern era.

The 1870s

In his autobiographical *Son of a Servant*, Strindberg described his very first attempt to paint, in February 1872. He made a copy in oils of a newspaper illustration depicting a castle ruin in Scotland. The description of how the picture came about in dicates what painting, and possibly even the creative process in general, meant to Strindberg, and how he experienced it: "When he saw how the blue paint turned into a clear sky, he was possessed by sentimentality; and when he went on to conjure forth green bushes and a lawn, he became indescribably happy – as if he'd just taken hashish."

This painting of a ruined castle was produced when the twenty-three-year-old Strindberg was in a state of crisis. He had

1. *Landscape Study*, 1872,
PENCIL, C. 20 X 17 CM, GÖTEBORGS UNIVERSITETSBIBLIOTEK. PHOTO: GÖTEBORGS UNIVERSITETSBIBLIOTEK.

In his letters and in his autobiography, Strindberg told how he had devoted himself to painting on several occasions in 1872. None of the paintings have been preserved, but we do have a few drawings of trees made on the island of Kymmendö in the Stockholm archipelago during the summer of 1872.

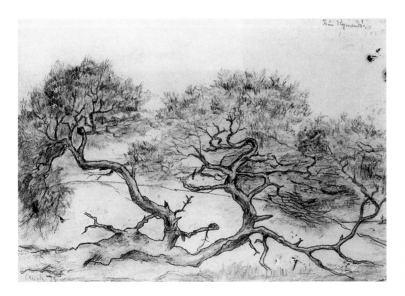

1b. *Twin Pines*, 1873,
PENCIL, 15.5 X 10 CM, NORDISKA MUSEET, STOCKHOLM.
PHOTO: NORDISKA MUSEET, STOCKHOLM.

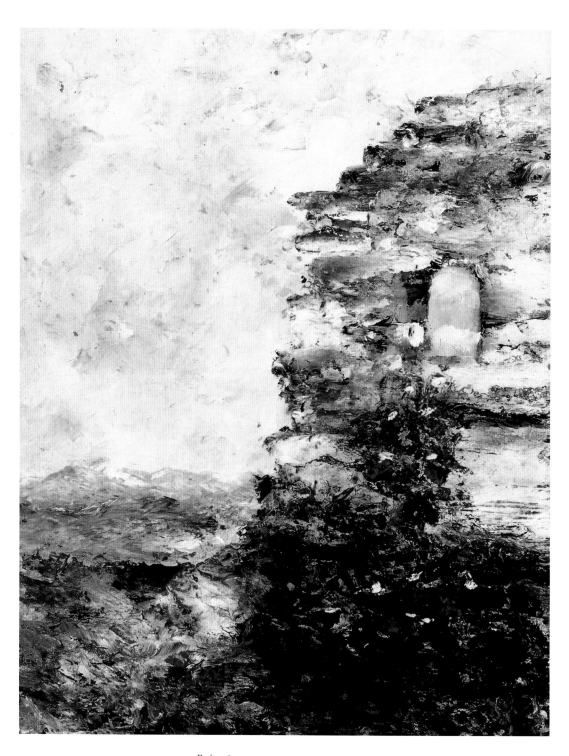

2. *Ruin*, 1894,

OIL ON PANEL, 39 X 26.3 CM, PRIVATE COLLECTION. PHOTO: CRAFOORD AUCTIONS.

In his autobiography *Son of a Servant*, Strindberg described how he painted in oils for the first time in 1872. He had seen a magazine illustration of a castle ruin in Scotland, and copied the picture in oils. Much later, during his stay in Paris – Passy in 1894, he repeated the motif.

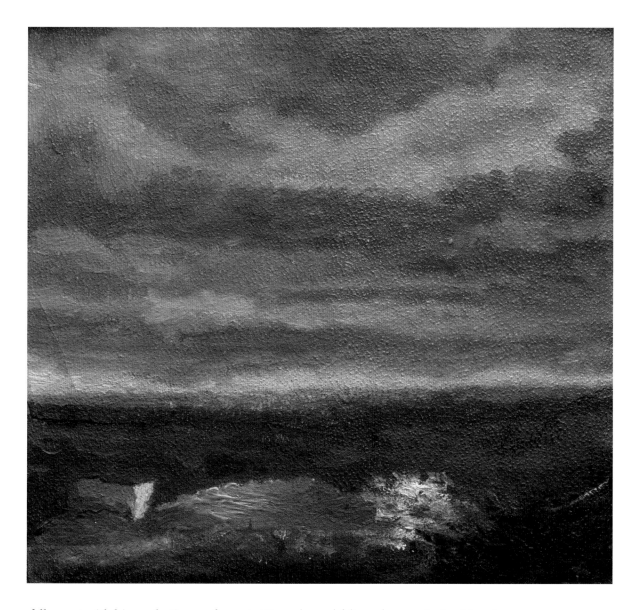

fallen out with his aesthetics professor in Uppsala, and felt wash-
ed out, unable to write. It has often been noted that it was in sit-
uations like this, when he felt unable to express himself in
writing, that he turned to painting. Shortly after painting the
ruin, he abandoned his university studies without taking any
examinations, and he was to spend the following two years
earning his living as a journalist, with varying levels of success.
From time to time he would also devote himself to painting.

The paintings Strindberg made in the Stockholm archipel-

3. *Rock and Sea*, 1873,
OIL ON PANEL, 16 X 17CM, NORDISKA MUSEET,
STOCKHOLM. PHOTO: NORDISKA MUSEET, STOCKHOLM.

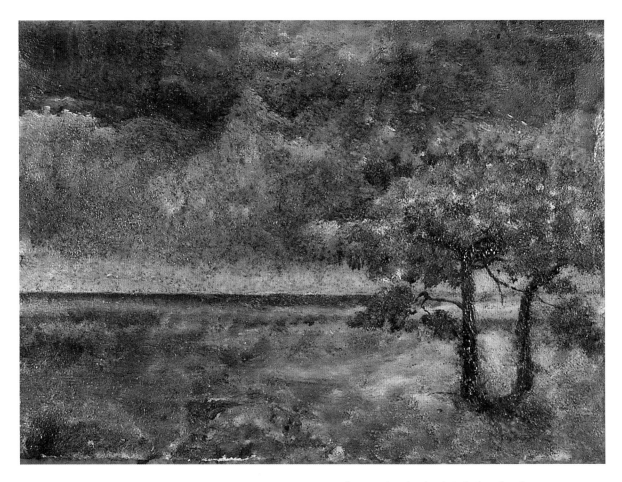

4. *Shore, Kymmendö, II,* 1873

OIL ON PANEL, 17.5 X 24.5CM, ÖREBRO STADS- OCH
LÄNSBIBLIOTEK. PHOTO: ÖREBRO KONSTHALL.
All the pictures from Kymmendö and
Sandhamn, 1873, portray the sea and the barren
landscape typical of the Stockholm archipelago.
They are the earliest paintings Strindberg made
of these motifs, which were so important to
him. In *Shore II*, Strindberg has depicted the
horizon in a way which was later to become
very typical of his archipelago scenes. The
horizon is constructed as a sort of a thin,
straight embankment made of oil paint.

ago in 1873 came about after he had failed as both a newspaper
reporter and a dramatist. Once again he was overcome by feel-
ings of failure about his writing. Instead he painted a series of
miniatures with archipelago motifs – fairly objective obser-
vations of nature, but hardly original. We see the broad horizon
of the open sea, a few pine trees on a rocky outcrop, a stretch of
beach with a few maritime plants dotted around. Similar motifs
were to keep reappearing in Strindberg's paintings during the
1890s and the first decade of the following century. His exper-
iences in the outer archipelago were also to play a large part in a
number of his literary works.

It is barely possible to discern any particular dominant influ-
ence in Strindberg's paintings dating from the 1870s. Neverthe-
less, he had a number of friends who were artists, among whom
Per Ekström is usually singled out as being his mentor and most

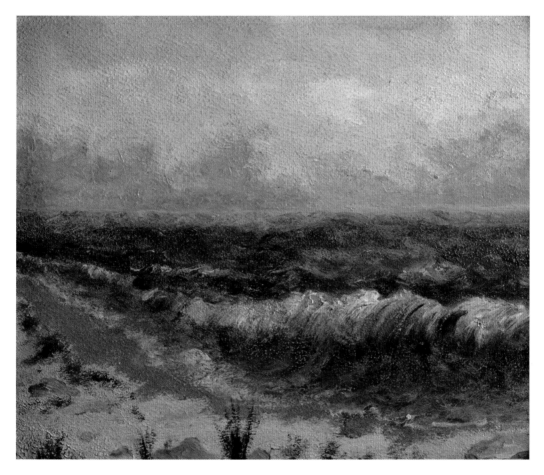

important source of inspiration. In fact Ekström was the model for the painter Sellén in *Röda rummet* (The Red Room), which brought Strindberg his big breakthrough as a novelist in 1879.

Strindberg's interest in pictorial art led him to begin writing art criticism. In his early reviews he concentrated primarily on the motifs and content of the paintings, but he soon went on to concentrate on scrutinizing the formal aspects of the works. In doing so, he broke with academic tradition and initiated a more modern form of art criticism in Sweden.

His theoretical starting point as an art critic was first and foremost the synthesis of realism and idealism postulated by Carl Rupert Nyblom, a professor of aesthetics, but it was not long before Strindberg aligned himself with the realistic French-orientated open-air painting championed in Sweden by Alfred Wahlberg. At the same time he could also be carried away by a

5. *Shore*, 1873,
OIL ON PANEL, 15.5 X 18.5CM, NORDISKA MUSEET,
STOCKHOLM. PHOTO: NORDISKA MUSEET,
STOCKHOLM.

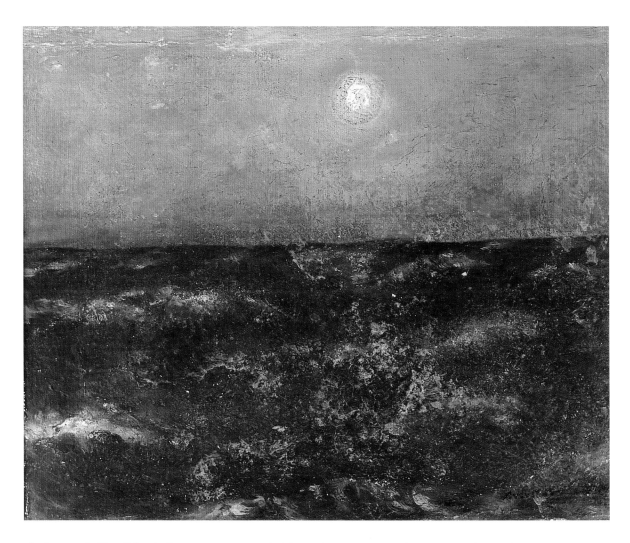

5b. *Seascape in Moonlight*, 1874?,
This painting must have been one of the last to
be made in the 1870s, and was probably one of
the few from this period that Strindberg
regarded as a finished picture, rather than a
study. The Romantic, desolate atmosphere
paves the way for the paintings Strindberg
produced in the 1890s.

work like Julius Kronberg's *Jaktnymf och fauner* (Hunting
Nymph with Fauns), a painting that might look decidedly aca-
demic to a modern eye, but which was regarded at the time as
an outstanding example of bold colourism.

Strindberg made his first visit to France in the autumn of
1876, and while there visited Durand-Ruel's gallery where he
saw works by the Impressionists and wrote about them in an
article for the daily newspaper *Dagens Nyheter*. He reacted very

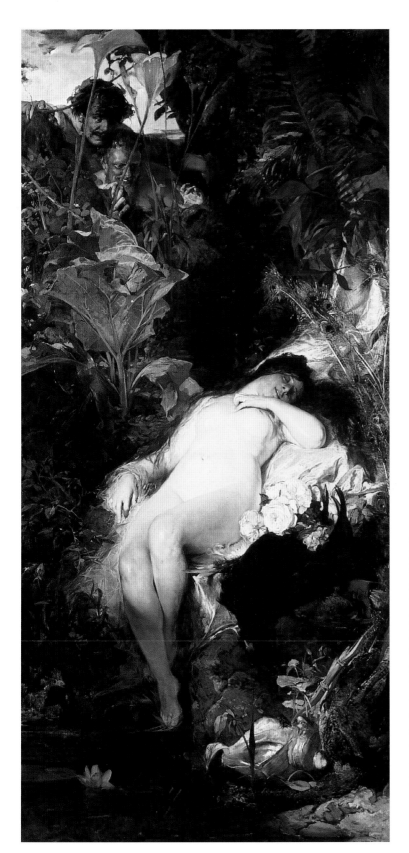

6. Julius Kronberg, Hunting Nymph with Fauns, 1875,

OIL ON CANVAS, 269 X 130CM, NATIONALMUSEUM.
PHOTO: NATIONALMUSEUM.

When *Jaktnymf och fauner* was exhibited in the Nationalmuseum in February 1876, there were long queues to get in. The painting was regarded as sensational, not least because of its provocative subject matter. Strindberg wrote a very positive review, stressing Kronberg's colouristic abilities. It is remarkable that Strindberg stuck to his guns, and as late as 1910 repeated the challenge he had given the art world more than thirty years earlier: "Go down on your knees and worship the god of painting!"

7. Sketch for *The Secret of the Guild*,

7b. August Strindberg, Draft Manuscript for *The Secret of the
Guild*, 1879-80,

8. August Strindberg, *Head Librarian Gustaf Edvard Klemming*, 1880,

WATER-COLOURED INDIAN INK DRAWING, KUNGLIGA BIBLIOTEKET, STOCKHOLM. PHOTO: MARCUS ANDRÆ, KUNGLIGA BIBLIOTEKET, STOCKHOLM.

Klemming was Strindberg's superior when the latter was employed as an assistant librarian at Kungliga Biblioteket (the Royal Library).

9. Sketch for the Title Page of *Master Olof*, enclosed with a letter from August Strindberg to Carl Gustaf and Siri Wrangel, November 1875,

WATERCOLOUR, 13.5 X 10CM, KUNGLIGA BIBLIOTEKET, STOCKHOLM. PHOTO: MARCUS ANDRÆ, KUNGLIGA BIBLIOTEKET, STOCKHOLM.

negatively at first, but after further consideration seems to have reached a profound understanding of the Impressionists' aims. He remarks about Monet that he has chosen to paint "the bustle of a throng of people on a landing stage, not a bustling throng of people; but bustle is a movement after all – is it possible to paint a movement?".

At the end of 1874 Strindberg was appointed temporary library assistant at the Royal Library in Stockholm. The post, which lasted until 1882, did not involve a lot in the way of work, nor was it well paid, but he was able to continue writing in his spare time. One significant outcome of his time at the library was was the method he adopted of decorating some of his manuscripts. One of the first examples of a decorated manuscript is a sketch for the cover of the verse version of *Mäster Olof* from 1875. Strindberg had studied mediaeval illuminated manuscripts at the Royal Library, and was inspired to produce

several richly decorated manuscripts of his own, based on mediaeval models. However, the majority of these date from the 1890s and the early years of the following century.

The 1880s. From Realism and Utilitarianism to Neo-Romanticism

In the autumn of 1883 Strindberg spent a few weeks in the Scandinavian artists' colony in the village of Grez-sur-Loing, to the south of Paris. Despite his association with the artists, Strindberg had now adopted a definite anti-aesthetic stance. He regarded pictorial art and creative literature as unnecessary luxuries with no moral justification. Society would have to be changed, and the job of a writer was to describe society and demonstrate how the changes could be made. In a poem that he wrote shortly after his stay in Grez, he announced his divorce from art: "farewell to the beautiful, nice for some, and welcome to the useful, of use to all".

Being an author in the service of utilitarianism could involve travels resulting in journalistic reportage. What was required were descriptions of real life, and a scientific analysis of it. In the autumn of 1884 Strindberg suggested that Carl Larsson might like to accompany him on a journey through France to study and report on the social situation of French peasants: Larsson's role would be to make a documentary report in the form of sketches. However, Larsson declined the offer and the journey did not take place until the autumn of 1886. Instead of drawings, Strindberg's new idea was that there should be a collection of photographs instead.

He made the journey in the company of the young Gustaf Steffen, who would later become a professor of Economics and Sociology. It was not long before they fell out, however, and after only a few weeks Strindberg broke with Steffen. For some reason most of the photographs taken during the journey were unsuccessful: not one has been preserved. What did emerge from the journey was the unillustrated collection of essays *Bland franska bönder* (Among French Peasants), published in 1889.

Photographs taken by Strindberg in the 1880s and still av-

10 and 10 b. Spreads from Strindberg's notebooks from his journey to France in 1886,
KUNGLIGA BIBLIOTEKET, STOCKHOLM. PHOTO: MARCUS ANDRÆ, KUNGLIGA BIBLIOTEKET, STOCKHOLM.
One spread shows a shepherd on stilts and a half-timbered house in Les Landes, and the other a priest from the Moulins area and a "Philistine" from Auvergne.

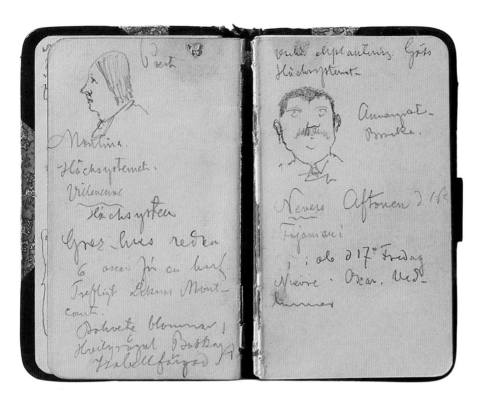

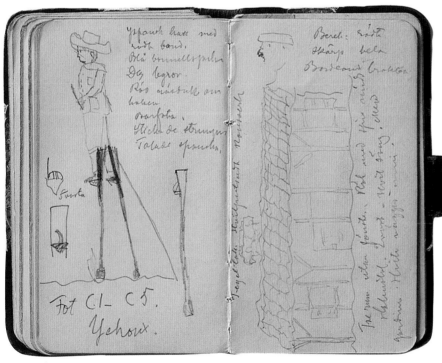

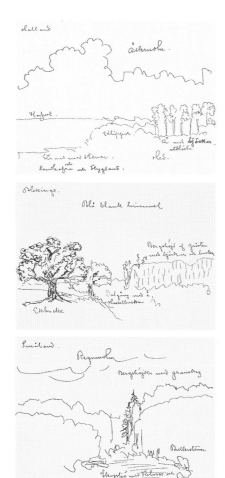

11. Original Drawings for *Sveriges natur*, 1900,

INK ON CARD, 8.5 X 11.5CM, KUNGLIGA BIBLIOTEKET, STOCKHOLM. PHOTO: MARCUS ANDRÆ, KUNGLIGA BIBLIOTEKET, STOCKHOLM.

ailable today include pictures of himself and his family taken in the little Swiss spa of Gersau (see page 103). The photos were taken in October and early November, 1886, a period in his life that seems to have been unusually calm and amicable. In November Strindberg mounted the photographs on cardboard and sent them to Bonniers in Stockholm. He had combined the pictures with brief quotations from his own writings, and the idea was that the album should be produced as a documentary record of the Strindberg family's life in Gersau. His own classification of the pictures was "impressionist-photographs". They were not published during Strindberg's lifetime, and for a long time it was assumed the album had been lost: however, it was discovered in Bonniers' archives in 1997.

Strindberg returned to Sweden in 1889, having spent almost six years abroad. By now he had an impressive list of literary publications to his name. The Naturalistic dramas *Le plaidoyer d'un fou* (A Madman's Defence), *Fadren* (The Father), *Fröken Julie* (Miss Julie) and *Fordringsägare* (The Creditors), as well as the novel *Hemsöborna* (The People of Hemsö) and the autobiography *Tjänstekvinnans son* (Son of a Servant), are now considered to be among his best works. However his circumstances were far from trouble-free. He had suffered agonies as a result of being prosecuted for blasphemy in his collection of short stories *Giftas I* (Getting Married), and for some years his marriage to Siri von Essen had been running into difficulties. Moreover, the late 1880s saw a fundamental change in his philosophical stance. He was distancing himself from Realism and Utilitarianism, and was hunting for new ways of expressing his creativity – these new paths explored in the 1890s led him away from imaginative literature and in the direction of science coloured by romanticism and the occult.

The journey through France undertaken in 1886 was followed up with a similar one through Sweden in the autumn of 1890. The book that came of it was to be called *Sveriges natur och folk* (Sweden's Countryside and People). On this journey he took two cameras with him, but even so, his photographs were again unsuccessful. The only pictures from the journey still preserved are some sketches in his log book.

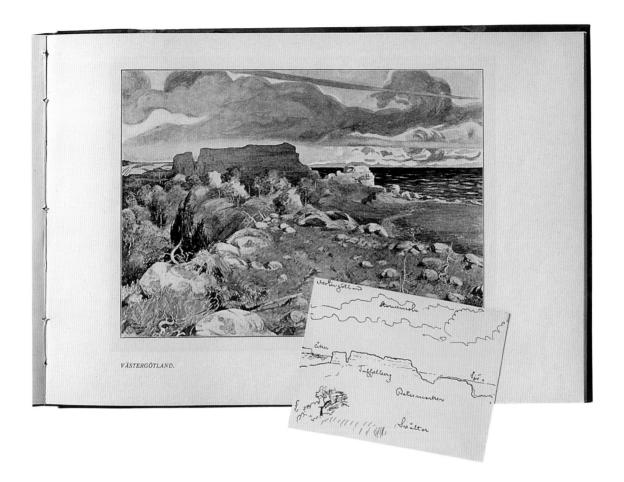

VÄSTERGÖTLAND.

Despite the fact that the pictures taken on the French and Swedish journeys were failures, it has to be said that the basic idea was a very modern one.

The Swedish journey of 1890 resulted in a short, unillustrated book entitled *Svensk natur* (Swedish Nature). However, ten years later it provided the inspiration for a new and ambitious project that would mark the beginning of Strindberg's cooperation with the illustrator Arthur Sjögren. By now Strindberg was less interested in depicting the Swedish people, and instead devoted himself exclusively to nature, to the various types of countryside in Sweden. He drew thirteen sketches of typical Swedish landscapes which were the basis for Sjögren to produce the illustrations for the book. Most of the final ones are very similar to Strindberg's sketches.

12. August Strindberg and Arthur Sjögren, *Sveriges natur* (Sweden's Countryside), 1901.
PHOTO: MARCUS ANDRÆ, KUNGLIGA BIBLIOTEKET, STOCKHOLM.

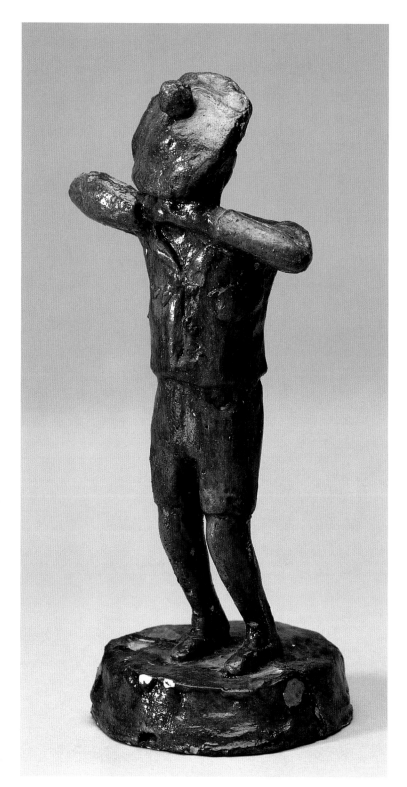

13. *The Weeping Boy*, 1891,

PATINATED PLASTER, HEIGHT 18.5CM, PRIVATE COLLEC-
TION. PHOTO: ERIK CORNELIUS, NATIONALMUSEUM.

This little sculpture, together with the portrait
of Hanna Palme von Born, are the only
examples of Strindberg's sculpting to be
preserved. In his essay *Des arts nouveaux! Ou le
hasard dans la production artistique* (The New
Arts! Or the Role of Chance in Artistic
Creation), Strindberg described how *The
Weeping Boy* came about. He had intended to
sculpt "a youth praying", based on a Classical
model, but was dissatisfied with it and let his
hand fall down on the figure's head. Strindberg
then realized the sculpture had changed – the
boy's hair had been flattened and turned into a
cap, and his hands had ended up in front of his
face, giving the impression that the boy is trying
to conceal the fact that he is crying.

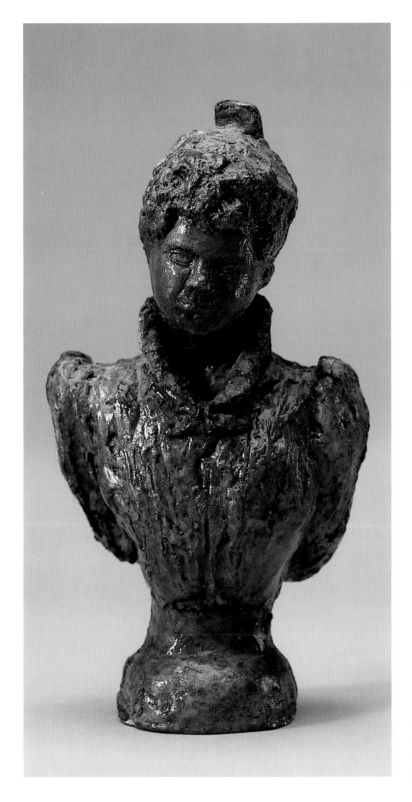

14. *Hanna Palme von Born*, 1891,
PATINATED PLASTER, HEIGHT 18.5CM, PRIVATE
COLLECTION. PHOTO: ERIK CORNELIUS,
NATIONALMUSEUM.

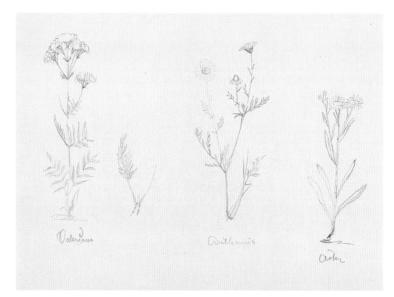

15. August Strindberg, *Valerian, Corn Chamomile and Sea Aster*, 1890,

PENCIL, 19.4 X 27CM, KUNGLIGA BIBLIOTEKET, STOCKHOLM. PHOTO: MARCUS ANDRÆ, KUNGLIGA BIBLIOTEKET, STOCKHOLM.

A small number of drawings made by Strindberg on the island of Runmarö, where he spent the summer of 1890, have been preserved. The motifs are reminiscent of the paintings he made two years later on Dalarö.

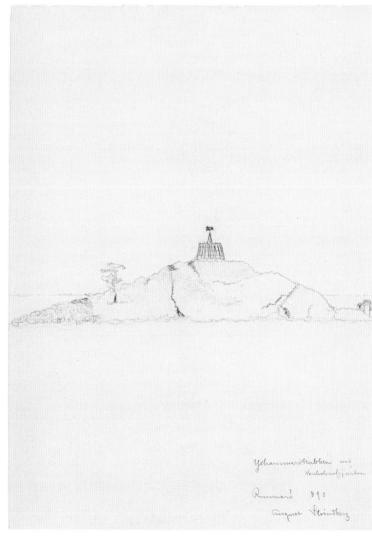

15b. *Yxhammarskubben*, 1890,

PENCIL, 27 X 19.4CM, KUNGLIGA BIBLIOTEKET, STOCKHOLM. PHOTO: MARCUS ANDRÆ, KUNGLIGA BIBLIOTEKET, STOCKHOLM.

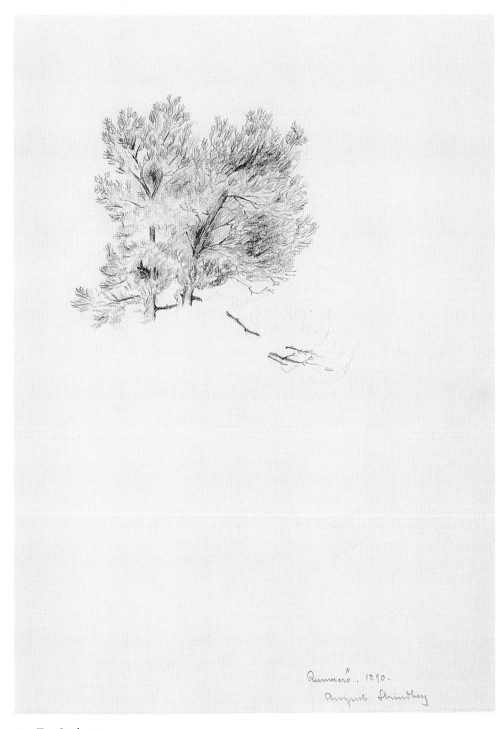

Runmarö, 1890.

August Strindberg

15c. *Tree Study*, 1890,

PENCIL, 27 X 19.4CM,

KUNGLIGA BIBLIOTEKET, STOCKHOLM. PHOTO: MARCUS ANDRÆ, KUNGLIGA BIBLIOTEKET, STOCKHOLM.

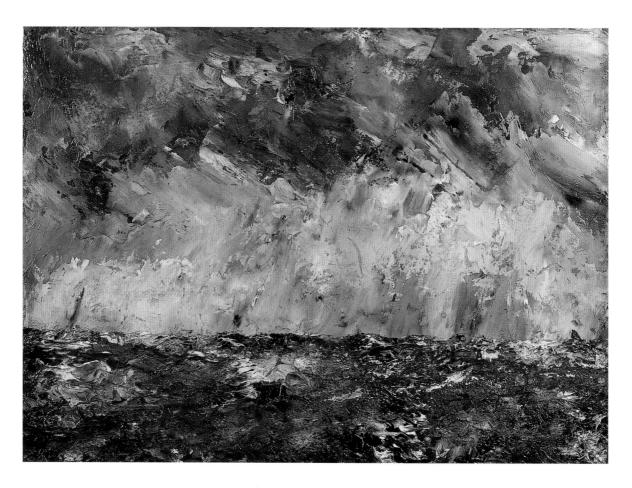

16. *Blizzard*, 1892,
OIL ON WOOD, 24 X 33CM, PRINS EUGENS
WALDEMARSUDDE. PHOTO: NATIONALMUSEUM.

The 1890s: Paintings from Dalarö

For Strindberg the 1890s were characterized by the so-called Inferno Crisis, which came to a head in Paris in 1896. For almost seven years he was unproductive as a creative writer. Instead he devoted himself to scientific experiments, and from time to time would paint. Now his painting suddenly becomes rather more than an amateur's careful attempts to copy nature.

The first reviews of Strindberg's paintings appeared in the summer of 1892. He had just exhibited a small number of new works at a venue in Stockholm known as Birger Jarls Bazar, and the event attracted the attention of several newspapers. Some of the reactions were cautiously positive, but one could also come across the kind of ironically teasing review that has often plagued modern art.

STRINDBERG AS A PICTORIAL ARTIST

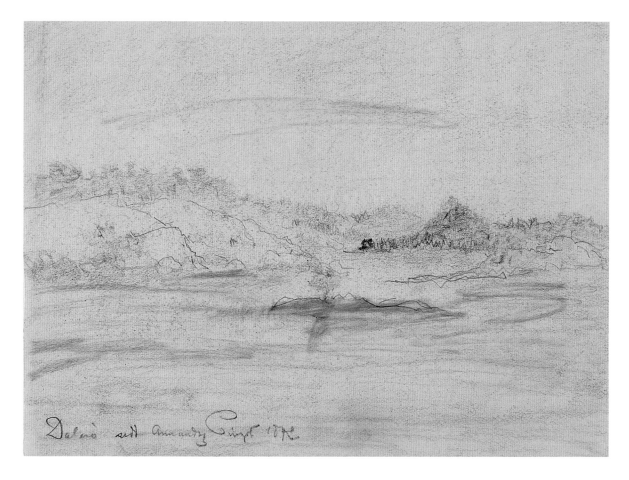

16b. *Landscape Study from Dalarö Head,*
1892,

PENCIL, 19.4 X 27CM, KUNGLIGA BIBLIOTEKET,

STOCKHOLM. PHOTO: MARCUS ANDRÆ, KUNGLIGA

BIBLIOTEKET, STOCKHOLM.

A reviewer writing in *Från Birger Jarls stad* (From the City of Birger Jarl) suspected that Strindberg's exhibition was a practical joke on the general public: in most cases it was very difficult to work out what the paintings were supposed to re-pre-sent. "If 'Snötjocka på hafvet' (Blizzard) is supposed to depict a dirty sheet hanging out to dry, or is an attempt to find a new way of painting barn doors, is impossible to say, just as one wonders whether 'Packis' (Pack-Ice) is supposed to be a plate of bread and margarine or a dish of grilled veal trotters in brain sauce."

The paintings displayed at the exhibition had been created while Strindberg was staying at Dalarö, south of Stockholm, in the spring and summer of 1892. Strindberg had been having trouble in getting his plays produced, and his divorce from Siri von Essen was about to be finalized. For the first time in nearly

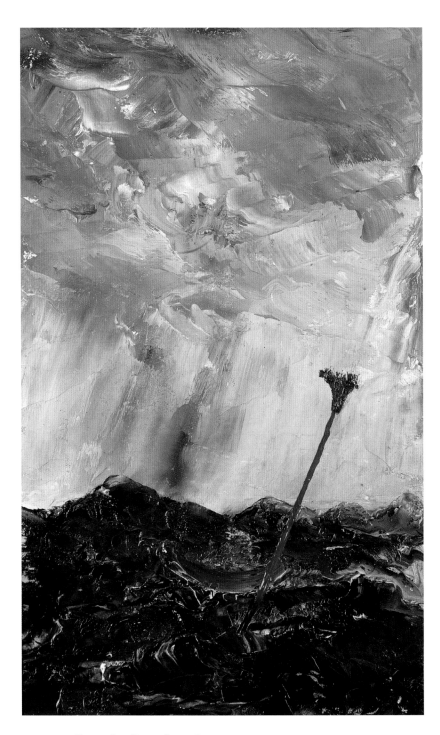

17. *Stormy Sea, Broom Buoy*, 1892,

OIL ON CARDBOARD, 31 X 19.5CM, NATIONALMUSEUM, STOCKHOLM, NM 6175, PURCHASED 1968.
PHOTO: NATIONALMUSEUM.

This picture was hung at the very first exhibition of Strindberg's paintings, at Birger
Jarls Bazar, Stockholm, in the summer of 1892. One reviewer had difficulty in seeing
what the picture depicted, and suggested it might just as well be "the back yard of a
cleaning company" as waves and a navigation mark.

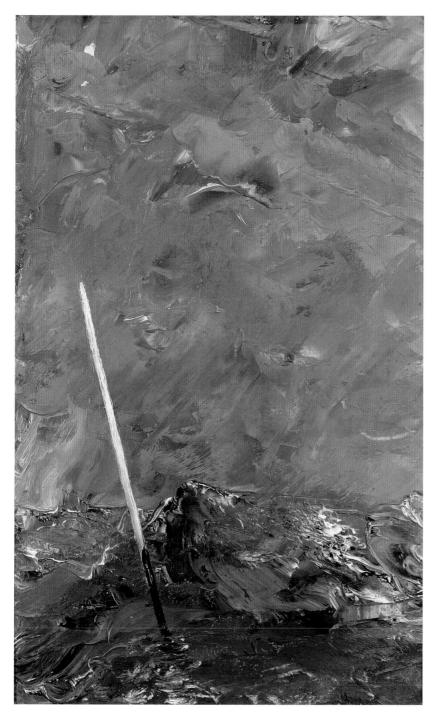

18. *Stormy Sea, Buoy without Top Mark*, 1892,

OIL ON CARDBOARD, 31 X 19CM, NATIONALMUSEUM, STOCKHOLM, NM 6174, PURCHASED 1968.

PHOTO: NATIONALMUSEUM.

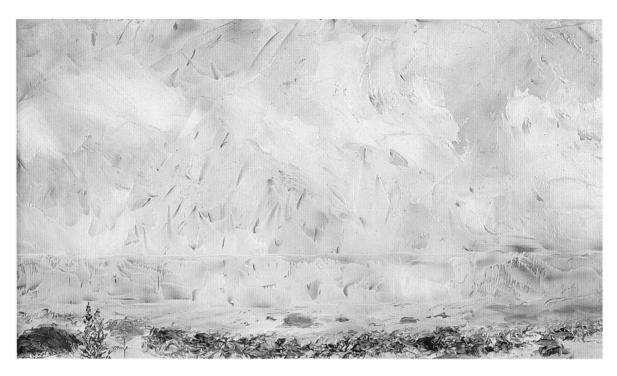

19. *Flower by the Shore*, 1892,
OIL ON ZINC SHEET, 25 X 44CM, MALMÖ
KONSTMUSEUM. PHOTO: MALMÖ MUSEER.

OPPOSITE PAGE:

20. *The Solitary Thistle*, 1892,
OIL ON PANEL, 19 X 30CM, PRIVATE COLLECTION.
PHOTO: BUKOWSKIS, STOCKHOLM.

21. *Little Water, Dalarö*, 1892,
OIL ON CARD, 22 X 33CM, NATIONALMUSEUM,
STOCKHOLM, NM 6633, PURCHASED 1975.

twenty years, he started painting in oils again. Strindberg wrote to Richard Bergh that he had invented a new kind of art that he called "skogssnufvismen" (wood-nymphism) – evidently he had already started to formulate the theory of random creation that he did not publish until a few years later in his essay (originally published in French)*: Des arts nouveaux! Ou le hasard dans la production artistique* (New Arts! Or the Role of Chance in Artistic Creation).

The 1892 paintings from Dalarö can be best characterized as images derived from Strindberg's memories of the outer archipelago and the open sea. He was now refining and developing the range of motifs he had created during the 1870s; the pictures are dominated by the open sea, the level horizon and extensive skies. In some pictures of isolated navigation marks the details are more clear-cut and the canvas has more of the character of a detailed study of a wave. One group of paintings depicts a stretch of beach with a single flower growing on it. The moods created by the paintings vary from calm, sunny situations, seen for example in some of the pictures of flowers on the shore to the stormy and chaotic in *Vita Märrn II* (The Vita Märrn

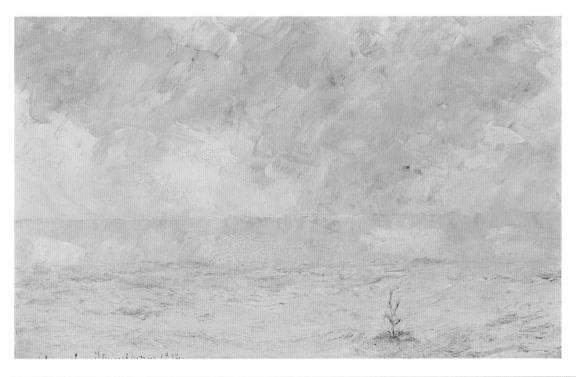

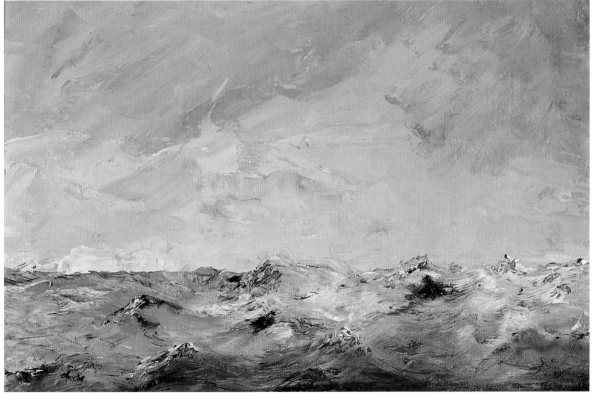

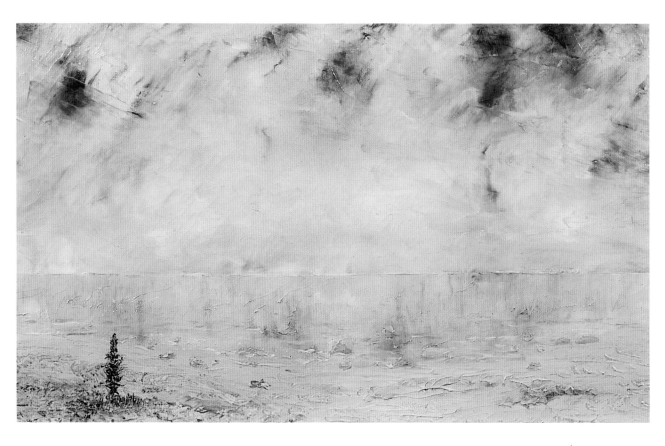

22. *Purple Loosestrife*, 1892,

OIL ON CANVAS, 35 X 56CM, PRIVATE COLLECTION. PHOTO: ALEXIS DAFLOS.

In the summer of 1892, when Strindberg took up painting again after a gap of nearly twenty years, he frequently repeated the motif of a solitary flower on a deserted shore. Although the flowers are often painted with a precision typical of miniatures, it is hard not to interpret the whole thing as being symbolic. The flowers have frequently been interpreted as symbolic self-portraits, as images of Strindberg's own isolation. Strindberg was very interested in botany, and descriptions of flowers and plants often occur in his writing. An excerpt from the short story "Fagervik och Skamsund" (Fairhaven and Foulstrand) from 1902 is closely related to the paintings of flowers on the shore: "The long, shallow creeks with the finest of writing-sand were what he liked most of all. The washed-up seaweed lay there like a forcing frame, a home for purple Loosestrife, golden-yellow Pimpernel, mauve Asters and white Sea Radish."

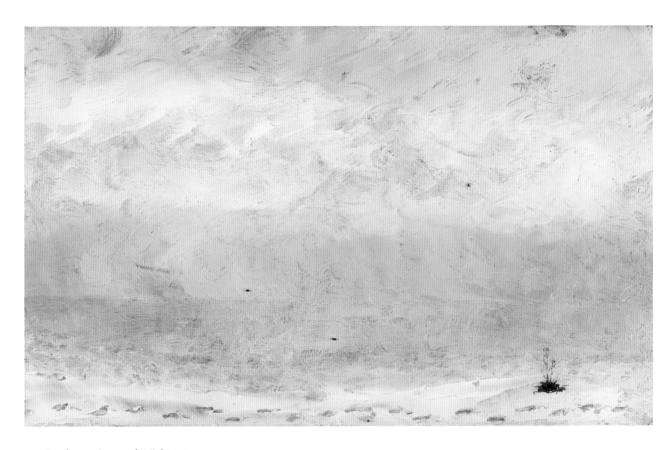

23. *Beach on a Summer's Night*, 1892,

OIL ON ZINC SHEET, 20 X 32CM, PRIVATE COLLECTION. PHOTO: BUKOWSKIS, STOCKHOLM.

This rendering of the light characteristic of a Swedish summer's night shows that Strindberg could also work with very subtle means. The colour scale of the landscape is restricted to a few shades of pink and light blue, which Strindberg makes shine through a thin superficial layer of white. He has scraped the paint in the foreground in order to create the effect of footsteps in the white sand. The very precisely painted flower contrasts with the bright haze that has settled over the rest of the picture, over the sky and the surface of the sea. Most of the paintings from Dalarö dating from the summer of 1892 are small in size, and several are painted on material that happened to be at hand, such as zinc sheets and pieces of cardboard. Only three are painted on canvas.

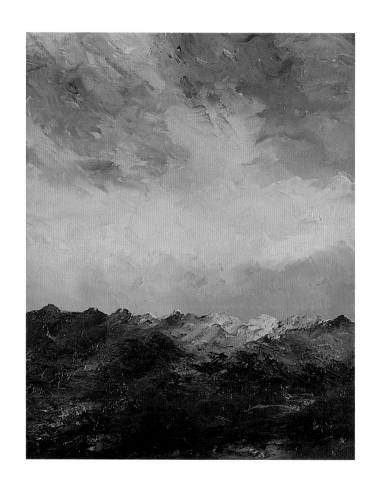

24. *Mysingen*, 1892,

OIL ON CARD, 45 X 36.5CM, BONNIERS PORTRAIT
COLLECTION, NEDRE MANILLA, STOCKHOLM. PHOTO:
STRINDBERGSMUSEET, STOCKHOLM.

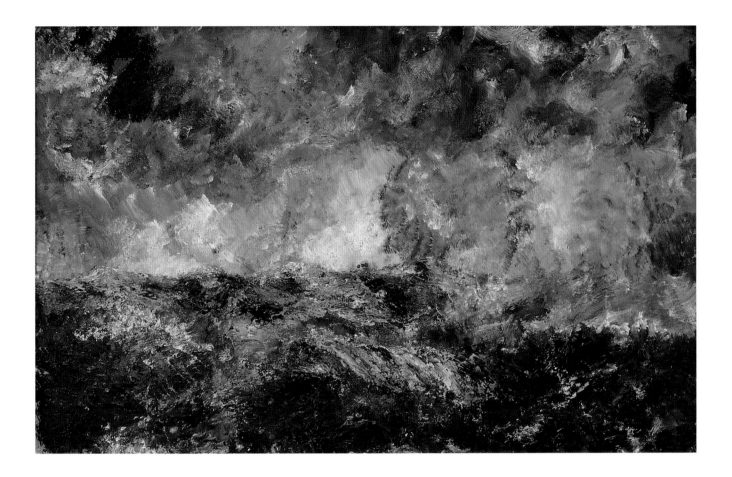

25. *Storm in the Archipelago (The Flying Dutchman)*, 1892,

OIL ON CARDBOARD, 62 X 98CM, STATENS MUSEUM FOR KUNST, COPENHAGEN. PHOTO: DOWIC PHOTOGRAPHY.

This painting was hung at the Nationalmuseum 1914–19, but was removed after the death of the museum director Richard Bergh. Strindberg probably thought up the title *The Flying Dutchman* long after the painting had been made. He told Vilhelm Carlheim-Gyllensköld that it was possible to interpret part of the picture as a ghostly ship sailing over the sea. The motif of the Flying Dutchman crops up in Strindberg's short story *Uppsyningsman* (The Supervisor) in the collection *Skärkarlsliv* (Men of the Skerries). The main character is a Customs supervisor whose ultimate fate is to embark on an eternal and pointless voyage through the archipelago. The motif also occurs in the poem *Holländarn* (The Dutchman) in *Ordalek och småkonst* (Word Play and Minor Art):

> The seventh year I voyaged aimlessly
> Through wat'ry deserts, avoiding the shoreline's temptations

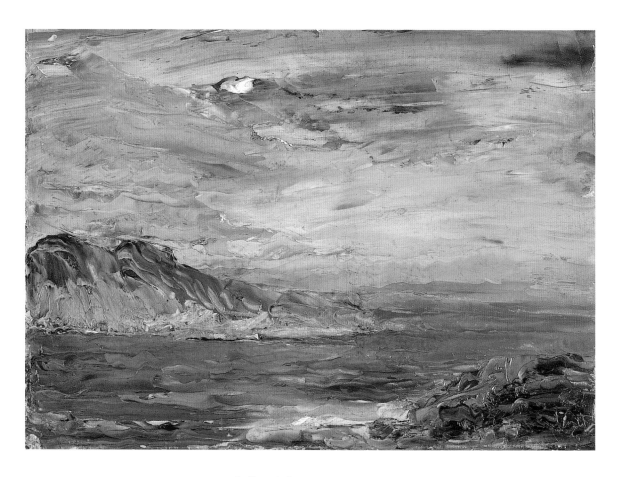

26. *Sunset*, 1892,

OIL ON CARDBOARD, 23.5 X 32CM, NATIONALMUSEUM, STOCKHOLM, NM 6168, PURCHASE 1968.
PHOTO: ÅSA LUNDÉN, NATIONALMUSEUM.

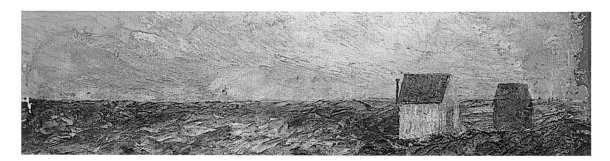

27. *Lighthouse*, 1892,

OIL ON PANEL, 6.5 X 18CM, KUNGLIGA BIBLIOTEKET, STOCKHOLM. PHOTO: KUNGLIGA BIBLIOTEKET,
STOCKHOLM.

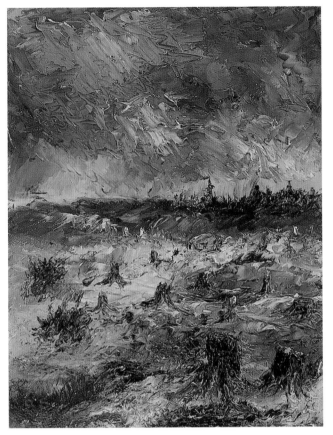

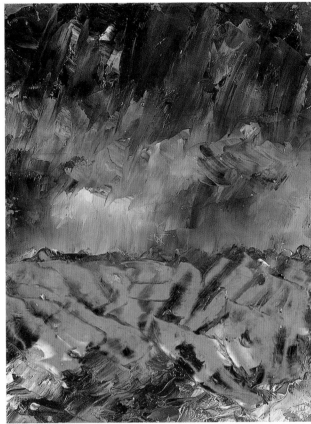

27b. *Burn-Beaten Land*, 1892,

OIL ON ZINC SHEET, 35 X 26CM, PRIVATE COLLECTION. PHOTO: JOCHEN LITTKEMAN.

This painting is the only one from 1892 that does not depict the sea. Strindberg probably thought the picture should be interpreted symbolically, and it may be possible to link it to a passage in the play *Fordringsägare* (Creditors) from 1888:

Gustaf: Oh, you do imagine things! – Anyway, I suppose your wife will be bringing your heart home soon?

Adolf: No, not now. Not now that you've burnt her for me! You've reduced everything to ashes – my art, my love, my hope, my faith!

Gustaf: That had been done already.

Adolf: But something could have been saved. Now it's too late. Incendiary!

Gustaf: All we've done is clear the ground: now we can sow in the ashes!

27c. *Stormy Sea*, 1892,

OIL ON ZINC SHEET, 35 X 26CM, PRIVATE COLLECTION. (ON THE REVERSE OF SVEDJELAND). PHOTO: BERND-PETER KEISER.

28. *The Vita Märrn Seamark II*, 1892,

OIL ON CARDBOARD, 60 X 47CM, NATIONALMUSEUM,
STOCKHOLM. NM 6980, PURCHASED 1999.
PHOTO: ÅSA LUNDÉN, NATIONALMUSEUM.
Several of the paintings from Dalarö in the
summer of 1892 have motifs that Strindberg had
previously depicted in his writing, especially
his novel *I havsbandet* (By the Open Sea), 1889.
One of the relevant passages deals with the
navigation mark in the painting *The Vita Märrn
Seamark II*.
"They approached the awful volcanic formation
of Svartbådan. The glistening black diorite with
the deathly white navigation mark known as
Vita Märrn (The White Mare) looked even
more barren and desolate in the sunshine,
which was trying in vain to reconcile the glaring
extremes of black and white." – "This example
of man's handiwork out here, where no man
was to be seen, this confusion suggestive of
the gallows, shipwrecks and coal, this crude
contrast between the unblended colourless
colours of black and white, of barren, violent
nature lacking in organic life, with no trace of
any lichen or moss anywhere on the rocky o
utcrop – this piece of carpentry, with no
vegetation to bridge the gap between primitive
nature and the work of man, seemed startling,
worrying and brutal."

Seamark II) and *Den flygande holländaren* (The Flying Dutchman).

Even if Strindberg's paintings can still be identified as depictions of nature, there is something expressive and symbolic about them which was hardly present in his work from the 1870s. They are also strongly linked to some of the literary works that signify Strindberg's breaking away from Naturalism at the end of the 1880s. The novel *I havsbandet* (By the Open Sea) in particular, dating from 1890, contains a number of scenes with motifs that recur in the paintings. This novel is the Nietzsche-inspired story of an Übermensch, Axel Borg, who takes up a post as a fisheries inspector in the Stockholm archipelago. At first Borg's intention is to improve the fishing in the area, but he soon adopts more daring aims. As his ambitions grow, so too does his isolation from the other people in his environment, and by the end of the story, after Axel Borg has almost succeeded in creating human life by artificial means, he goes out of his mind completely and heads out into the open sea to his death. According to Strindberg himself the theme of the novel was "the downfall of an individual when he isolates himself".

Throughout the story Strindberg uses depictions of the sea and the archipelago as a symbolic background to the plot. Of course, it is impossible to say that the 1892 paintings should be interpreted in the same way as the depictions of corresponding motifs in *By the Open Sea*, but even so, the novel could give us an indication of how Strindberg might have seen them himself. At the end of the novel, for instance, Strindberg described the sea as "the source of life and the enemy of life."

Several descriptions of navigation marks in *By the Open Sea* have direct parallels in his paintings. At one point he describes a whistle buoy, a motif that crops up again in a little painting that is probably one of the earliest produced during his stay at Dalarö in 1892:

And there it was, bobbing up and down on the waves, vermillion-red and glistening damp like an excised lung with its big, black windpipe pointing aslant up into the sky. And the next time a wave compressed the air it raised a cry, as if the sea were roaring at the sun. Its anchor cable rattled away until it had reached full stretch, and then, as the wave receded and sucked back the air, a

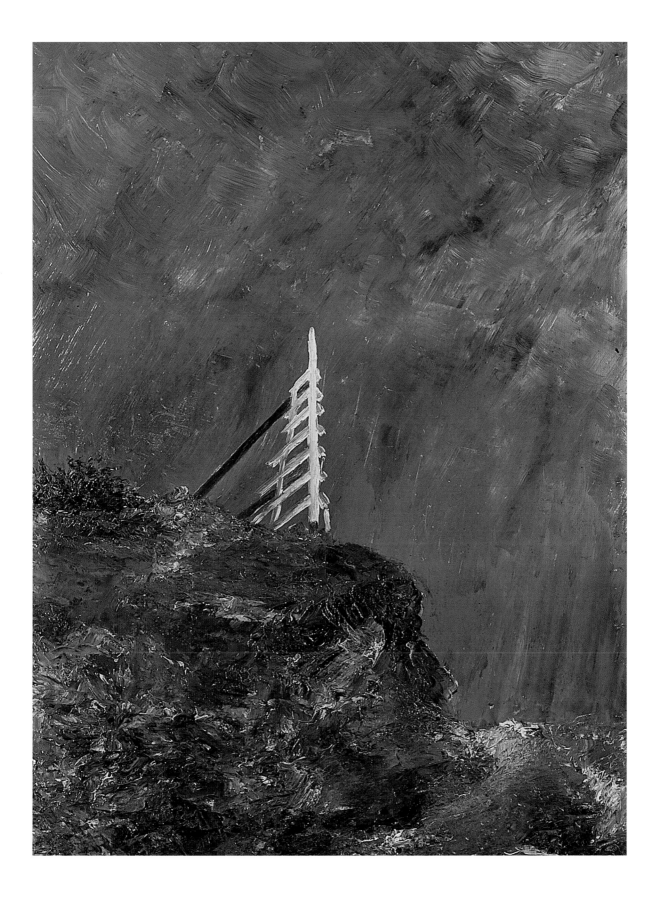

STRINDBERG AS A PICTORIAL ARTIST

howl rose up from the depths as if from the giant trunk of a drowning mastodon.

The quotation is typical of Strindberg's ability to see something, an object or an event, as something else. In his imagination the whistle buoy becomes a living creature.

Despite the similarities in motifs between *By the Open Sea*, for instance, and Strindberg's pictures dating from 1892, one can hardly maintain that Strindberg's painting ever became narrative or literary in the traditional sense. There were probably two reasons for this: firstly, he seems to have recognized his technical limitations as an artist and hence avoided depicting people, and secondly, he was interested in the distinctive nature of painting, in what differentiates a painted image from a literary one. It is obvious that Strindberg was fascinated by the physical qualities of paint, its matter and its structure.

In his book, *August Strindberg. Inferno Painting: Pictures of Paradise*, Douglas Feuk has indicated the unclear nature or ambiguity of the motifs in many of Strindberg's paintings. This is true mainly of the paintings dating from 1894, but in some from 1892 it is also difficult to be certain of what is actually depicted. The most remarkable of them is the so-called *Dubbelbild* (Double Picture), which is a collage with two pictures superimposed. It is probably a picture like *The Vita Märrn Seamark II* that Strindberg has used for the dark part to the left and at the top, while the right-hand side could perhaps be a light mountain landscape. On the other hand, the light part could perhaps also be regarded as a sea-scape with white wave crests. In any case, the result is completely anti-naturalistic – a dark and a light landscape interposed onto each other.

Double Picture is unique in contemporary pictorial art. We do not know where Strindberg got the idea from, nor do we know how he wanted the picture to be interpreted. It is possible that he might have gained inspiration for the composition from Carl Larsson's cover for *I havsbandet*. That cover picture is an archipelago scene with a landing stage in the foreground, enclosed on the left by a frame with swimming fish. The final impression is that of the sea both above and beneath the surface.

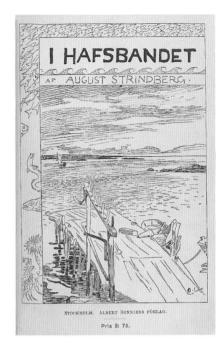

30. *I hafsbandet* (By the Open Sea), 1890,
BOOK COVER BY CARL LARSSON. PHOTO: MARCUS ANDRÆ, KUNGLIGA BIBLIOTEKET, STOCKHOLM.

29. *Double Picture*, 1892,
OIL ON PANEL, 40 X 34CM, PRIVATE COLLECTION.
PHOTO: ALEXIS DAFLOS.

Berlin – Dornach – Paris.
Imitating Nature's Way of Creating

In the autumn of 1892 Strindberg went to Berlin. Once there, he became the centre of an intellectual circle that used to meet at the wine bar known as Zum Schwarzen Ferkel (The Black Piglet). Included in the group were the Norwegian painters Edvard Munch and Christian Krohg, the Finnish writer Adolf Paul and the Polish author Stanislaw Przybyszewski.

While in Berlin Strindberg met his future second wife, the Austrian journalist Frida Uhl. He continued to paint, and became increasingly interested in scientific experiments. It may seem strange that the paintings he made during this period comprised more or less the same motifs as those from his time at Dalarö, despite the fact that he was in a cultural metropolis with many links to the international avant-garde as far as painting was concerned. However, his motifs and technique remained the same, although the way he interpreted his own pictures shifted in the direction of Symbolism.

He and Munch submitted several canvases to the Berlin Art Exhibition, but they were rejected and were exhibited instead in the Salon des Refusées, which was organized at the same time. Strindberg's relationship with Munch was evidently important for him and is worth commenting on. Several researchers have already pointed out that in his paintings, Strindberg refrained from depicting the kind of conflicts he often featured in his dramas, but Edvard Munch on the other hand created several pictures with situations and atmospheres that remind one of motifs in Strindberg's literary works.

Robert Rosenblum has made an interesting comparison between Strindberg's and Munch's paintings, his starting point being Munch's canvas *Sjalusi* (Jealousy) and Strindberg's *Svartsjukans natt* (Night of Jealousy). Both deal with the same emotion but they are very different. Strindberg's picture contains no human beings. He has created a chaotic mixture of dark colours, a landscape so obscure in its significance that he evidently felt obliged to present his own interpretation of the painting, and he wrote on the back a description of the motif and its symbolic

31. *Night of Jealousy*, 1893,
OIL ON CARDBOARD, 41 X 32CM, STRINDBERGSMUSEET, STOCKHOLM. PHOTO: HANS THORWID, NATIONALMUSEUM.
Strindberg gave this painting to his future second wife, Frida Uhl, as an engagement present. It is not clear whether or not the title, Night of Jealousy, refers to a specific incident. Strindberg wrote a dedication on the reverse: "To Miss Frida Uhl from the artist (the Symbolist August Strindberg). The painting depicts the Sea (bottom right), Clouds (top), A Cliff (on the left), A juniper bush (top left), And symbolizes: a Night of Jealousy."

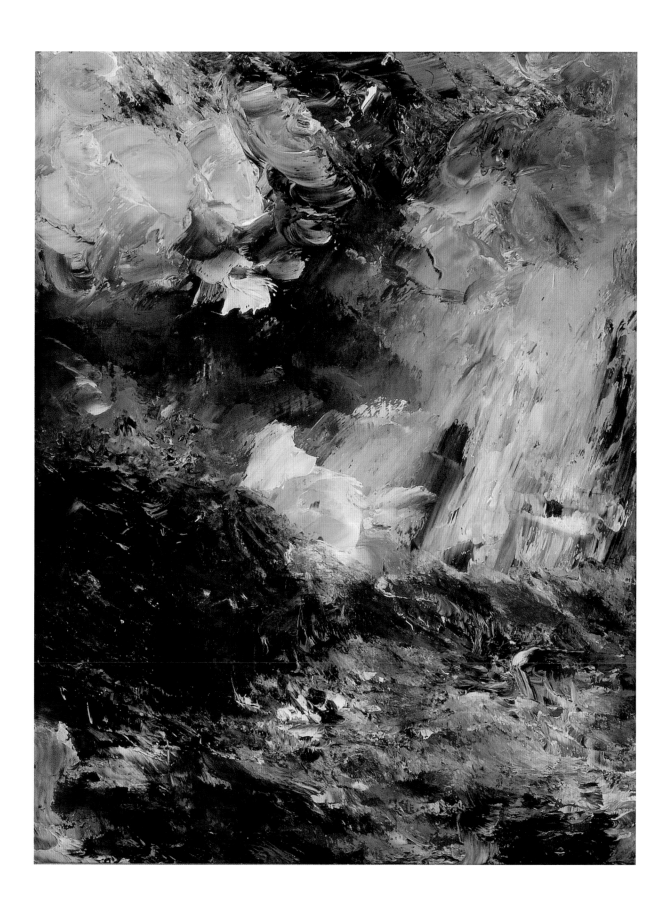

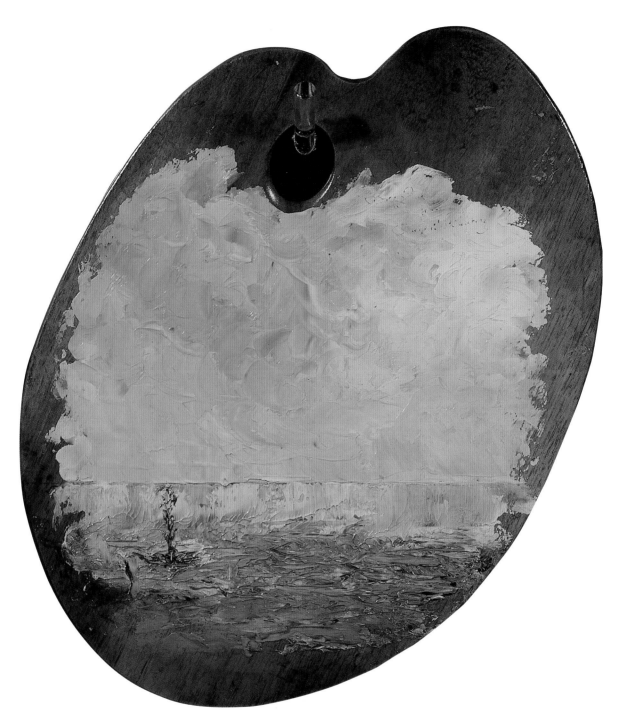

32. *Palette with Solitary Flower on the Shore*, 1893,

OIL ON WOOD, C. 38 X 34CM, PRIVATE COLLECTION. PHOTO: STRINDBERGSMUSEET, STOCKHOLM.

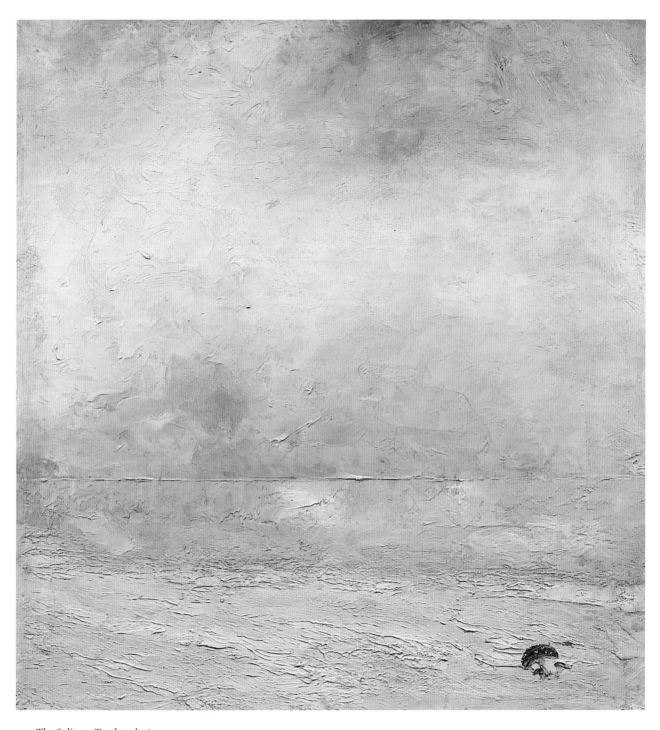

33. *The Solitary Toadstool,* 1893,

OIL ON CANVAS, 47 X 45 CM, PRIVATE COLLECTION. PHOTO: NATIONALMUSEUM

In the letter to Leopold Littmansson in which Strindberg lists the paintings he had made in Dornach, 1894, he provides an interpretation of *The Verdant Island*: "The high summer of life (For me Kymendö 1880), hence the island itself veiled – in white, yellow and pink." Verdant and idyllic islands occur several times in Strindberg's literary works, including the short story *Skräddarns skulle ha dans* (A Dance at the Tailor's) in the collection *Skärkarlsliv* (Men of the Skerries), from 1888. This tells how a tailor used all his enthusiasm and skill to grow fruit trees and flowers on a barren island in the archipelago, so that visitors would believe they "had come to an enchanted isle". An idyllic island is also depicted in *De lycksaliges ö* (Island of Bliss). The painting *The Verdant Island* has often been interpreted as a mirror image of Arnold Böcklin's famous painting *Dödens ö* (Island of Death), one of Strindberg's favourite pictures. When Strindberg's and August Falck's experimental theatre "Intima teatern" was set up in Stockholm in 1907, copies of Böcklin's *Island of Death* and *Island of Life* were placed on each side of the stage, and in the final scene of *Spöksonaten* (The Ghost Sonata), Strindberg uses the *Island of Death* as a back-drop.

content. Munch's painting is an attempt to represent an emotionally charged tension between the three persons depicted. Despite the differences, Rosenblum maintains that both pictures can be characterized as Symbolist works of art.

August Strindberg and Frida Uhl were married in the spring of 1893 and a year later moved to Austria where they lived in a cottage on Frida's grandparents' estate of Dornach, on the Danube. Strindberg was now intensely involved with his painting, and some of his most remarkable pictures were created here. Frida was pregnant, and Strindberg maintained later that he painted pictures so that the walls of the cottage could be adorned in time for the child's arrival.

This was also the year when he evolved the artistic method described in the essay *Des arts nouveaux! Ou le hasard dans la production artistique* (The New Arts! Or the Role of Chance in Artistic Creation). The essay is about unexpected and random motifs and forms, patterns and figures, that crop up in a work of art without the artist intending to create them. Strindberg compares this haphazard method of creating images with the popular idea of a wood nymph:

> Gentlemen, you all remember the fairy tale about the boy wandering though the woods who suddenly comes across a wood nymph. She's as beautiful as the day is long, with emerald-green hair, etc. He goes up to her, but she turns her back and it looks for all the world like a tree trunk. Obviously all the boy actually saw was a tree trunk, and his lively imagination invented the rest.

Strindberg concludes his essay by urging: "Imitate nature in an approximate way, imitate in particular nature's way of creating!

In a letter to his childhood friend Leopold Littmansson, he expanded his theory further: "Every picture is double-bottomed, as it were: each one has an exoteric aspect that everybody can make out, albeit with a little effort, and an esoteric one for the painter and the chosen few." Strindberg had now adopted the ideas of the Symbolists regarding a kind of art that is only accessible to a few of the initiated. Nevertheless, his method is radically different from literary orientated Symbolism in that both the creation of the painting and its interpretation have the char-

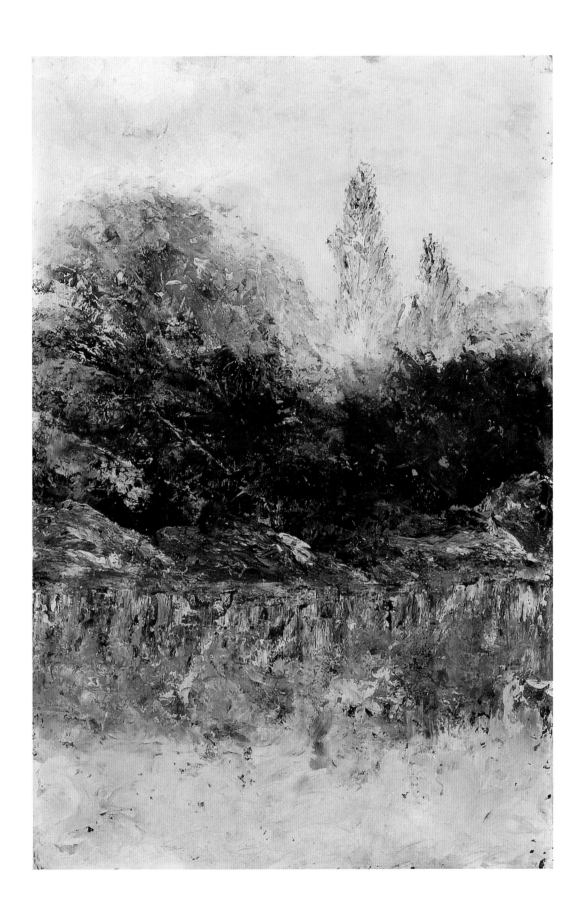

36. *Proposal for a Stage Set for To Damascus I*, 1909,

ANILINE ON BLOTTING PAPER, 14.8 X 28.4CM, KUNGLIGA BIBLIOTEKET, STOCKHOLM. PHOTO: MARCUS ANDRÆ, KUNGLIGA BIBLIOTEKET, STOCKHOLM.

35. *Golgotha*, 1894,

OIL ON CANVAS, 91 X 65CM, PRIVATE COLLECTION.

This painting, which was made while Strindberg was in Dornach, Austria, in 1894, is a variation of the composition Strindberg had used earlier in *The Vita Märrn Seamark II,* and which he would use again in *Snowstorm at Sea* and *Seascape with Rock*. The almost monochrome black colour nevertheless permits a landscape to be discerned, albeit hazily. It is easy to see the painting as an abstract work of art, but there is a realistic element in the three white masts, or crosses, that project from the black waves in the bottom right-hand corner of the painting. Moreover, Strindberg himself suggested that a splash of colour on the cliff could be a man contemplating the crosses. Strindberg maintained that it was possible to see "an excellent picture of Rembrandt" in the cloud formations. The three-mast motif evoking three crosses goes back to an experience Strindberg had at Sandhamn in 1873. One moonlit night he was convinced he had seen Christ on the cross between the other two crosses at Golgotha, but soon realized that what he had actually seen was just three masts on a ship. Later on Strindberg would make use of the motif in a scene in *Till Damaskus* (To Damascus):

The Lady: Don't look at the clouds. . .

The Stranger: And underneath them, what's that?

The Lady: It's just a sunken ship!

The Stranger (whispers): Three crosses! – What new Golgotha confronts us now?

The Lady: But they're white: that bodes well!

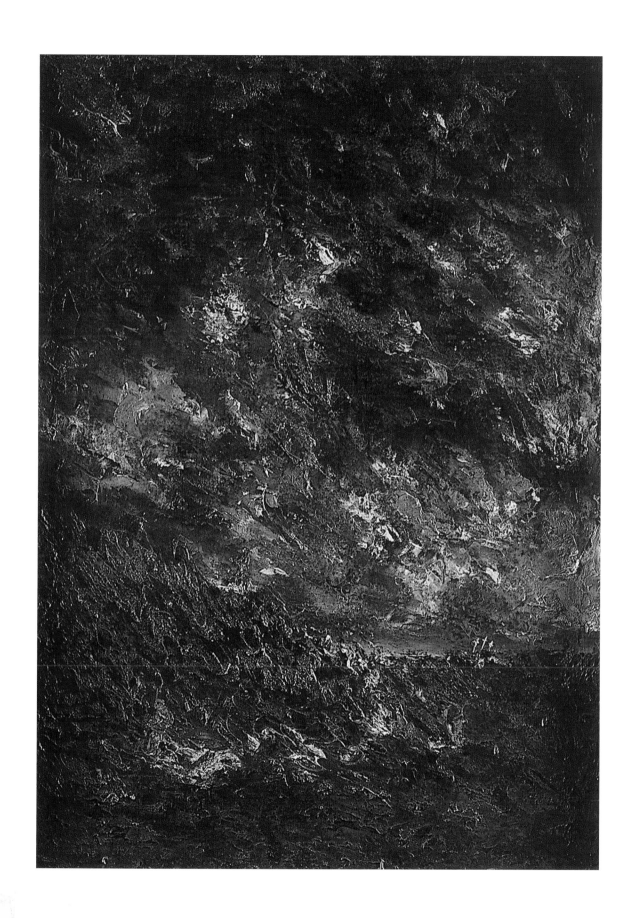

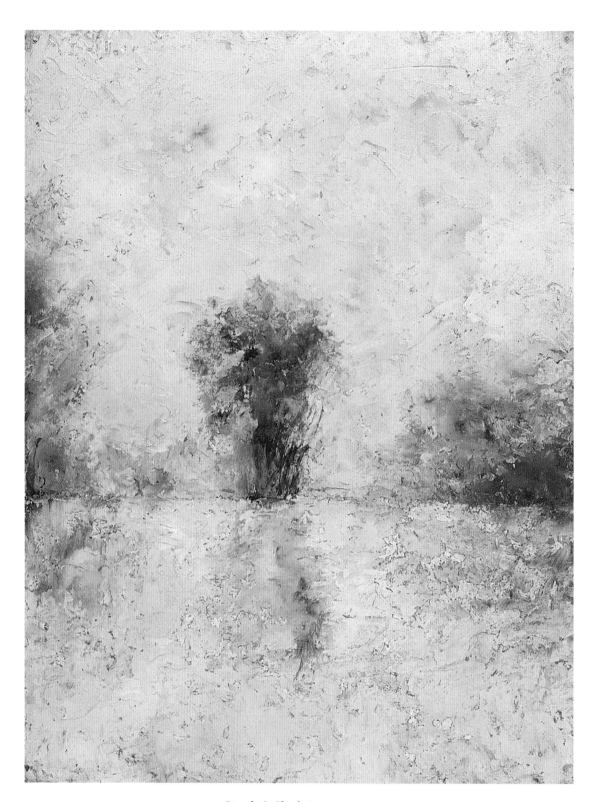

37. *Danube in Flood*, 1894,

OIL ON PANEL, 44 X 33CM, PRIVATE COLLECTION. PHOTO: BEIJER'S AUCTIONS.

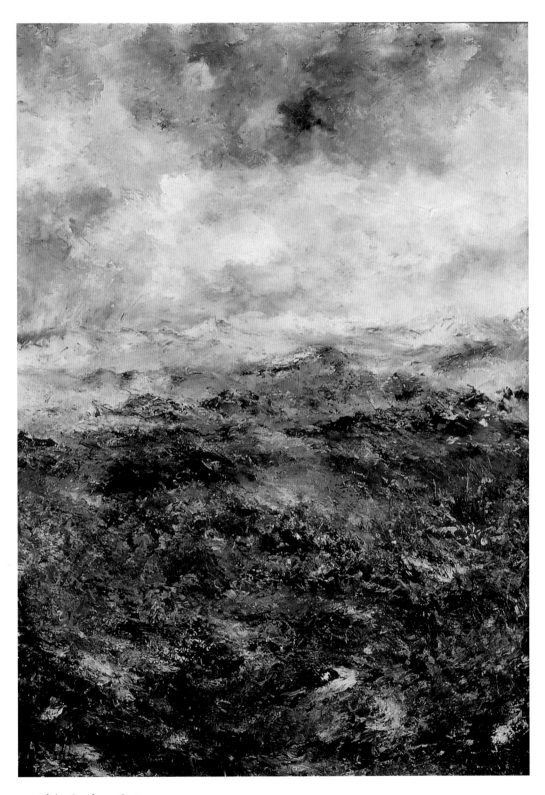

38. *Alpine Landscape I*, 1894,

OIL ON PANEL, 72 X 51CM, PRIVATE COLLECTION. PHOTO: STRINDBERGSMUSEET, STOCKHOLM.

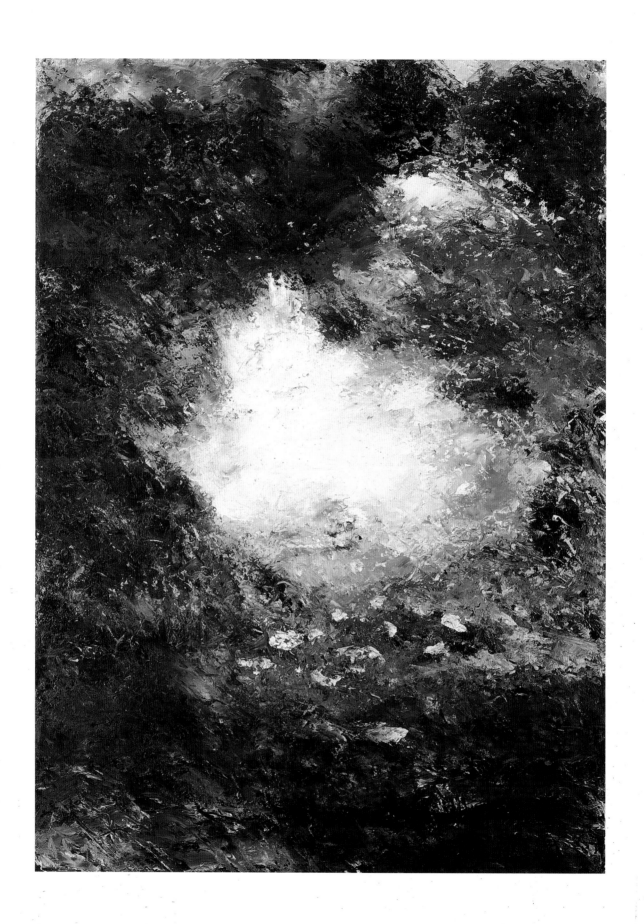

acter of an open and unprejudiced process. The artist works haphazardly and the viewer is free to assign to the picture whatever content he chooses. Strindberg's random method anticipates both the Surrealists of the 1920s and the Abstract Expressionism and informal art of the post-war years.

The paintings made by Strindberg in Dornach in 1894 are listed in an appendix to his letter to Littmansson. Strindberg also provides interpretations of the pictures, and in accordance with Symbolist principles the interpretations are divided into the exoteric (interpretations for all comers) and esoteric (interpretations accessible only to the initiated). The painting *Underlandet* (Wonderland) is given the following exoteric interpretation: "A dense forest: in the middle the scene opens out to display an idealistic landscape drenched in sunlight of every colour. In the foreground rocky outcrops and stagnant water in which malvaceous plants are reflected." The esoteric interpretation is more loaded with significance: "Wonderland: the battle between light and darkness. Or the realm of Ormuzd opened up, and liberated spirits fleeing into the land of the sun; underneath, the flowers (they are not malvaceous) decay in a state of *gnothi seauton* before the dirty water reflecting the sky (Petter Nycklas' Heavenly Realm)."

Strindberg would go on to repeat the cave-like composition of *Wonderland* several times. Even if the first version of the motif came about as a result of haphazard creation, it is clear the cave motif was of special interest to him. Göran Söderström has suggested that Strindberg's inspiration for the composition came originally from his friend Per Ekström's painting *Franskt vårlandskap. Motiv från slottet St Germain-en-Laye* (French Spring Landscape. Motif from the castle St. Germain-en-Laye) dating from the end of the 1880s. The picture was presented to Strindberg by Ekström in 1891.

Harry G. Carlson has pointed out that the cave motif played an important part in Strindberg's imaginative world. He seems to have been especially fascinated by the so-called Fingal's Cave on the island of Staffa in the Inner Hebrides, off the west coast of Scotland. This remarkable cave, formed by the waves from an island consisting of basalt lava, is characterized by the tall, six-

39. *Wonderland*, 1894, OIL ON CARDBOARD, 72.5 X 52CM, NATIONALMUSEUM, STOCKHOLM, NM 6877, GIFT FROM KARL OTTO, ELIZABETH, PONTUS, EVA AND ÅKE BONNIER, 1992. PHOTO: ERIK CORNELIUS, NATIONALMUSEUM.

Strindberg described the origins of the painting in his essay "Des arts nouveaux! ou le hasard dans la production artistique" (New Directions in Art! Or the Role of Chance in Artistic Creation). He explains how he had first intended to paint "a shaded forest interior, from which you see the sea at sunset." After painting for a while, he realizes that he cannot in fact see the sea, but instead sees the light central area as "an endless perspective of rose-coloured, bluish light, in which disembodied and undefined beings float like fairies, trailing clouds behind them." He notes that the forest has turned into a cave, and that the foreground looks like cliffs covered in lichens. Strindberg is working here in accordance with the haphazard method: the painting comes about as a combination of a conscious attempt to achieve a particular motif, and diversions from that motif the artist comes up against whilst working on it.

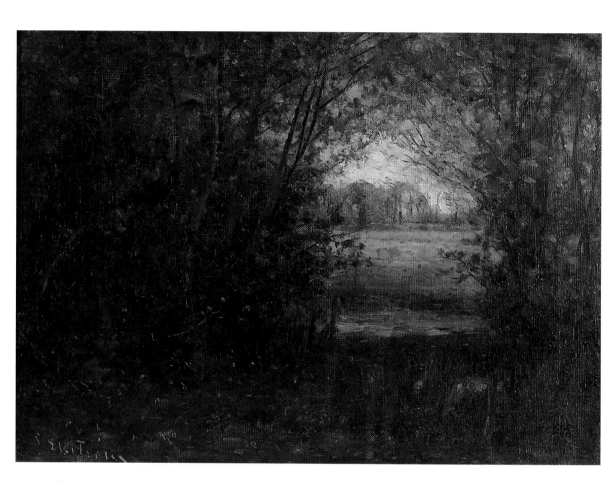

40. Per Ekström, *French Spring Landscape.*
Motif from St. Germain-en-Laye, 1887–8,
OIL ON CANVAS, 33 X 46CM, KALMAR ART MUSEUM,
KALMAR. PHOTO: ROLF LIND. © PER EKSTRÖM/BUS 2001.
Strindberg was presented with the painting by
his friend Per Ekström, probably in 1891. It may
be that the composition of the painting inspired
Strindberg's composition of his picture
Wonderland.

40b. *Crayon From the Draft of Folkungasagan* (The Saga of the Folkungs),
1899,

COLOURED CHALK, KUNGLIGA BIBLIOTEKET, STOCKHOLM. PHOTO: MARCUS ANDRÆ, KUNGLIGA
BIBLIOTEKET, STOCKHOLM.

The blurred woodland scene from a draft of *The Saga of the Folkungs* is reminiscent of
the leafy-cave motif in *Wonderland*.

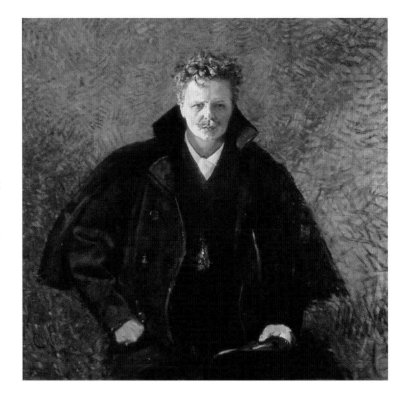

42. Christian Krogh, *August Strindberg*, 1893,

OIL ON CANVAS, 156 X 157.9CM, NORSK FOLKEMUSEUM — IBSENMUSEET, OSLO. PHOTO: NORSK FOLKEMUSEUM — IBSENMUSEET.

The portrait was painted in Berlin, and Strindberg later described how he found posing for it most trying: "After a month of posing I didn't recognize myself. I caught myself out as a poseur and my personality disgusted me; I started by taking down the mirrors in my room, and then I have no desire to set eyes again on the painter or his portrait." The portrait is strikingly similar to the photograph of Strindberg, probably a self-portrait, taken about the same time.

41. *Self-Portrait*, 1892-3, ORIGINAL PHOTO-GRAPH, 13 X 9CM, KUNGLIGA BIBLIOTEKET, STOCKHOLM. PHOTO: MARCUS ANDRÆ, KUNGLIGA BIBLIOTEKET, STOCKHOLM.

sided basalt columns surrounding its mouth. In his short story *Den romantiske klockaren på Rånö* (The Romantic Sexton on Rånö), Strindberg compares Fingal's cave to a gigantic organ, and one of the scenes in *Ett drömspel* (A Dream Play) is set in it. Harry G. Carlson maintains that in Strindberg's works overall, caves are a location for transformations, or even the source of imagination itself.

During his stay in Dornach, Strindberg started to devote himself to photographic experiments of a new kind. He took pictures of the moon and the stars, some of them using a camera with no lens, and others using no camera at all but simply exposing the naked plate to starlight. Strindberg distrusted lenses, both in cameras and in people's eyes. He therefore considered the pictures he managed to produce without lenses to be more real than those projected onto one's retina. Around the middle of the 1890s Strindberg also experimented with photograms of crystallizations, another form of photographic picture made without using a camera or lens.

Furthermore he had plans to develop a photographic method

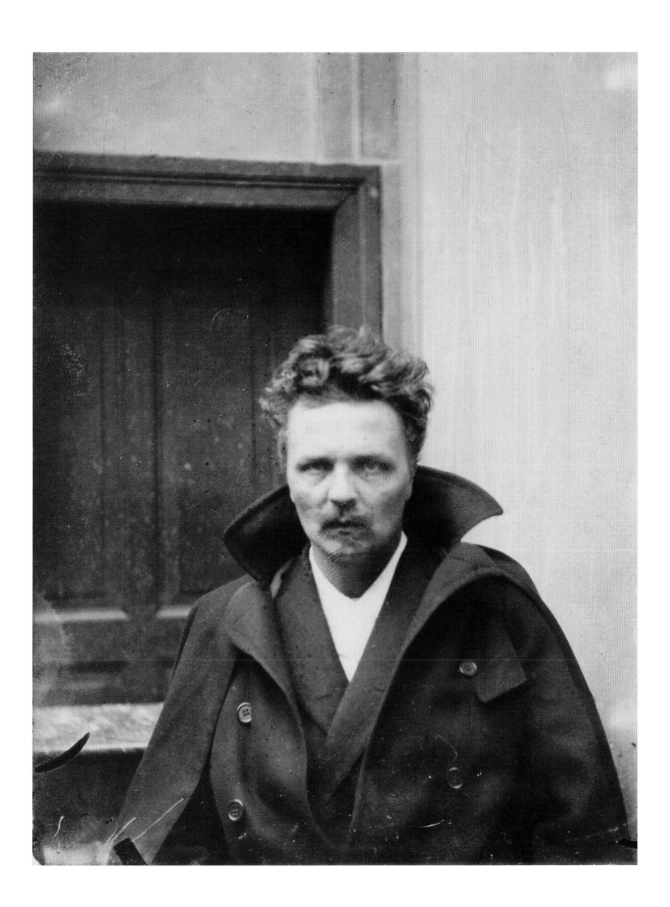

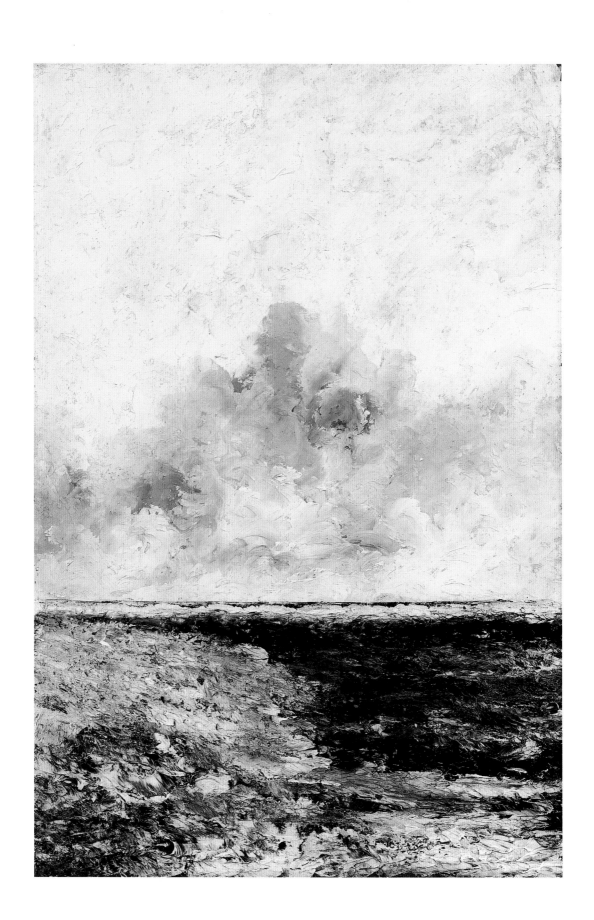

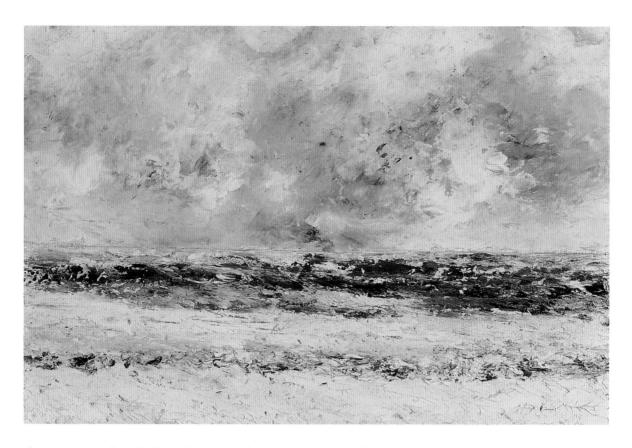

for producing "psychological portraits" using a camera with no lens. During the long exposure time the model would be subjected to suggestion, and the camera would capture their spiritual qualities. It is not clear whether he ever tried out his idea in practice. A few photographic portraits, probably self-portraits taken by a traditional camera with a lens, have been preserved from the Berlin period, 1892–3.

Strindberg moved to Paris in the autumn of 1894, and continued painting there. He had come into contact with a Danish painter and art dealer who called himself Willy Gretor, and offered to back Strindberg as an artist in Paris. Strindberg was lent an exclusive flat in Paris-Passy by Gretor, and while living there started to work on a series of paintings intended for an exhibition. An important reason why Strindberg accepted his offer was that he really did think he would be able to earn a good living from selling his pictures. As so many times before, he was in a poor state financially.

44. *Stretch of Shore*, 1894,
OIL ON PANEL, 28 × 42 CM. PRIVATE COLLECTION.
PHOTO: TORD LUND.

43. *Seascape*, 1894,
OIL ON CARDBOARD, 46.5 X 31.5CM,
NATIONALMUSEUM, STOCKHOLM NM 6968. PHOTO:
BODIL KARLSSON, NATIONALMUSEUM.

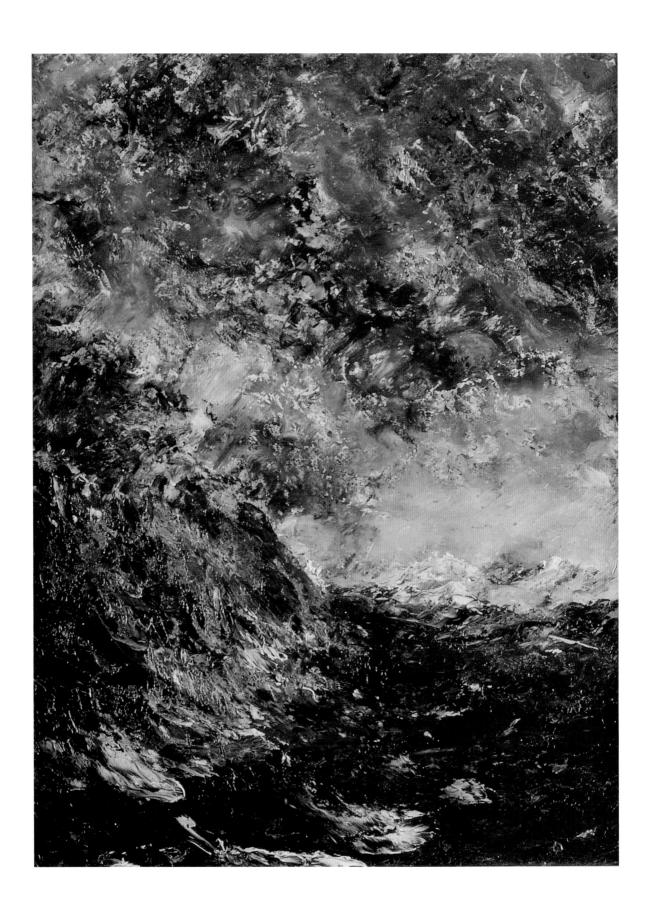

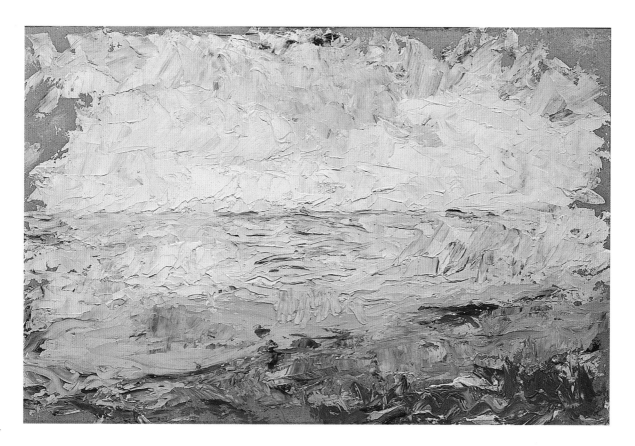

Strindberg's technique was now quite advanced, and his lack of formal training barely noticeable. A few paintings of shore motifs are reminiscent of Gustave Courbet's and Carl Fredrik Hill's pictures of desolate beach scenes. Perhaps Strindberg was trying to adapt himself to what he thought were the requirements of the French art market. If so, his attempt was in vain as the planned exhibition never took place: instead Strindberg broke off all connections with Gretor, who was suspected of dealing in forgeries.

In what were probably his last paintings from Paris in 1894, Strindberg once more takes up motifs he had previously used in some of the Dalarö paintings dating from 1892. The pictures *Snöstorm på havet* (Snowstorm at Sea) and *Hög sjö* (High Seas) are both depictions of nature's fury. Water, wind, snow and darkness collide in chaos, where the boundaries between the elements are lifted completely. It is possible that Strindberg was inspired by William Turner's paintings. The date that he first saw the work of

46. *Shore Scene* (unfinished), 1894,
OIL ON PANEL, 26 X 39CM, STRINDBERGSMUSEET, STOCKHOLM. PHOTO: ERIK CORNELIUS, NATIONALMUSEUM.

45. *Seascape with Rock*, 1894,
OIL ON PANEL, 40 X 30CM, PRIVATE COLLECTION.

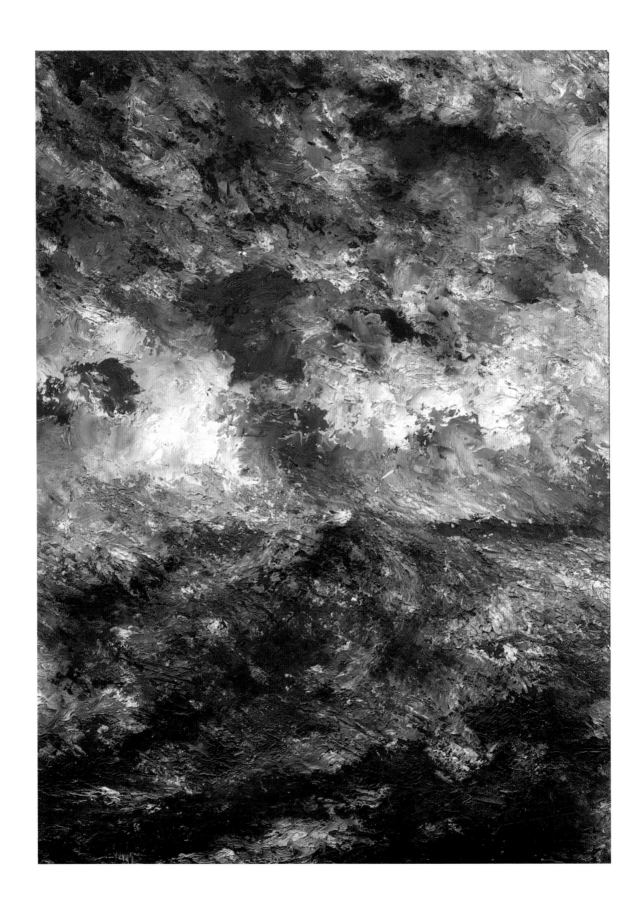

48. *Snowstorm at Sea*, 1894,

NORDISKA MUSEET, STOCKHOLM. PHOTO: NORDISKA MUSEET, STOCKHOLM.

47. *High Seas*, 1894,

96 X 68CM, MIXED TECHNIQUES ON CARDBOARD, FOLKHEM. PHOTO: ERIK CORNELIUS,
NATIONALMUSEUM.

High Seas is considered to be the last painting Strindberg made in the 1890s. As far as
the motif is concerned, it is linked to some of the paintings from Dalarö in 1892, but
from a technical point of view it is a new creation. Strindberg used very dry paint that
was probably mixed with plaster of Paris in order to give the picture a powerful surface
structure. In order to increase the degree of blackness he has burnt some sections, most
likely using a burner or a paraffin lamp.

49. *Frottage made from a Shell of a Crab*, enclosed with a letter from August Strindberg to Torsten Hedlund, 18 July 1896,

PENCIL, ALBERT BONNIERS FÖRLAG, STOCKHOLM.
PHOTO: HANS THORWID, NATIONALMUSEUM.

Turner it is not known, but he certainly had the opportunity of doing so when he visited London in 1893.

There again, it is also possible to find starting points for these portraits of chaos that have nothing to do with art. Douglas Feuk has pointed out that the 1894 pictures can be interpreted against the background of Strindberg's own speculations concerning the philosophy of nature. Strindberg challenged current scientific ideas and wanted to create a new monistic doctrine. His basic idea was that everything exists in everything else, and that everything can change into everything else. One direction in which these ideas took him led to his attempts to produce

50a, b, c. *Three Charcoal Sketches Depicting Partially Burnt Lumps of Coal,*
KUNGLIGA BIBLIOTEKET, STOCKHOLM. PHOTO:
MARCUS ANDRÆ, KUNGLIGA BIBLIOTEKET,
STOCKHOLM.

51. Page from *Ockulta dagboken* (An Occult Diary), 1898,

Strindberg kept his *Occult Diary* from February 1896 to June 1908. It contains masses of observations of phenomena that Strindberg interpreted as omens and messages of an occult or spiritual kind.

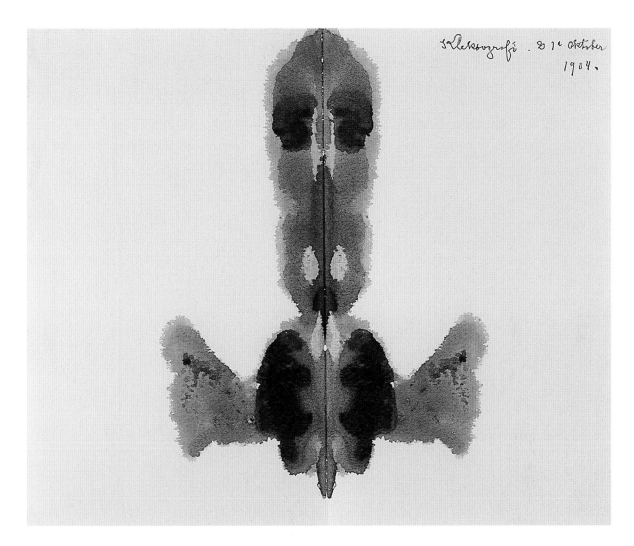

Kleksografi . & 1.ᵉ Oktober 1904.

gold. Feuk sees the 1894 paintings as being strongly influenced by these ideas. Strindberg seemed to be trying to demonstrate in his works that the elements have a common origin, and he abolishes the distinctions between air, earth and water.

These scientific speculations, and the influence of popular occult ideas, are also typical of other aspects of Strindberg's experiments with images in the middle of the 1890s. He interprets randomly formed shapes on his pillow as marble sculptures, and sees strange figures in pieces of coal he takes out of the stove. Strindberg also begins to interpret coincidental occurrences and images as secret messages. It was not long before he was experiencing these messages as pointers towards scientific

51b. *Kleksografi* (Inkblot Picture), supplement to *An Occult Diary,* 1904, KUNGLIGA BIBLIOTEKET, STOCKHOLM. PHOTO: MARCUS ANDRÆ, KUNGLIGA BIBLIOTEKET, STOCKHOLM.
This inkblot picture is an example of Strindberg's interest in randomly created images.

52. Manuscript for *Inferno*, 1897,

Inferno is Strindberg's portrayal of the difficult period he spent in Paris in the mid-1890s. He had first intended to let the book remain in manuscript form, which he considered to be "ideal for the occultist way of writing".

discoveries, or warnings of imminent dangers.

His theory of random occurrence became combined with an element of persecution mania that was sometimes very marked during his Inferno crisis, a crisis whose cause, significance and consequences have long been a matter of scholarly debate. It is likely that the causes were a combination of circumstances: the break-up of his marriage to Frida Uhl, his inability to write creative literature and his failures in the scientific field were factors that combined to bring about a series of psychological breakdowns. The most severe of these, which occurred during the summer of 1896, is often characterized as a psychosis, although several researchers maintain that Strindberg was not really psychologically ill at all.

After the Inferno – Painting and Photography After the Turn of the Century 1900

Strindberg summed up his crisis period in the autobiographical novel *Inferno*, which he wrote in French after returning to Sweden in 1897, to live in Lund. Strindberg the author was now on the brink of a new phase of unprecedented productivity. In the space of only four years he wrote over twenty full-length plays, several of which are among his best and most original. The Dream Play technique Strindberg was now developing can be traced back to some extent to his theory of random artistic creation. Fragments of dreams and reality are woven together to form unexpected and fantastic connections.

In the autumn of 1899 Strindberg moved back to Stockholm, where he was to remain until his death thirteen years later. When he resumed painting in 1901 he was once again undergoing a crisis. On this occasion, however, his painting did not seem to be a means of escaping from a writer's block: he was, in fact, in the middle of one of his most productive periods. The crisis was instead connected with his recent marriage to the young actress Harriet Bosse, who was threatening to leave him. The marriage was dissolved formally in 1904.

Strindberg painted sporadically until 1905, often repeating

53. Manuscript of *Jakob brottas* (Jacob Wrestles), 1897,
KUNGLIGA BIBLIOTEKET, STOCKHOLM. PHOTO: MARCUS ANDRÆ, KUNGLIGA BIBLIOTEKET, STOCKHOLM.

53b. Printed picture representing Saint Theresa, from Strindberg's collections,
KUNGLIGA BIBLIOTEKET, STOCKHOLM. PHOTO: MARCUS ANDRÆ, KUNGLIGA BIBLIOTEKET, STOCKHOLM.

Margareta Brundin has pointed out that Strindberg evidently used this picture as the model for the figure he placed in the illuminated initial letter of the text Coram Populo.

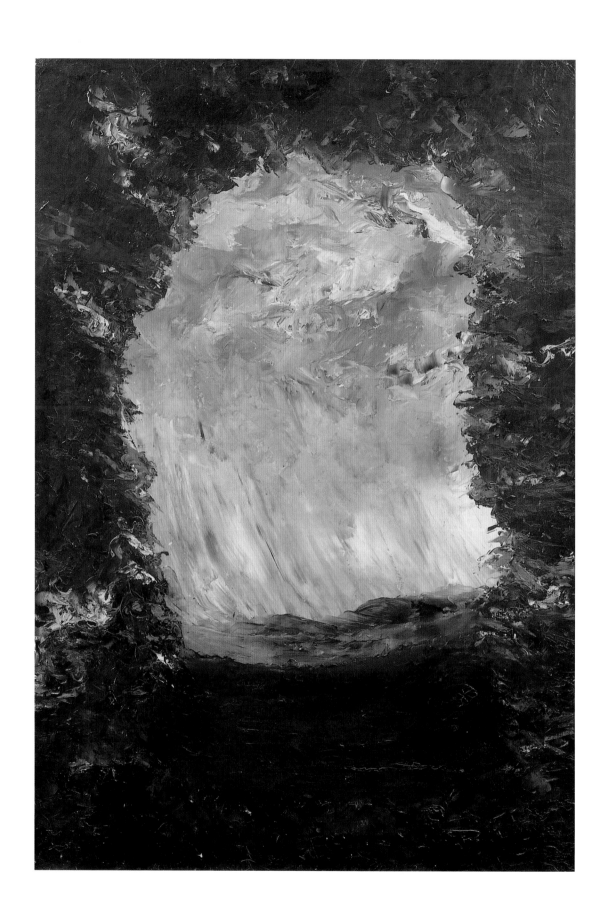

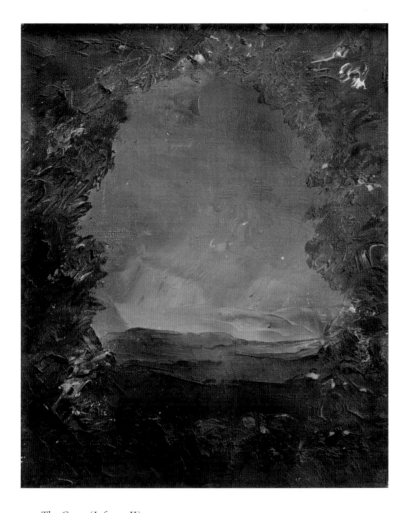

55. *The Cave, (Inferno II)*, 1902,

OIL ON CARDBOARD, 21 X 17CM, NORDISKA MUSEET, STOCKHOLM. PHOTO: NORDISKA MUSEET.

54. *Inferno*, 1901,

OIL ON CANVAS, 100 X 70CM, PRIVATE COLLECTION. PHOTO: ALEXIS DAFLOS.

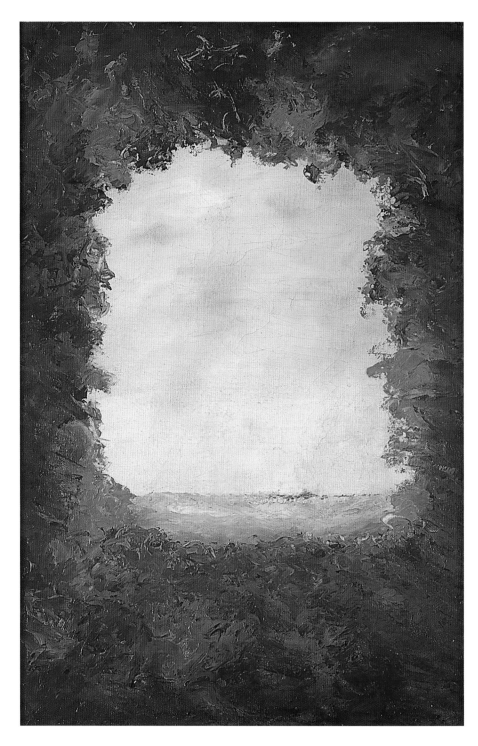

56. *The Yellow Autumn Painting*, 1901,

OIL ON CANVAS, 54 X 35CM, PRIVATE COLLECTION. PHOTO: BERNARD BLEACH PHOTOGRAPHY.

STRINDBERG AS A PICTORIAL ARTIST

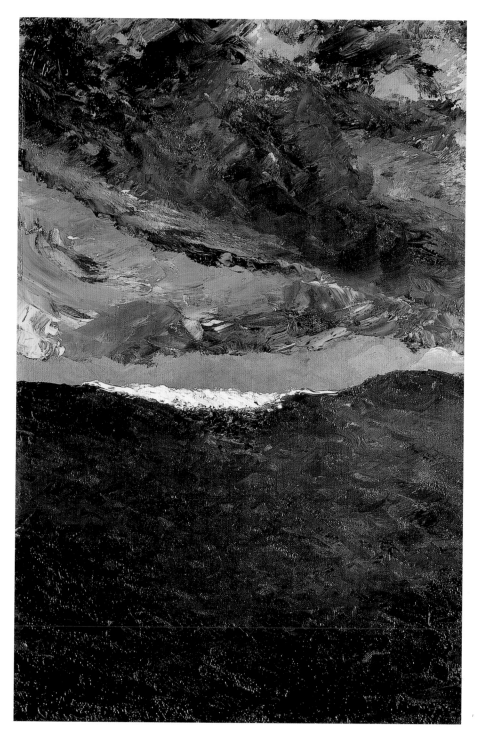

57. *The Wave VII*, 1901,

OIL ON CANVAS, 57 X 36CM, MUSÉE D'ORSAY. PHOTO: RMN – JEAN SCHORMANS.

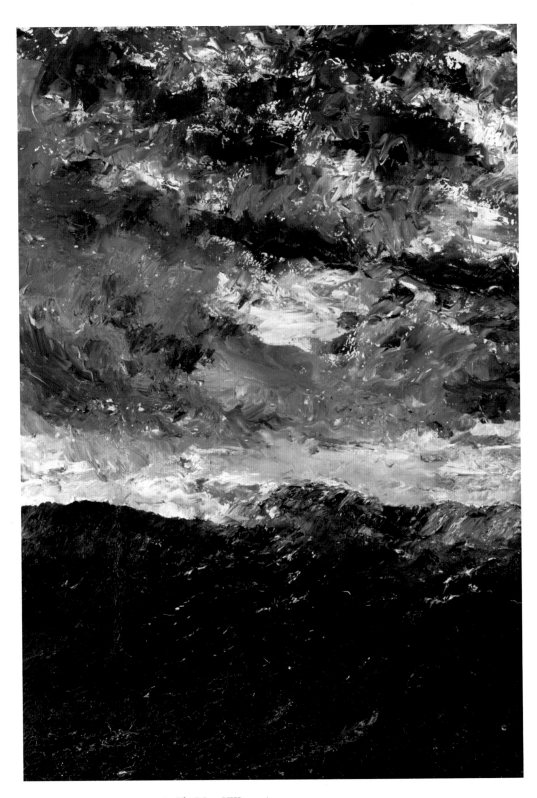

58. *The Wave VIII*, 1901/1902,

OIL ON CANVAS, 100 X 70CM, NORDISKA MUSEET, STOCKHOLM. PHOTO: NORDISKA MUSEET, STOCKHOLM.

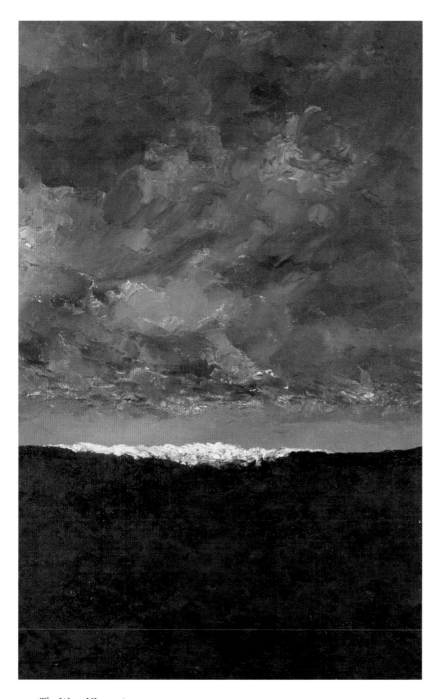

59. *The Wave VI*, 1901/1902,

OIL ON CANVAS, 100 X 70CM, NORDISKA MUSEET, STOCKHOLM. PHOTO: NORDISKA MUSEET, STOCKHOLM.

Several of Strindberg's paintings in the early years of the 20th century have motifs that can be traced back to experiences from a much earlier period. In some cases one can also find links between them and motifs used previously in his writing. At the beginning of *I havsbandet* (By the Open Sea) is a passage that corresponds closely to the wave-motif: "The sight of the breaker had the same effect on the Inspector as when a man doomed to die glimpses the coffin in which his dismembered body will lie, and at the moment of apprehension he felt a mortal dread of both cold and suffocation [...]"

motifs he had started during the 1890s. Several of the paintings from 1901 are variations on the motif from *Underlandet* (Wonderland) – the view from a cave or a landscape framed by a wreath of leaves. The most dramatic variation occurs in the magnificent *Inferno*, one of the paintings he himself rated most highly. The placid light streaming in through the central part of *Wonderland* has now been transformed to look like pouring rain, but the motif is multi-faceted and the streaky mass of greens and reds surrounding the opening does not really put one in mind of leaves. Nor is it possible to decide whether the lower part of the painting should be interpreted as solid land or water. When Richard Bergh painted his celebrated portrait of him in 1905, *Inferno* was hanging in the background.

At the beginning of the twentieth century Strindberg explored another variation of the White Mare motif, and also developed several versions of the wave theme. Some have a remarkable composition in which the surface of the painting is divided into three distinctly separated fields. He has transformed the open sea and the endless space of the sky into something resembling a sheer wall of darkness. Clouds and waves seem almost to merge, and threaten to annihilate the narrow crack of light that still separates them.

One of the most remarkable pictures from the years immediately following the turn of the century is *Staden* (The Town), dating from 1903. The canvas is dominated by the dark night sky, and the city that can just be made out in the far distance could just as well be a mirage. Perhaps he was thinking of Venice, or maybe Stockholm. The lower part appears to be water, and in the foreground is a black shore.

As before, Strindberg also worked on lighter motifs. Some coastal landscapes, also composed as almost parallel horizontal fields, are imbued with a feeling of complete calm. These statically constructed pictures have sometimes been compared to stage backdrops. Of course, it was the theatre and drama that were now taking up most of his interest.

The mood in several of these placid paintings from the first few years of the new century is reflected in the clarity and calm of his autobiographical prose tale *Ensam* (Alone) from 1903.

60. *The Vita Märrn Seamark IV*, 1901, OIL ON PANEL, 51 X 30CM, ÖREBRO STADS- OCH LÄNSBIBLIOTEK, ÖREBRO. PHOTO: ÖREBRO KONSTHALL.

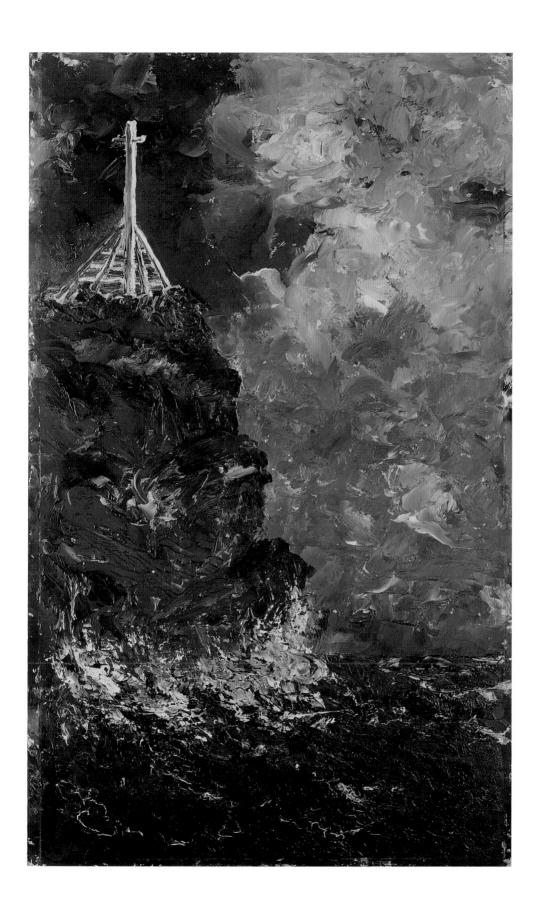

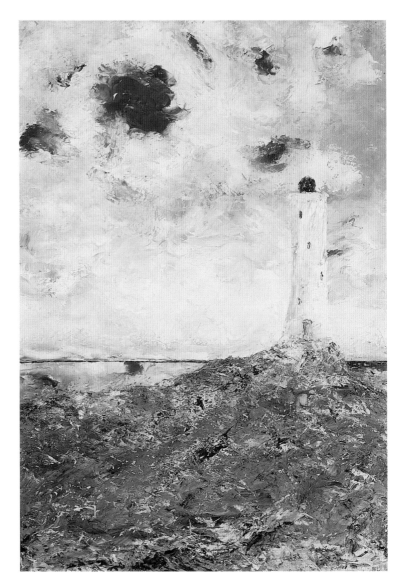

61. *The Lighthouse III*, 1901,

OIL ON CANVAS, 99 X 69CM, UPPSALA
UNIVERSITETSBIBLIOTEK. PHOTO: UPPSALA
UNIVERSITETSBIBLIOTEK.

Strindberg had painted a seascape with a lighthouse on a skerry as early as the 1870s. The motif goes back to an experience he had while sailing to Sandhamn in 1868, an incident described in a short story dating from 1874. In 1900 Strindberg wrote in his Occult Diary: "I woke up and went on deck – didn't know where we were; saw Korsö lighthouse in the light of the rising sun. Felt ecstatic and saw some vision of the future linked to Korsö lighthouse: that was one of the most splendid moments of my life and I have recalled it many times since; and I've often intended painting the lighthouse at that instant!" Strindberg presented the painting together with *The Flying Dutchman* to Gustaf af Geijerstam as a wedding gift on 2 January, 1902.

Moreover, some of the paintings have motifs Strindberg took from the view from his flat in Karlavägen, which in those days was on the outskirts of the city. Other motifs, such as *Allén* (The Avenue) and *Rosendals trädgård* (The Garden at Rosendal) might have been inspired by his walks to Djurgården. But he was also capable of returning once more to a motif such as that of *Alplandskap* (Alpine Landscape), the final version of which is characterized by a free and fluent technique.

Strindberg resumed his photography in the summer of 1906,

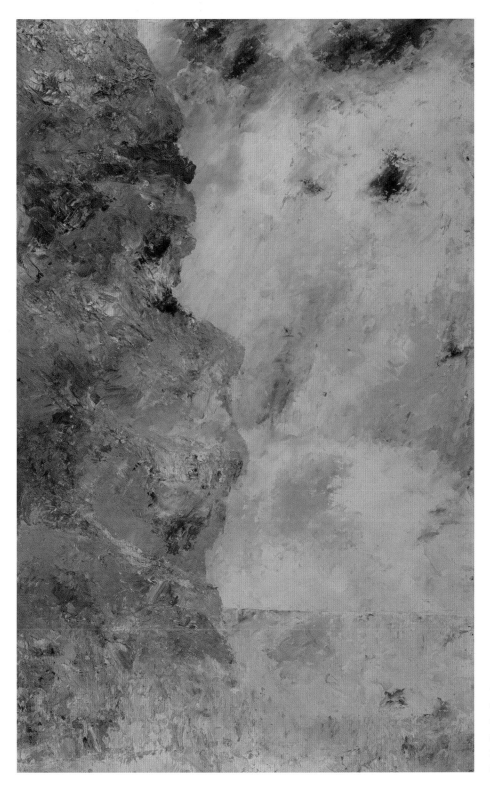

62. *Falaise III*, 1902,
OIL ON CARDBOARD, 96 X
62CM, NORDISKA MUSEET,
STOCKHOLM. PHOTO:
NORDISKA MUSEET,
STOCKHOLM.

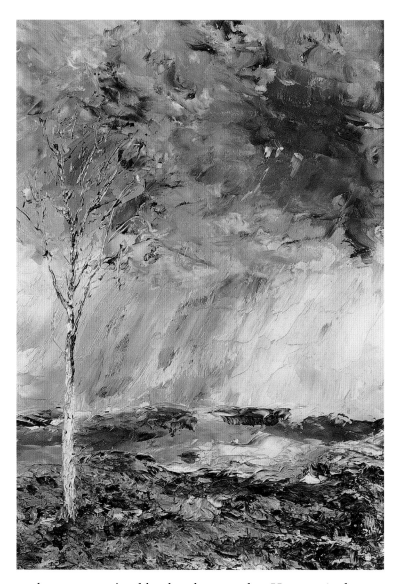

63. *The Birch Tree I*, 1902,
OIL ON PANEL, 33 X 23CM. PHOTO: HANS THORWID,
NATIONALMUSEUM.

64. *The Avenue*, 1903,
OIL ON CANVAS, 94 X 53CM, THIELSKA GALLERIET.
PHOTO: HANS THORWID, NATIONALMUSEUM.
Göran Söderström has suggested that
Strindberg's walks along the avenue between the
Djurgårdsbrunn Canal and Rosendal Gardens
in Stockholm were of significance for the
conception of the painting *The Avenue*. It is also
obvious that Strindberg intended the painting to
have a symbolic significance. He wrote to Carl
Larsson in 1905 about "the yellow avenue with
the great unknown in the background". The
painting also has a link with Strindberg's last
play, *Stora landsvägen* (The Great Highway),
from 1909, in which the main theme is man's
constant journey towards death.

and was now assisted by the photographer Herman Anderson,
one of the reasons for this being his aim of developing his ideas
on the psychological portrait. Experiments were made with the
"Wunderkamera" constructed by Strindberg, but it was soon
replaced by a conventional camera. Some of the self-portraits
preserved may well have been taken with the "Wunderkamera".
The portrait technique developed by Strindberg and Anderson
was based on the model's features being life-sized and illumin-
ated by soft, natural light. Some of these portraits were taken by
Anderson.

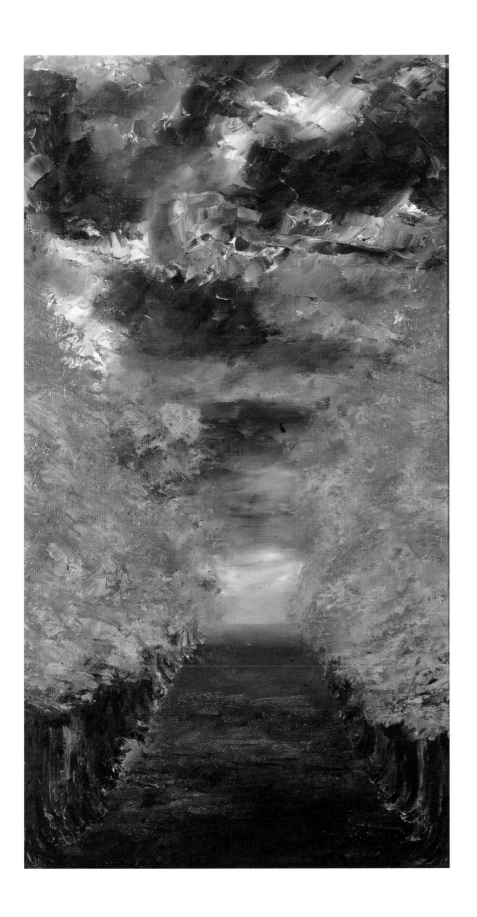

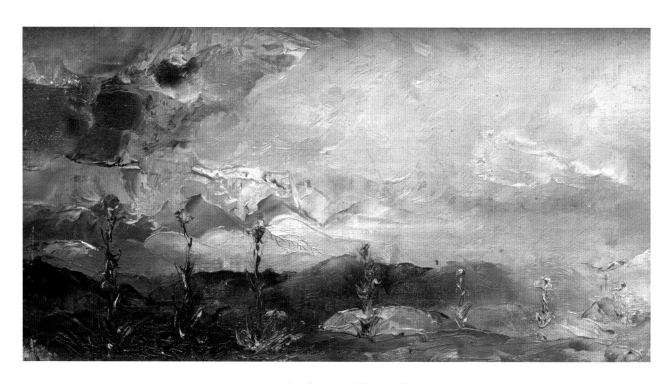

65. *Landscape with Tobacco Flowers*, 1902,

OIL ON CANVAS, 12 X 23CM, NORDISKA MUSEET, STOCKHOLM. PHOTO: NORDISKA MUSEET, STOCKHOLM.

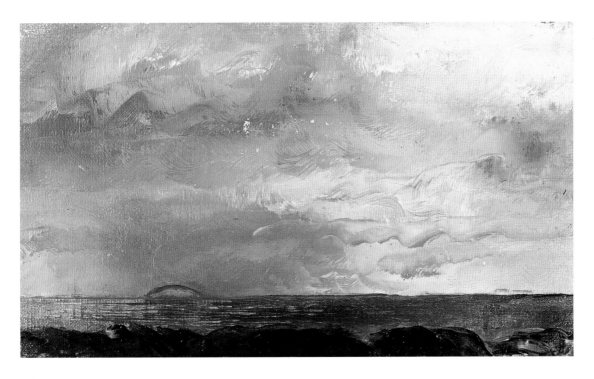

66. *Sunset*, 1902,

OIL ON CANVAS, 12.5 X 20.5CM, PRIVATE COLLECTION. PHOTO: BUKOWSKIS.

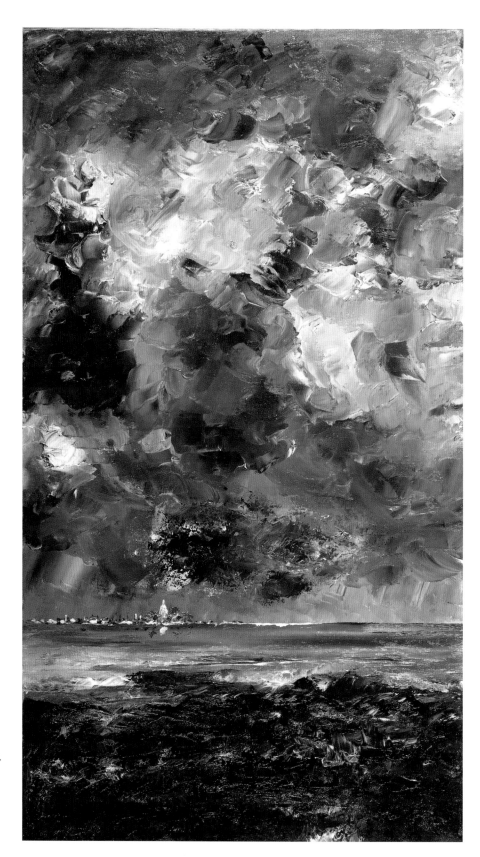

67. *The Town*, 1903,
OIL ON CANVAS, 94.5 X 53CM,
NATIONALMUSEUM, STOCKHOLM,
NM 4516. PHOTO:
NATIONALMUSEUM.

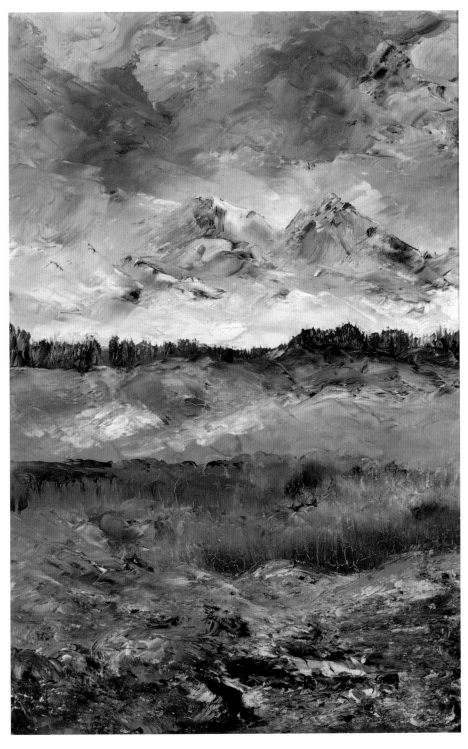

68. *Landscape Study*, also called *Alplandskap II*, 1905,

60 X 40CM, THIELSKA GALLERIET. PHOTO: ERIC CORNELIUS, NATIONALMUSEUM.

 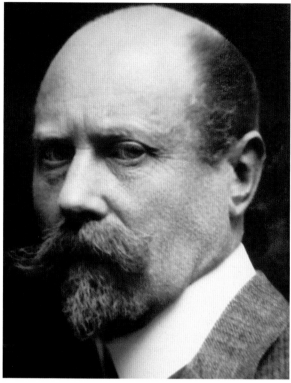

69. Herman Anderson, *Portrait of August Falck*, 1906,

PHOTOGRAPH, ORIGINAL SIZE 30 X 24CM, STRINDBERGSMUSEET, STOCKHOLM. PHOTO: HANS THORWID, NATIONALMUSEUM.

70. Herman Anderson, *Portrait of Karl Nordström*, 1906,

PHOTOGRAPH, ORIGINAL SIZE 30 X 24CM, STRINDBERGSMUSEET, STOCKHOLM. PHOTO: HANS THORWID, NATIONALMUSEUM.

71. *Self-Portrait Possibly Taken with the Wunderkamera*, 1906,

PHOTOGRAPH, ORIGINAL SIZE 30 X 24CM, NORDISKA MUSEET, STOCKHOLM. PHOTO: NORDISKA MUSEET, STOCKHOLM.

Strindberg also turned to photography in connection with the studies of meteorological phenomena that he had been making for some years. In *En blå bok* (A Blue Book), which is a mixture of diary-like observations, notes on scientific topics and polemical discourses on questions of current scientific interest, he included a text entitled "Recurrent Cloud Formations". He thought he had observed that certain cloud formations kept on recurring, at the same place and the same time, and interpreted these formations as a sort of mirage. He made carefully annotated studies of the forms, and also took a series of photographs.

What Did Pictorial Art Mean to Strindberg?

It is easy to see that painting, drawing and taking photographs held different levels of significance for Strindberg. Gunnar Brandell has drawn attention to the fact that there were many periods throughout Strindberg's life when he did a lot of draw-

STRINDBERG AS A PICTORIAL ARTIST

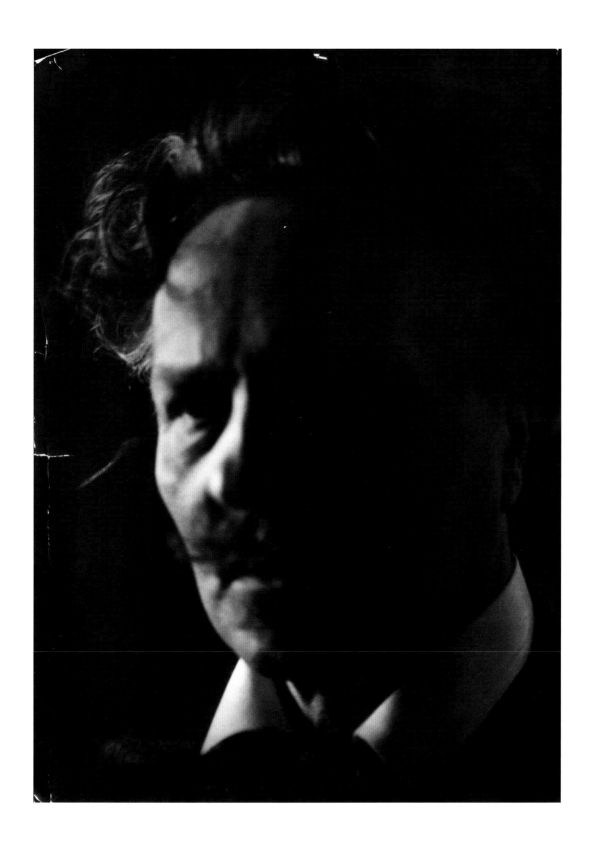

72a, b, c. *Cloud Formations*, 1907,
PENCIL, 11 X 19CM, KUNGLIGA BIBLIOTEKET,
STOCKHOLM. PHOTO: MARCUS ANDRÆ, KUNGLIGA
BIBLIOTEKET, STOCKHOLM.

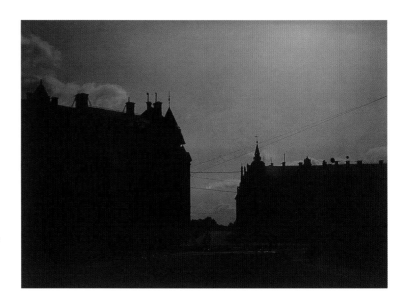

73. *Cloud Formations*, 1907–8, PHOTOGRAPHS,
ORIGINAL SIZE 12 X 16.5CM, KUNGLIGA BIBLIOTEKET,
STOCKHOLM. PHOTO: JAN O ALMERÉN, KUNGLIGA
BIBLIOTEKET, STOCKHOLM.

ing. The drawings are very varied in type: caricatures, sketches for stage designs, and studies made in connection with scientific observations. He only painted during a few relatively clearly defined periods, often in connection with crises. As far as motifs are concerned, he restricted himself to landscapes. One reason for this difference is no doubt a purely practical one: Strindberg was a writer, and always had pens and pencils at hand. Painting required more in the way of preparation.

The relationship between Strindberg's photography and painting has been discussed by Per Hemmingsson, who claims that photography interested Strindberg first and foremost because of the medium's objective and documentary qualities. Hemmingsson however also detects some kind of link between his painting and his photography. Perhaps Strindberg's keen devotion to portrait photography was a sort of compensation for his inability to depict people in his painting.

For the whole of his adult life Strindberg associated frequently and willingly with artists and sculptors. He was a close friend of several of the leading Swedish artists of the day, and for short periods he also associated with internationally significant painters such as Edvard Munch and Paul Gauguin. There is no doubt that at the turn of the last century, Strindberg was one of the best-informed Swedes when it came to con-

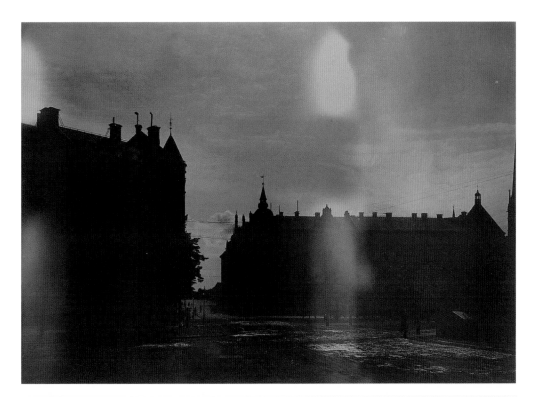

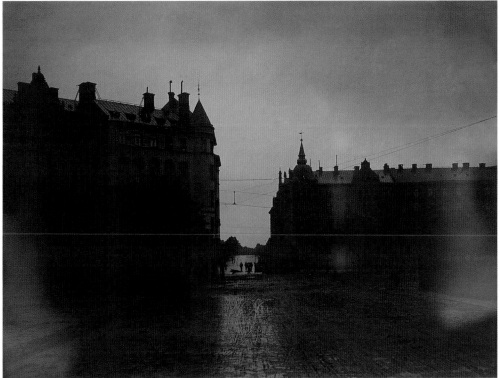

74a, b. *Cloud Formations*, 1907–8,

PHOTOGRAPHS, ORIGINAL SIZE 12 X 16.5CM, KUNGLIGA BIBLIOTEKET, STOCKHOLM. PHOTO: JAN O
ALMERÉN, KUNGLIGA BIBLIOTEKET, STOCKHOLM.

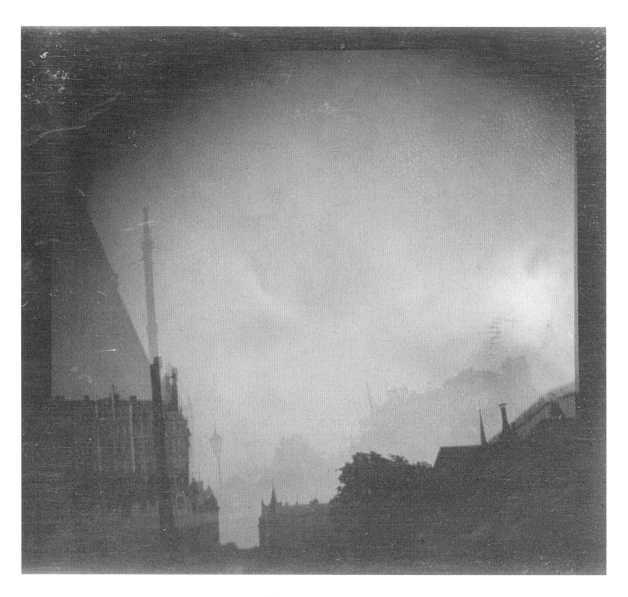

75. *Triple Exposure*, 1907–8,

PHOTOGRAPH, KUNGLIGA BIBLIOTEKET, STOCKHOLM. PHOTO: JAN O ALMERÉN, KUNGLIGA
BIBLIOTEKET, STOCKHOLM.

temporary pictorial art. It is also striking how often he gave leading roles to artists in his literary works.

When he wrote his autobiographical novel *Tjänstekvinnans son* (Son of a Servant) in the middle of the nineteenth century, Strindberg was passing through a phase when he was sceptical about artistic creation. Nevertheless, it is noticeable how often the main character in *Son of a Servant* reflects on matters involving pictorial art and artistic creation. Strindberg occasionally comments on the significance of painting for writing: "As a result of his painting, his gaze had become sharpened, as it were, so that he could clearly discern details, and by grouping together and arranging these details he could evoke a strongly defined vision in the reader of what he was describing." The keen-sighted visual observations in Strindberg's texts would thus seem to have their origins in his painting.

More often, however, the musings are about what differentiates painting from writing. Strindberg notes, for instance, that there was no other occupation "that absorbed all thoughts and all feelings in the way painting does". He also compared it with "sitting down to sing" and claimed that it was "allowing turbid emotions to take shape". It has often been suggested that for Strindberg, painting was a way of giving expression to emotions that he couldn't describe in words. Harry G. Carlson has wondered whether Strindberg may have found painting more physically satisfying than writing.

There is a spontaneous or anti-intellectual aspect of his random art theory, of course, which seems to have occurred to him while working on a painting. He starts painting, more or less aimlessly. He produces a straight line – a horizon – or some formless, fluid splodge of paint – clouds, waves, leaves. But while he is painting he discovers that he can also see something there that he didn't expect to see. That discovery sets him thinking, and before long his theory of haphazard artistic creation is formed.

Strindberg always wanted to come up with something new, always wanted to change things. Characteristic of this desire for renovation and progress is the difficulty he experienced in living in the same place for very long. Movement and the will to

change also affects Strindberg's relationship with pictorial art, even if it is also possible to find contrary tendencies there – he doesn't seem to have been very keen to extend his range of motifs, for instance. His drive for renovation does not affect his choice of motif, but his way of working. Many of his paintings are characterized by an experimental and exploratory technique. Even if the motifs are often repeated, the paintings often differ strikingly in the way they are made. In many cases individual canvases can contain several different ways of painting. Sweeping and rapidly applied layers of paint are combined with more carefully and delicately formed areas. The colour treatment is also surprisingly rich and varied in individual works.

Strindberg the painter is remarkably isolated in relation to the rest of the art world at the turn of the century. Despite his great knowledge of both contemporary and historical pictorial art, he seems not to have had any models and one has the impression he was not interested in emulating, and perhaps even lacked interest in, the style of paintings. The possible exceptions to this are some of the paintings from Paris-Passy in 1894, which are reminiscent of Courbet's and Hill's pictures of lonely stretches of shore. These paintings may be his technically most accomplished, but also his least distinctive.

Unlike Strindberg the painter, Strindberg the writer was very open to influences from contemporary and historical pictorial art. An example is his novel *Hemsöborna* (The People of Hemsö), which was written with Dutch seventeenth-century genre-painting as its model. Another example is *Fröken Julie* (Miss Julie), whose stage design he wanted to arrange in accordance with the asymmetrically composed paintings of the Impressionists.

Of course, August Strindberg was not primarily a painter or a photographer. It was as a writer, and more especially as a dramatist, that he became an internationally renowned person. At the same time, it is obvious that his visual sensitivity played a fundamental role in all parts of his extensive works. Images and his visual imagination even played a crucial part in Strindberg's scientific speculations of the 1890s. For Strindberg, painting and photography were just two ways of formulating visual ideas and experiences.

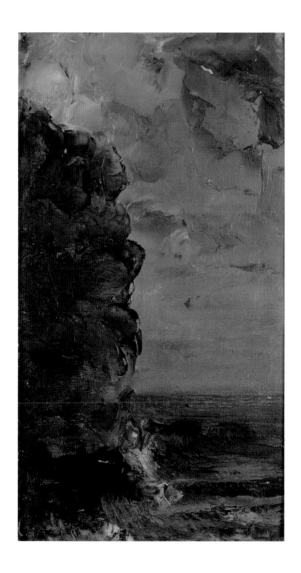

76. *Falaise I*, 1902,

OIL ON CANVAS MOUNTED ON CARDBOARD, 20 X
11CM, NORDISKA MUSEET, STOCKHOLM.PHOTO:
NORDISKA MUSEET, STOCKHOLM.
If you turn the picture upside down,
Strindberg's profile can be seen in the outline of
the cliff.

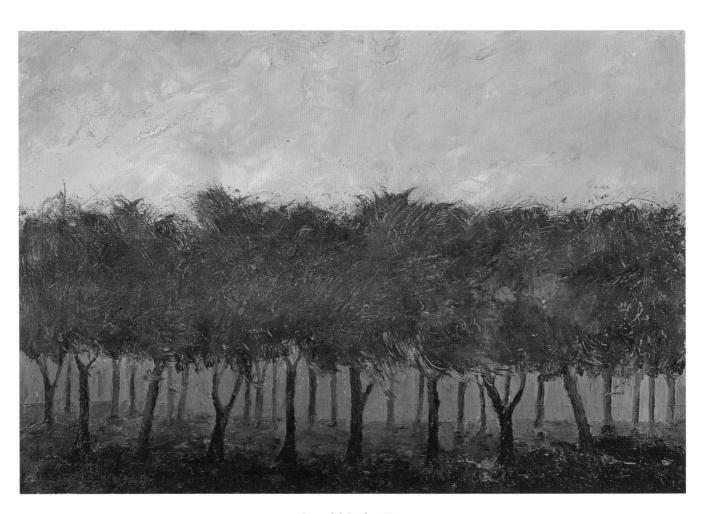

72. *Rosendal Gardens II*, 1903,
OIL ON CANVAS, 36 X 54CM, GÖTEBORGS KONSTMUSEUM. PHOTO: EBBE CARLSSON.

STRINDBERG AS A PICTORIAL ARTIST

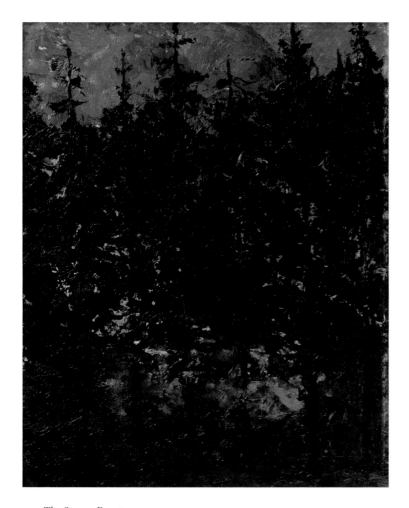

73. *The Spruce Forest*, 1905,

OIL ON CARDBOARD, 27 X 21CM, NORDISKA MUSEET, STOCKHOLM. PHOTO: NORDISKA MUSEET, STOCKHOLM.

Several of Strindberg's paintings made in the 1900s are reminiscent in various ways of the autobiographical story *Ensam* (Alone), dating from 1903. Some of the paintings also have motifs corresponding directly to passages in the text: "But I can see the edge of a forest in the distance. It is mostly spruce and pine, black-green in colour and spiky, and for me it is the most remarkable sight in Swedish nature, and I point to it and say: that's Sweden."

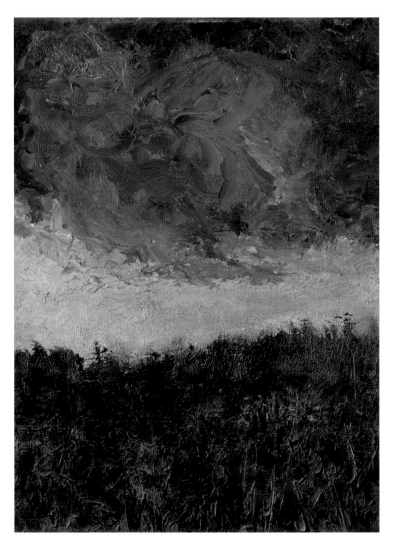

74. *The Edge of the Forest*, 1905,

OIL ON CARDBOARD, 29 X 22CM, NORDISKA MUSEET, STOCKHOLM. PHOTO: NORDISKA MUSEET, STOCKHOLM.

75. *Landscape Study*, also called *The Heath*, 1905,

OIL ON CANVAS, 50 X 35CM, THIELSKA GALLERIET. PHOTO: ERIK CORNELIUS, NATIONALMUSEUM.

It is not known whether the banker Ernest Thiel bought his three Strindberg paintings *The Avenue*, *The Heath* and *Alpine Landscape* because he really admired them, or because he wanted to support Strindberg financially. Strindberg was in dire financial straits for long periods, and at one point the artists Carl Larsson, Richard Bergh and Karl Nordström had the idea of trying to persuade the rich art collector Thiel to purchase some of Strindberg's paintings.

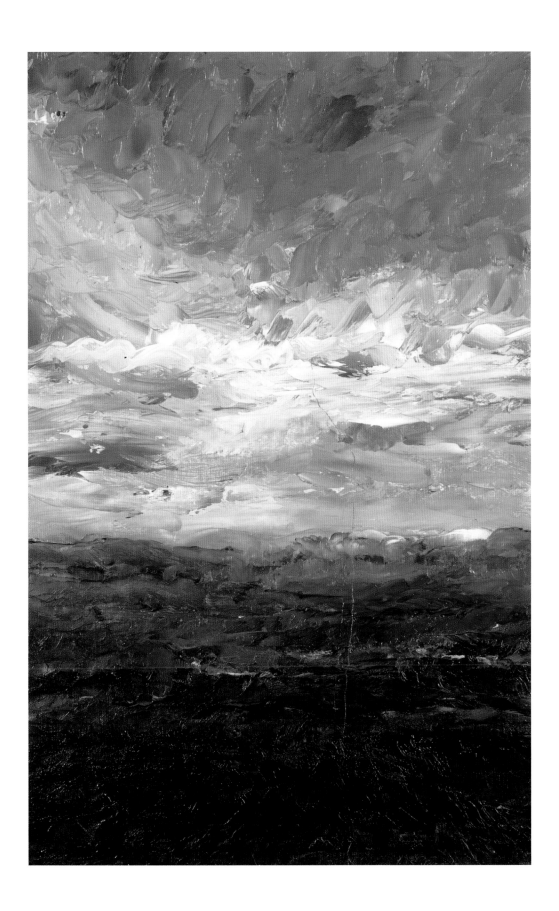

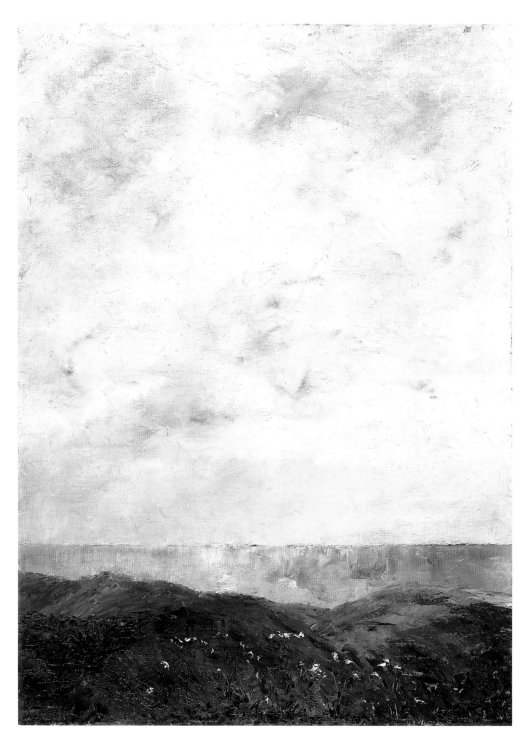

64. *A Coast II*, 1903,

OIL ON CANVAS, 76 X 55CM, NATIONALMUSEUM, STOCKHOLM, NM 2722, PURCHASED 1929. PHOTO:
NATIONALMUSEUM.

63. *The Sun Sets over the Sea*, 1903,

OIL ON CANVAS, 95 X 53CM, PRIVATE COLLECTION

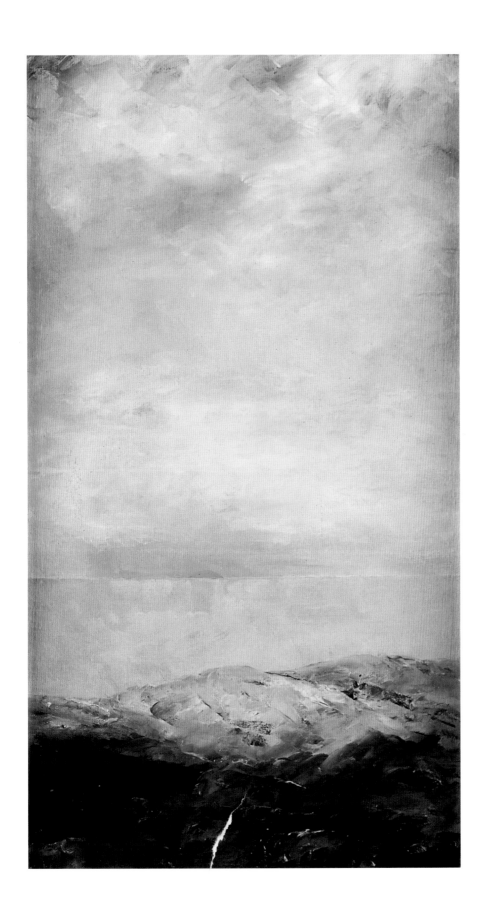

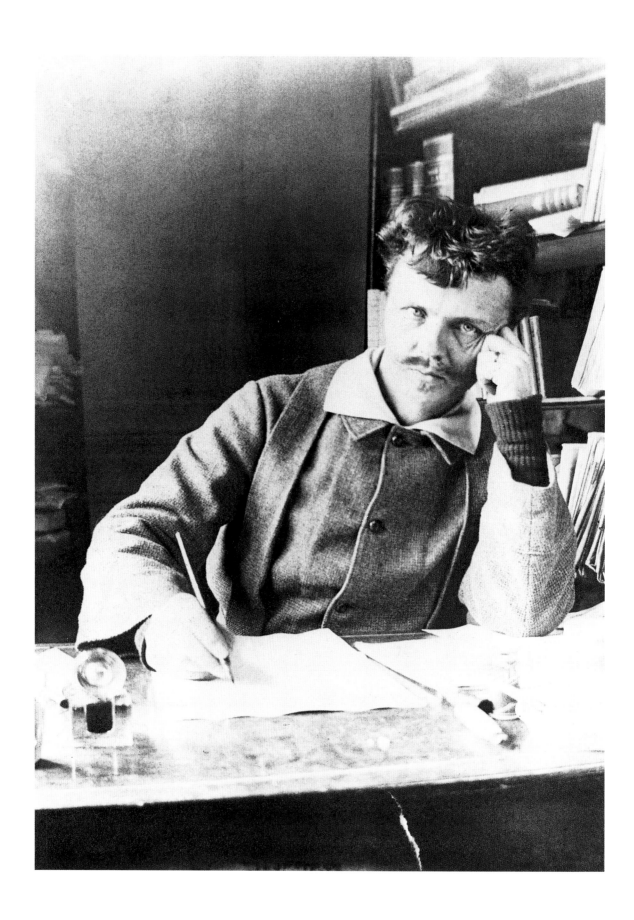

Strindberg: The Gersau Photographs

AGNETA LALANDER

AND ERIK HÖÖK

In 1886, the year in which his autobiography *Tjänstekvinnans son* (The Son of the Servant), was published, was also the year Strindberg produced his first photographic self-portraits. On 1 October he had moved with his wife, three children and a nursemaid to a pension in the resort of Gersau in Switzerland. Using a newly acquired camera, he made a series of portraits of himself and his family. They were taken in the home: at his desk, with the evening toddy, on the stairs, in the garden. The result was successful: no less than thirty-seven shots, the oldest surviving pictures from Strindberg's hand.

In twenty-five of the photos, Strindberg himself is the principal character, which proves to be significant. He would continue to arrange portraits of himself "at home": in 1891 on Värmdö with John Lundgren taking the photographs, and in 1904 at Furusund with Otto Johansson. His last self-portrait, however, is something different: an attempt to capture his very soul. In this 'psychological portrait' of 1906, there is no suggestion of any setting. Instead, his life-size face fills the whole picture. The self-portraits of 1886 and 1906 represent the two poles of his photographic oeuvre, namely naturalism and occultism.

Some time during the autumn of 1886, Strindberg's eye was caught by a sensational novelty: one of the first ever photo-interviews was published on 5 September in *Le Journal illustré*. It portrayed the colour chemist M-E. Chevreul in a series of photographs taken while he was being questioned about the art of being a hundred years old. His Gallic facial expressions, together with his answers printed under each picture, illustrated in no uncertain terms that photos can be used to bring a text to life. The famous photographer Félix Nadar, who was interviewing Chevreul, appears in most of the pictures with his back

1. Self-portrait, 1886,
PHOTOGRAPH, STRINDBERGMUSEET.
PHOTO: STRINDBERGMUSEET.

to the camera. His son Paul took the photos and the interview was recorded by a stenographer.

On 15 November Strindberg submitted a publishing proposal to Albert Bonnier, consisting of eighteen self-portraits accompanied by his own captions. The following was suggested for the title-page: "August Strindberg. Impressionist images by S. S. – With text."

An explanatory letter was attached:

> Dear Herr Bonnier,
> A parcel has been dispatched by post today containing 18 Impressionist photographs (with text) taken by my wife, who has asked me to negotiate this affair with you, if this be possible. The photographs show the terrible misogynist Aug Sg. in 18 realistic situations (the idea taken from the Chevreul issue). As you will see the pictures are not samples of beautiful photography, but just what they say they are. /.../. The idea would of course be to phototype them.

A couple of points in the letter are worth noting further. Firstly, as on the title page, attention is directed at Strindberg, while Siri is named as the photographer, a fact that some have interpreted as a trick on Strindberg's part to get a second fee out of Bonniers, to whom he owed money. If this were so, it remains to be explained why Strindberg refers to his wife as the photographer on later occasions as well. In fact we know very little about the way the photography proceeded. Sometimes it may well have been Siri who released the shutter, and at other times Strindberg himself. For some of the shots he may have used a delayed shutter, as his daughter Karin has reported. It seems probable, however, that the Gersau series was a result of collaboration, whereby Strindberg concentrated on the staging of the pictures. For him the model was clearly the priority.

In the letter Strindberg emphasizes that these images were genuine reproductions of reality. He appears in a series of roles in his own life; most importantly that of author, followed by that of paterfamilias accompanied by his children. In ten pictures we see him at work, sitting at his desk with his travelling library behind him. The main variation between these shots lies in his shifting posture, because remarkably his expression remains almost the same: serious, slightly tense, gazing straight at the camera. (Fig. 1)

These portraits include the famous one of Strindberg lean-
ing on the desk, his face in his hands. Some have interpreted it as
the author's despair as he confronts the empty page, while the
last rose of autumn in the foreground suggests a romantic mood.
The original idea is supposed to have been Siri's; she wanted to
document her husband's beautiful hair. Strindberg himself set
great store by this photograph. (Fig. 2)

Another picture that invites interpretation shows Siri and
August playing backgammon; this is also, as it happens, the only
picture in which the couple appear together. Symbolically the
relation between the sexes is depicted in this picture as a strug-
gle. In the second part of *Giftas* (Getting Married) he had estab-
lished himself as an aggressive reactionary on the "woman
question". Otherwise, though, there is little of the "terrible
misogynist" to be seen. (Fig. 3)

In most of the images the clothes-conscious Strindberg is

2. August Strindberg, Self-portrait, 1886,
PHOTOGRAPH, ALBERT BONNIERS FÖRLAG.
PHOTO: HANS THORWID, NATIONALMUSEUM.

3. August Strindberg and Siri von Essen
playing backgammon, 1886,

dressed in what is known as a Norfolk jacket. For his gardener
role, he has changed into a light summer jacket and a straw
hat, only to change again a moment later into a top-hatted,
frockcoated gentleman, elegantly smoking a cigarette. This last
photograph bears a striking resemblance to the portrait in the
contemporary realist style that Sophie Holten had painted a year
earlier. (Fig. 4)

The accompanying text doesn't claim to resemble an inter-
view. Rather, Strindberg chose quotations from his own literary
texts, above all from *Svenska öden och äventyr* (Swedish Des-
tinies and Adventures, 1882) and *Röda rummet* (The Red Room,
1879). The connection between text and image is often per-
plexing; in several cases there is no immediate correspondence

4. Self-portrait, 1886,
PHOTOGRAPH, STRINDBERGMUSEET.
PHOTO: STRINDBERGMUSEET.

and the comments appear to have been chosen almost arbitrarily. One picture, where Strindberg is playing a guitar, his right arm resting idly on a table laid ready for toddy-drinking, has been supplied with the caption "Det hjälper inte att äta gräs" (It doesn't help to eat grass). The quotation comes from *Utveckling* (Development), dealing with, among other things, the conflict between asceticism and hedonism. (Fig. 5)

The caption "Jo, vi måste bli trädgårdsmästare" (Well, we must all cultivate our gardens) for an image of Strindberg posing with his daughters in the garden, his right foot resting on a spade, seems more relevant. The caption alludes to the closing words in Voltaire's *Candide*, but also represents a manifesto in the spirit of Rousseau. By this time Strindberg was calling him-

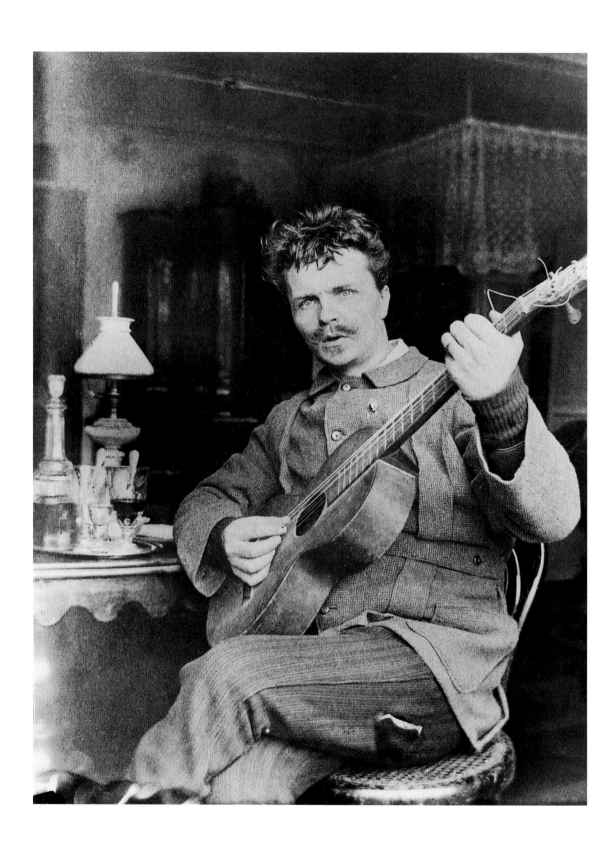

6. Self-portrait with his daughters Greta
and Karin, 1886,
PHOTOGRAPH NORDISKA MUSEET. PHOTO: NORDISKA
MUSEET.

self an "Agrarian Socialist". (Fig. 6). Otherwise, the texts seem to
accompany the photographs quite neatly.

When the publishers rejected his proposal, Strindberg sent
a set to his friend the journalist Edvard Brandes, who immed-
iately identified a strong personal charge in them. In his reply
Brandes thanks Strindberg for "the highly enlightening Photo-
graphs", among others the one in which Strindberg is "disguised
as . . . a Russian Nihilist". We don't know whether this audacious
and amusing comment originates with Strindberg or with the
radical Brandes, as only the latter's letter survives. It presumably
refers to the photo in which Strindberg, dressed in a coat but-

5. Self-portrait, 1886,
PHOTOGRAPH, ALBERT BONNIERS FÖRLAG.
PHOTO: HANS THORWID, NATIONALMUSEUM.

7. Self-portrait, 1886,
PHOTO: STRINDBERGMUSEET.

8. Self-portrait, 1886,
PHOTOGRAPH, STRINDBERGMUSEET.
PHOTO: STRINDBERGMUSEET.

toned to the neck and wearing a Persian-lamb cap, appears on his balcony with the onion dome of a church in the background. The same image appears in the Bonnier series, but in that context no political connection is made. (Fig. 7)

In early 1887 Strindberg sent a series of sixteen photos to his friend the author Gustaf af Geijerstam. This time he was not thinking of publication, which might explain their more private nature. The quotations are both fewer and shorter, while the choice of images and texts is bolder and more provocative. The photo in which Strindberg the pacifist challenges the viewer to battle with a foil, is a surprising inclusion. (Fig. 8) Otherwise he is absent from half of them. Instead the focus turns on the

"Kom nu djeflar så ska vi slåss!"

10. Greta, 1886,
PHOTOGRAPH, STRINDBERGMUSEET.
PHOTO: STRINDBERGMUSEET.

children, who in a couple of impressionistic pictures are simply being themselves, studying or at play. (Figs 9 and 10)

By 1891 he hadn't given up the idea of publishing the Gersau series. When the writer Birger Mörner presented a proposal for a Strindberg book, Strindberg responded that it should include among other things fifteen "photogravure portraits taken at home". Around ten would probably have been the Gersau images, but the idea was never realized.

However, they were published during Strindberg's lifetime. On the initiative of Karl Börjesson six of them were reproduced

9. Hans, 1886,
PHOTOGRAPH, STRINDBERGMUSEET.
PHOTO: STRINDBERGMUSEET.

in Herman Esswein's *August Strindberg. En studie och en öfverblick*, (A Study and a Survey), which appeared for the author's sixtieth birthday in 1909. Strindberg's original idea, of publishing them with a text, was not achieved until 1997, when Bonniers published them in facsimile as a Christmas book.

Finally, a few words about the camera used. At the beginning of a trip to the French countryside in September 1886, Strindberg gave his fellow-traveller Gustaf Steffen the task of acquiring one. He chose one of E. von Schlicht's cameras, which was ordered from the Romain Talbot in Berlin. The photos from this trip were not altogether successful, however, and they disappeared long ago. After making the Gersau series later the same autumn, Strindberg's interest in photography seems to have cooled temporarily, and in February 1888 he sold the camera in Copenhagen for 200 Kronor. It was not discovered until 1996, and was then included in the collections of the Strindberg museum. The purchase included the original camera bag and the cassettes, but the tripod had vanished. This camera is made of cedar wood and is not possible to open today, so we have to content ourselves with the information, provided by the patent specification, that it has an "achromatic planoconvex landscape lens". The focusing lever on top of the camera consists of a black sliding scale with markings between two ivory plates, which indicate the distance from 1.5 m to infinity. The focusing lever is connected to the handle on the underside. This has a double function: to move the plates in relation to the lens and also to lock them. On the upper side there is a viewfinder.

The 9x12 cm glass plates are so-called dry-plates, which came into use around 1884. They were placed two at a time in double plateholders attached to an opening on the side of the camera. A wooden pin was pulled down, after which the plates could be shaken into the camera. The rotary shutter was oper-ated by a spring, now missing.

According to the patent specification the negatives obtained were "extremely sharp", something to which the surviving plates bear witness.

12. E. von Schlitcht's camera for 9x12 cm plates,
STRINDBERGMUSEET. PHOTO: HANS THORWID, NATIONALMUSEUM.
Strindberg used this camera to photograph the Gersau series, 1886.

11. Self-portrait with his children, 1886,
PHOTOGRAPH NORDISKA MUSEET. PHOTO: NORDISKA MUSEET.

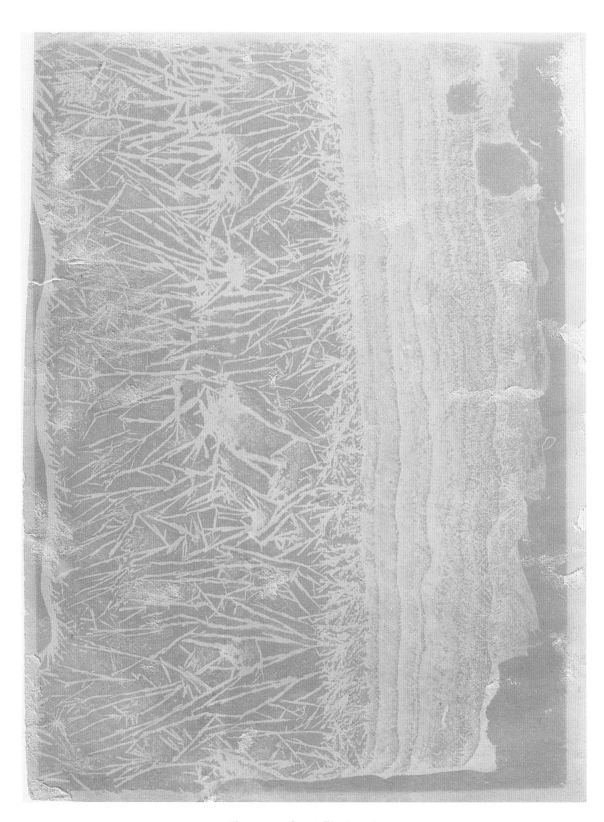

1. Photogram of crystallization, 1890s,

Dreaming Materialized

On August Strindberg's photographic experiments

For six years during the 1880s, when Stindberg was roaming the continent with his family, a steady stream of words was flowing from his pen. His output was roughly three books a year, and the range was broad: cultural and social criticism, collections of short stories, a series of autobiographical novels, and plays including *The Father* and *Miss Julie*. But, back in Sweden in 1889, he found inspiration eluding him, and was forced to confess to his publisher: "My great poetic udder has run dry". The following year a heart-rending divorce from his wife began, and his literary creativity more or less came to a standstill. Instead, he threw himself with wild energy into other activities, sometimes working intensively at painting but for six or seven years during the 1890s devoting himself mainly to the natural sciences, particularly to experiments in chemistry and botany.

In several letters he swears that the practice of research is "an unparalleled delight", often convincing himself that he is about to overturn some of the most entrenched of scientific truths. But despite all this energy, and his belief in what he was doing, Strindberg was full of uncertainty during these years about the direction and meaning of his life. Was he really finished as a writer, or was there some hope of rebirth? His attraction to these particular natural sciences – concerned so intimately with the possibility of change – was not, I believe, a coincidence. As a researcher he called himself a "transformist", and one of his fundamental notions was that all matter, even the kinds that appear completely lifeless, have the potential for growth and development. Under certain circumstances nature's basic ele-

DOUGLAS FEUK

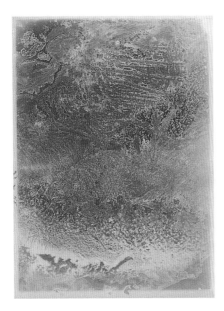

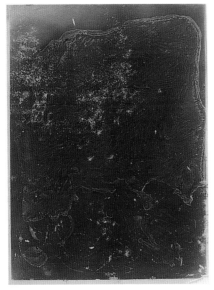

2–3. Photograms of crystallization, 1890s,
ORIGINAL SIZE 12X9 CM, KUNGLIGA BIBLIOTEKET.
PHOTO: JAN O ALMERÉN.

ments can transmute into others that are simpler or more highly differentiated. Iron and silicon can beget gold, stones possess the capacity for germination – imperceptibly, the possibilities of life are present everywhere.

"Silicon breathes and possesses the changeability of protoplasm", he says for example in *Stenarnas suckan* (The Sighing of the Rocks) in the mid-1890s. The title of this piece alludes to the Swedish romantic poet Stagnelius and his idea of nature´s longing for release and redemption. Strindberg expresses this mysticism almost as clearly when he declares that "rock is living and can bring forth life through fermentation. Coal is born of the mountain. . .". In such texts the alchemical imagery prevails, but even Strindberg's more practical experiments are essentially a kind of magical-poetical invocation. He once referred to his formulae and laboratory records as "sonnets in chemistry", and his imagination seems to draw him into the closest empathy with the matter burning in his china crucible. From these experiments we learn less about the chemical substances and more about Strindberg the man and his desire for change.

This, too, is more or less how I interpret the photographic experiments that he performed during the 1890s, and which are the real subject of this article. The surviving pictures are preserved in the Kungliga Biblioteket in Stockholm. Their existence has long been known, but they are generally mentioned with a certain cautious brevity, as though people do not quite know what to make of them or how to evaluate them. In any case there are no more than ten or fifteen in which a "subject" can still be more or less distinguished. Strindberg's practical dealings with photography were, of course, dogged by frequent mishaps, and these images – dark or, conversely, almost completely faded and sometimes inadequately fixed as they are – could also suggest a somewhat maladroit handling of the medium. On the other hand, Strindberg possesses something that many of those with a more professional technical touch do not have, namely a vision or view of his own.

The primitiveness of his technique was perhaps rather advanced in its own way, not least in that he abstained from using any of the photographic equipment that was currently avail-

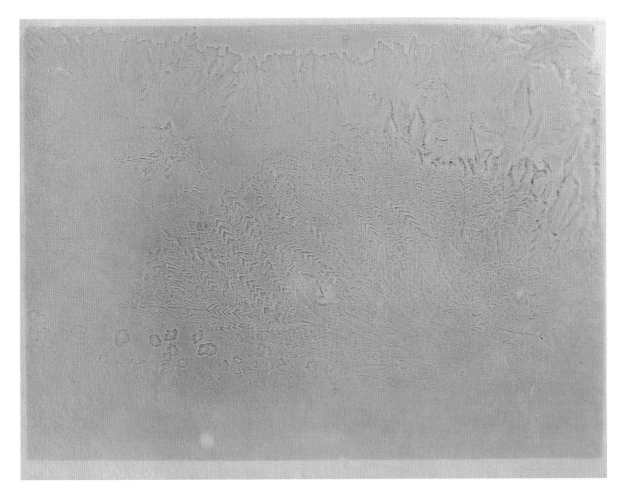

3b. Photogram of crystallization, 1890s,
ORIGINAL SIZE 12X9 CM, KUNGLIGA BIBLIOTEKET.
PHOTO: JAN O ALMERÉN.

able. He mistrusted camera lenses, which in his view gave a distorted representation of reality, and over the years built several simple apparatuses himself. These had no lenses, consisting simply of a cigar box or similar container, plus a sheet of paper with a minute pin-hole. The photographs discussed here, however, were produced by even more direct methods: they were made not only without a lens, but without any camera at all.

Two groups of subjects emerge here: one starts from a series of experiments inspired by hoar frost and ice-ferns. Strindberg got a variety of saline solutions to crystallize on glass plates that he exposed to heat or cold. He then copied the result on to photographic paper direct from the plate. What fascinated him most were the crystal formations that seemed to imitate living matter, a flora of grass and lichens and ferns. One of these

photograms in particular offers a beautiful example of this metamorphosis of frozen matter. A clearly delineated and extraordinarily illusionistic vegetation of twigs and mosses takes shape in the picture, like a fossil embedded in some pale ochrecoloured mineral, where sap and fibre have been replaced by a harder substance.

To many observers this petrified and slightly osseouslooking vegetation might seem to reflect something of the stillness and silence of death, but in Strindberg these apparent parallels between the kingdom of minerals and the kingdom of vegetation evoked a very positive metaphor, an intimation of connections in nature more intimate than those accounted for by science. As he saw it, these similarities between the organic and inorganic simply confirmed that the same forces are at work everywhere. Indeed, was it not actually a sign that the distance between the inanimate and the living can be overcome? During the crisis years in the 1890s, at any rate, this was certainly an image that spoke powerfully to his own longing to rediscover the creative forces of life.

Strindberg's writings during this period provide many examples, at the same time concrete and fantastic, of such putative analogies between the diverse kingdoms of nature, and in fact his experimentation with chemicals and paints reveals similar dreams of correspondences between the natural elements. In the landscapes he painted in 1894 the boundaries between air and water or earth and light often appear fluid. Each element looks as though it could be dissolved and transmuted into one of the others, and the real "subject" of the paintings is probably his dream of a secret concordance in which "everything is in everything" – and able to become everything else.

In the photograms it is sometimes even more difficult than it is in the paintings to determine what it is that we see there. "Sulphurous ferric oxide" is what Strindberg has written on the back of one of the pictures, and undeniably this cracked surface that seems to be crumbling away as we look at it does seem to suggest nature at some kind of microscopic level. But equally well, at least to a present-day observer, the pictures recall a satellite photo of the surface of the earth with mountains and

plains, bays and cloud formations. Moreover, in its way, a dual perspective of this kind in which widely diverging phenomena seem to enter into and be absorbed by one another, appears to comply with Strindberg's "transformistic" perception of nature.

Strindberg himself, however, was most intrigued by the ambiguity he sensed in the capacity of crystals to assume the appearance of plant or animal forms. In most of the photograms this is not nearly as demonstratively obvious as it is in the above example. Sometimes the picture as a whole may be difficult to grasp. One, for example, is dominated by a cloudy sepia-coloured mist, that only on closer observation reveals a few fragile structures, little more than intimations that seem to come and go. This sense of the fleeting and lingering in the picture evokes above all a meditative mood in the viewer.

The mood invites dreams of matter and its imaginary "inner" forces. Sometimes the crystallization has assumed shapes recalling feathers or ears of corn, and Strindberg asks himself in *Stenarnas suckan* (The Sighing of the Stones) whether this might not be an expression of elements that carry the "memory" of earlier forms of existence through which they have passed; whether water, perhaps, which has traversed the natural cycle of animals and plants many times, is "remembering" these vegetative or animate forms when it freezes into crystalline form.

As a physical explanation this doesn't sound very convincing, but as a fantasy on the hidden psychic forces of life, it has a certain evocative power. And it is essentially as such a materialization of dreams that I interpret Strindberg's photographic experiments. When he reflects upon the transformations in the interior world of matter, I believe that a powerful force behind his thinking is that transmutation for which he longs in his own life, but he prefers to interpret the plant forms as a "message" from matter itself. During the 1890s he had come to feel increasingly that nature's essence has a spiritual quality. And in line with much romantic nature philosophy, he meant that it tended to manifest itself to us in obscure and elusive symbols.

In *En ny blå bok* (A Blue Book) of 1908 he reproduces a picture of a small natural object that seems to partake of both language and matter. It shows the shell of a tropical mollusc, on

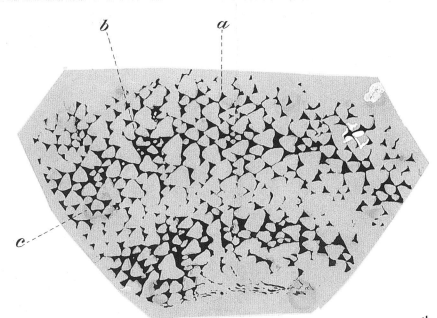

En bland de märkvärdigaste Lusus
naturæ är teckningarne på true-
kan Conus Marmoratus från
Indiska Oceanen. *Bifogade
figur visar en tydlig likhet med
Kilskriften, så att man kunde
tro det Assyrerna fått idén till
sina bokstäfver ifrån dessa
tecken. Den som i föregående
supplement följt mina Assyriska
forskningar skall straxt kän-
na igen gamla bekanta.
Vid a synes straxt ~~komma i~~
~~minne~~ polyfonen Sat eller hat
(från Tegnér 1878) ⧖ | med betydelsen Berg.

Vid b och flerestädes påträf-
fas tecknet ⧖ med variant
=Egendom.
⧖ vid c visar sig teck-
net ◇ som betyder
Sol och allt möjligt, ~~samt~~ med Inhägnad.
Tecknet ⊳—⊲ hykan sökas flere-
städes likasom äfven ⊳—⊲
Sjelfva Sar-tecknet finnes
här och hela grupper af lik-
nare tecken. Kanske man
med något letande skulle fin-
na sjelfva Nebukadnezar.

4. From the manuscript for *A Blue Book*, KUNGLIGA BIBLIOTEKET. PHOTO: MARCUS ANDRÆ, KUNGLIGA BIBLIOTEKET.

which nature has delineated an elegant pattern. In his fancy, he sees many signs of cuneiform script here, enough even to suggest the drawing on the shell as a possible model for the Assyrian alphabet. Admittedly the cuneiform script arouses in him both scorn and loathing; sometimes he even regards it as a complete fraud. Yet when he speaks of the signs on the shell as a "game" of nature, his remark implies a positive awareness of a certain artistic calculation in the visual pattern. And here, as in all crystalline sediments, he sees traces of Nature's own striving for form, something he often refers to as "the image-making instinct" in matter.

Look, for example, at the page reproduced here from *A Blue Book*, which demonstrates in pictures and words just this urge towards imagery – "so strong that the forms rise again from destruction". The text declares specifically that the ashes of a burnt flower can precipitate crystals so closely resembling parts of the living flower, that he sees it as a resurrection. The pictorial examples undeniably fire the imagination, but I wonder whether the fancies they inspire are not rather different from those cherished by Strindberg when he melted sulphur in the 1890s, and watched as the burnt remains formed crystalline structures resembling ice-ferns. That "picture" at least does not seem to me to symbolize something returning from a past life; surely it is a sign instead of that transmutation of matter which Strindberg thought his experiments had achieved.

Fifteen years later the illustrations in *A Blue Book* reveal greater symmetry between what perishes and what is left, and thus also reveal certain elements of a traditional religious metaphor for death and resurrection. But when Strindberg speaks in letters in the mid-1890s about resurrection, it is rather in the sense of a transmutation of the senses, a human rebirth. The young Strindberg "is no more than a memory" he writes to a friend in September 1896, "but", he adds, "some new incarnation may appear within his mortal frame". The possibility of such recreation is something to which his imagination frequently returns during the Inferno period, both in a text like *Stenarnas suckan* and in many of the paintings – and, above all, in the chemical and photographic experiments.

More remarkable than the photograms, however, and even

5 AND 6. *A Blue Book*, 1907,
PHOTO: MARCUS ANDRÆ, KUNGLIGA BIBLIOTEKET.

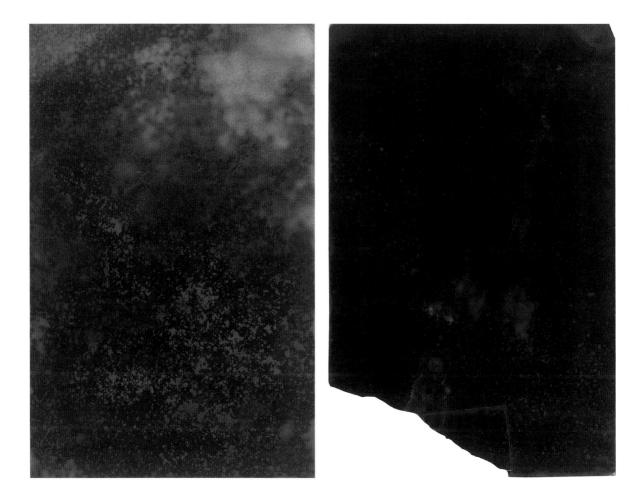

7–8. August Strindberg, Celestographs, 1894,

ORIGINAL SIZE 12X8 CM, KUNGLIGA BIBLIOTEKET.

PHOTO: JAN O ALMERÉN.

more telling as regards the metamorphoses that Strindberg craved, is the second group of experimental photos. He calls these pictures celestographs, and again they are photographs taken without either lens or camera. These experiments were carried out in Austria in the late winter of 1894 by exposing his photographic plates to the starry sky, on a window-sill or perhaps on the ground (sometimes, he tells us, they were already lying in the developer!). The images that gradually appeared are black or a dark earth colour, and are sprinkled all over with myriads of small lighter dots, which he saw as stars. It seems more likely to me that these spots arose more or less by accident during the chemical process. At any rate it is extremely uncertain what it was that left its mark on the light-sensitive emulsion. Maybe it was atmospheric particles, or simply dirt in the

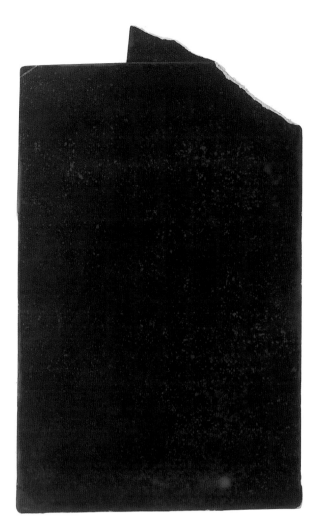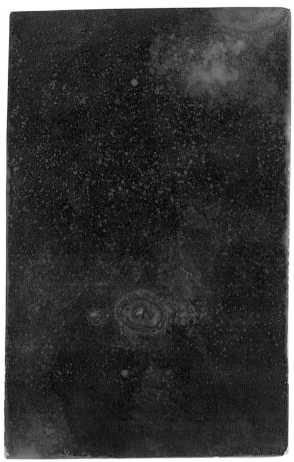

rinsing water, that have reappeared here? Something of this kind at any rate must have contributed to the effect.

As soon as the experiments were finished, Strindberg sent the photos and a written account to Camille Flammarion at the Société Astronomique in Paris. Around New Year 1895 the two also met personally on one or two occasions, but despite his own leanings towards mysticism, Flammarion must have regarded Strindberg's methods as altogether too absurd, and the official verdict from the Société that he had hoped for never arrived. Indeed, when regarded as a contribution to science or as representations of nature, the pictures are worthless, but this does not necessarily deny them considerable value in the realm of the imagination. Thus, if they help us to understand anything, it is again the man rather than the firmament.

9–10. August Strindberg, Celestographs, 1894,

ORIGINAL SIZE 12X8 CM, KUNGLIGA BIBLIOTEKET.

PHOTO: JAN O ALMERÉN.

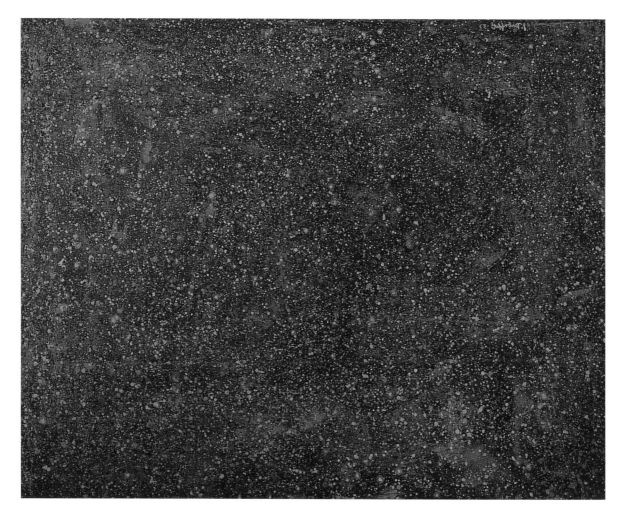

11. Jean Dubuffet, *Mechanism for destroying tracks*, 1957,

OIL ON CANVAS, 74X93 CM, MODERNA MUSEET.

PHOTO: MODERNA MUSEET © JEAN DUBUFFET/BUS 2001.

Certainly these images do quite often resemble the night sky, sometimes in delicate veils of bluish sediment, or in rust-brown oxidized spots evoking associations with interstellar clouds of matter or simply with ordinary earth-bound clouds lit up from below. But it is equally easy to perceive them as gravel and dust, close-up shots of worn asphalt, or a patch of dark soil. In fact these images do not differ greatly from the topographical earth studies that years later, in the 1950s, engaged the attention of Jean Dubuffet, who described them collectively as texturologies.

What is so splendid about Strindberg's photographs is precisely that they offer this kind of dual view, whereby the starry sky and the earthly matter appear to move within and through one another. And scientists do in fact believe that this is precisely

126

the way things are. All elements heavier than hydrogen and helium are created by nuclear reactions in the interior of stars, and are hurled out into space particularly during gigantic supernova eruptions. Almost every atom that goes to make up our earthly world – rocks, plants, human beings – must once have been inside exploding megastars, and thus in a dizzyingly material sense we do in fact consist of astral matter.

But in a more symbolical sense Strindberg's photographs seem to me to reflect upon the connections between the dark earth and the celestial light and life-force. Surely it is no coincidence that his experiments are concerned with solely the two themes we have spoken of here. After all, the association of crystallization and the influence of the stars is a very old notion in alchemy. Influence flows from the astral to the mineral, causing the earthly substance to "mature" slowly and sometimes transmute into a concentration of light and clarity: a pure crystal, just as mysterious as an astral body or the philosopher's stone.

In Strindberg's celestographs and crystallizations I see a kind of reverie along rather similar alchemical lines. A meditation over the links between the micro and the macro cosmos, between the earth-bound and the celestial, between light and dark, gold and dross.... This may sound like idealist symbolism of the most traditional kind, but even there we find parallels with the conceptual world of the alchemist. When the alchemist forces sulphur through the flame of his retort, he is attempting to purify and distil matter, but the act is also a metaphor for his own longed-for transmutation. He is subjecting himself to a self-imposed test, with a view above all to purifying himself – a situation in which Strindberg frequently found himself. "Under my hand every experiment half succeeds", he wrote from Paris in 1896, "and I don't think God wants to let me out of the mire, since he knows I cannot bear good fortune or renown".

This "God", who was gradually taking shape in Strindberg's mind during the Paris years, has the attributes of both a judging and a forgiving father figure, not unlike an idealized superego. With this interior being as his discussion partner, Strindberg can continue the process of coming to terms with himself that had begun in the Inferno period. In his letters at this time he often

Fig. 56¹.

12. Picture representing the so-called Wid-manstetten structures.

speaks of his "longing for a better self". Sometimes he adopts a not altogether constructive religious language, talking about "cleansing himself" from the earthly and the physical. But what it is essentially all about is a kind of moral speculation upon the self. Above all, perhaps, it means that as time passes he is learning to acknowledge and to live with the feelings of guilt that have long been blocking his literary creativity. At any rate, towards the end of the century the transmutation and rebirth around which the paintings and photographs of the 1890s had built their fantasies, became a reality for Strindberg as a writer as well, and it was not long before a mighty torrent of new works for the theatre began to flow from his pen.

His earlier pictorial creativity had certainly been, to some extent, a pointer introducing a new boldness into his ideas and his vision. For the artist and experimental photographer the subject was primarily the "correspondences" that the pictures seemed to be revealing, a position that in many respects finds its sequel in the *Blue Book*s. An example from these provides an apt conclusion. In a commentary on *A Blue Book* (National edition) Gunnar Ollén has reproduced two pictures connected with one of the brief texts: 'The Secrets of the Heavens'. One of these pictures leaves a surprisingly 'modern' impression on the viewer. It could easily be interpreted as an attempt to illustrate some kind of electronic cyberspace, but in fact it obviously represents the crystalline pattern to be seen on certain iron meteorites. In the text Strindberg compares this geometrical tangle of criss-crossing strips with the structures seen in recently formed ice on shallow pools of water; and even records this in a little sketch. He finds the markings so similar that he wonders – preposterous idea! – whether the ice can be a 'reproduction' of the firmament from which the meteorites once fell.

As an intellectual notion this is naturally laughable, just as absurd as his suggestion in another context that "Gold is sunshine photographed and fixed!". But in both cases it is also a question of grand cosmic visions in which heaven and earth communicate with one another in a manner that approaches mutual understanding. And if anyone feels he can see the heavens not just reflected but even represented in the ice, then

DREAMING MATERIALIZED

we are undeniably justified in speaking of celestography, a
"heavenly script". And so we have just one more example of
what Strindberg saw as nature's dreamlike striving for form:
matter's own code – elusive, difficult to grasp, yet full of hope
as a glimpse of that other great boundless connection.

13. Notes and cuttings regarding
the Widmanstetten structures.

Strindberg had noted that the so-
called Widmanstetten structures, a
type of pattern that had been
observed on stony meteorites, showed
a certain resemblance to the patterns
that form on recently frozen puddles.

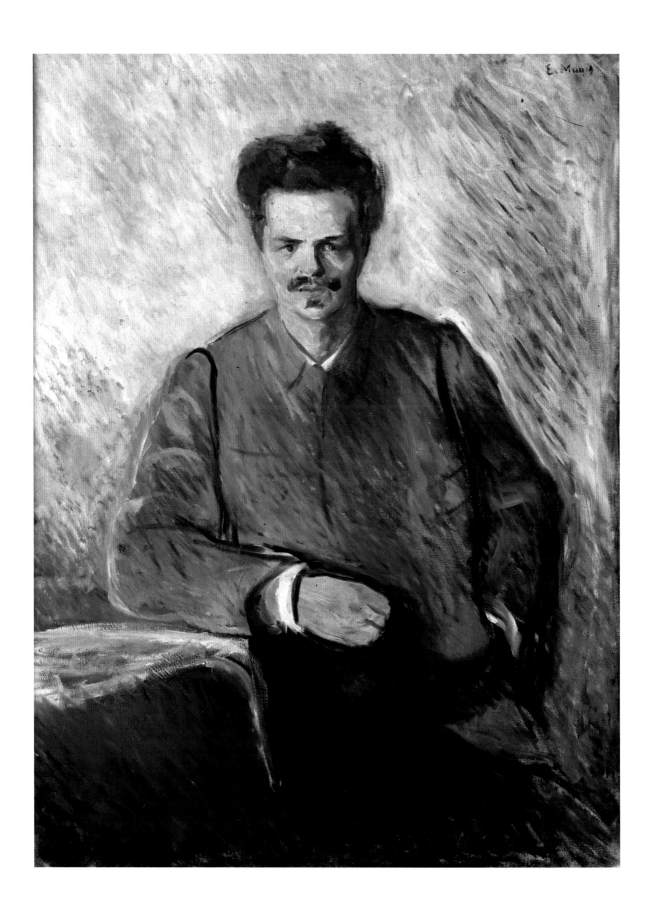

Strindberg in the Artists' Community of Paris

The First Visits to Paris

In 1956 the Strindberg scholar Stellan Ahlström called his dissertation on Strindberg and France *Strindbergs erövring av Paris* (Strindberg's Conquest of Paris). Even as a young man, Strindberg was an eager reader of newspapers, periodicals and books in order to keep abreast of developments in Paris, not least in the field of art. At the beginning of the 1870s, when Paris had become the capital of European art, he emerged as one of the most unbiased and perceptive art critics in the Swedish press. Artist friends among his contemporaries were some of the first to join forces with colleagues from all over Europe and continue their artistic studies in Paris instead of Düsseldorf, Munich, Rome or London.

In the summer of 1876 Strindberg set in motion the preparations for a new cultural magazine of his own in tabloid form, to appear weekly. It was intended to be a forum for his journalistic activities: a very large proportion of the contents was to be devoted to art, and to include reports from Swedish artists in Paris as well as from the old haunts of Rome, Munich and Düsseldorf. Only one issue was ever published, in September 1876, and the letter from Paris was signed by Charles, most probably a pseudonym for the artist Carl Skånberg. Skånberg took the opportunity of attacking Strindberg the art critic, notably for the latter's positive criticism of Julius Kronberg's *Jaktnymf och fauner* (Hunting Nymph and Fauns), dating from that same year – allegedly praise that would have been unthinkable in France, where artistic tastes were much more fastidious.

It is probable that Skånberg's criticism increased Strindberg's

GÖRAN SÖDERSTRÖM

Edvard Munch, *The Author August Strindberg*, 1892,

OIL ON CANVAS, 120 X 90CM, MODERNA MUSEET, STOCKHOLM. PHOTO: MUNCH-MUSEET (ANDERSEN/DE JONG) 2001, © MUNCH-MUSEET/MUNCH-ELLLINGSEN GRUPPEN/ BUS 2001.

The portrait was painted in Berlin in 1892. At that time both Strindberg and Munch were members of the circle that used to meet at the wine bar Zum Schwarzen Ferkel. They also kept each other company in Paris for a while in 1896.

desire to move to where it was all happening, to see all the new art that was only available in Sweden in the form of inadequate reproductions. He also wanted to make direct contact with the Swedish artists in France. In fact he went to Paris for the first time as early as October that year, in the company of an artist friend. A series of articles for the Stockholm daily newspaper *Dagens Nyheter* reports on the discussions he had with artists, and his first impressions of modern French art.

What struck him was how confused the young artists were by what was happening. They tried to keep up with what was being exhibited at the Salon, but felt generally disillusioned. The only artist to be accepted without reservation was in fact Théodore Rousseau. Strindberg toured the art dealers and viewed the kind of painting that was being hung at the Salon, but they left him cold. He was looking for a trend: "I was unable to find the consistent principle – the new, the Frenchness, the landscapes." Suddenly he came upon the Impressionists at the Durand-Ruel gallery and described his reactions in the famous foreword to the catalogue for Gauguin's final exhibition in 1895:

> A young artist, then unknown, was my guide, and we saw a lot of marvellous things, most of them signed by Manet or Monet. As I had other things to do in Paris besides looking at pictures [...] I regarded these modern paintings with a sort of unmoved equanimity. But I returned the next day, without knowing why, and discovered "something" in these remarkable manifestations. I saw the bustle of a throng of people on a landing stage, without seeing the actual throng; I saw the dash of an express train through the Normandy countryside, the movement of wheels along a street, horrible portraits of ugly old men who were unable to pose placidly for the artist. Impressed by these remarkable canvases, I sent an article to one of the newspapers back home, trying to put into words what the Impressionists had tried to create (as I saw it), and my article was rather successful, being regarded as something incomprehensible.

The 1876 article is a brilliant analysis, in dialogue form, of paintings by Sisley and Monet. Strindberg plays the part of the sceptic reluctantly persuaded by his companion. The dialectic format he chose has led many to maintain that he was reactionary in his

previous attitude towards the Impressionists, but on the contrary, he was the first to introduce them to the Swedish public in positive fashion. Even in a European context he was something of a pioneer: his criticism is one of the first well-informed interpretations, despite the reservations he makes in the article.

There is nothing to suggest that on his first visit to Paris, Strindberg moved in circles other than those of his Scandinavian artist friends, who did not have much contact with French art in general at this time.

His second visit to Paris, in September 1883, had the official aim of producing an article on Carl Larsson and the Scandinavian artists' colony in Grèz-sur-Loing. In fact he had long cherished the idea of emulating his Norwegian colleagues Ibsen and Björnstjerne Björnson in establishing himself abroad, enabling him to work more freely and reach out to a European readership. After the irksome conflicts caused by the publication of his *Svenska Folket* (Swedish People) and *Nya riket* (The New Kingdom), he also felt excluded from Swedish bourgeois society. When, at the end of 1884 he finally settled down in Paris, or to be more precise in Passy and Neuilly, he remained on the periphery even in a figurative sense. He was shy of making new acquaintanceships, and in France this combined with a reluctance to speak the language to prevent him even from trying to make contact with people he had previously corresponded with. It was 1888 before he attempted to get in touch with his outstanding Naturalistic predecessors Zola and Maupassant by sending them a French translation of *Fadren* (The Father), made partly by himself. With the exception of Björnson and Jonas Lie, who looked him up in Neuilly, Strindberg seems only to have mixed with Scandinavian artists on this visit as well.

Nor does he appear to have come into contact with any French authors or artists on his third visit, in 1885. He again took up residence in Neuilly before moving on quite soon to Luc-sur-Mer and the Scandinavian artists' colony in Grez. Although there were times in the 1880s when it was easier for him to have his works published abroad than in Sweden, during his first lengthy stay outside his homeland, from 1883 to 1889, he was more of a Swedish author in exile than a genuine European writer. He took

an interest in what was happening on the Continent, and was astute in his awareness of it all, especially in Paris, but what he actually produced himself was still aimed at readers in Sweden, even though they no longer wanted anything to do with him. In 1885 a close friend of his, Karl Nordström, who was part of the artists' colony in Grez, wrote that: "It is strange to observe how he is dying to be noticed and admired and considered great abroad, but then concentrates on belittling his fellow country-men, whose ill-treatment of him he can never forget."

Interlude in Zum Schwarzen Ferkel

It wasn't until after his rather triumphalistic return to Stockholm around 1890 and his equally inglorious exit to Berlin in the autumn of 1892 that Strindberg really turned his attention to the Continental arena. The coterie of Scandinavian artists, writers and European apprentices he gathered around himself in the little wine bar in Berlin called "Zum Schwarzem Ferkel" (The Black Piglet) would become the cradle of Scandinavian Symbolistic Expressionism, and also that of subsequent German Expressionism in painting and the theatre. On the other hand, Strindberg was completely divorced from Swedish cultural life in between 1893 and 1897. As late as the 1960s Swedish literary scholarship regarded the whole of the 1890s spent by Strindberg in Europe as a sterile period of illness, leading up to his "Inferno".

There is no doubt that Strindberg was the spiritual centre for the coterie of European artists at Zum Schwarzen Ferkel long after he had left Berlin. There are several examples of latecomers to the circle who did not arrive in Berlin until he had gone, but who nevertheless refer to him in their memoirs as if he had still been there. The close friends and "apprentices" he left behind, especially Edvard Munch, the German Symbolist poet Richard Dehmel and the Pole Stanislaw Przybyszewski, continued to develop the aesthetic ideals of the Ferkel.

It is not necessary to go into detail about the history of the Ferkel circle, apart from noting that it was the preamble to Strindberg's important stay in Paris that followed. It was in Berlin and among his friends at the Ferkel that Strindberg

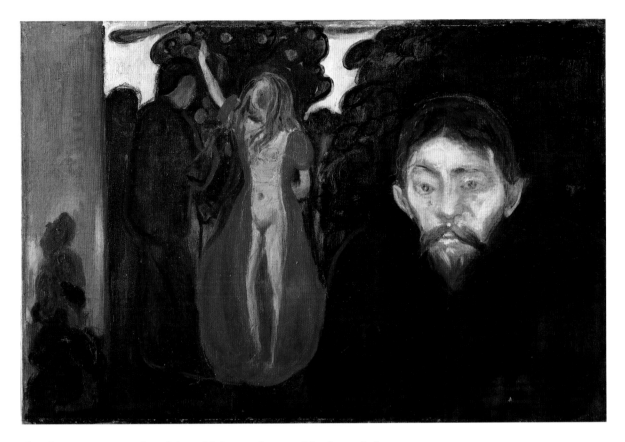

finally manage to free himself from the straitjacket of the
Swedish cultural scene, and exposed himself to powerful im-
pressions from other European intellectuals. It seems that
Strindberg found the discussions with his "favourite apprentice"
Przybyszewski, called "Popoffsky" in *Inferno*, especially pro-
fitable. Shortly before Strindberg came to Berlin the Swedish
writer already living there, Ola Hansson, had introduced
Przybyszewski to French Symbolism: Baudelaire, Mallarmé and
the Decadents made a very powerful impression on the young
writer. He even modelled his lifestyle on the likes of Verlaine
and Rimbaud, attempting to extract new sensations by means
of copious consumption of alcohol and complicated erotic rel-
ationships. He had a need to worship, and in the autumn of
1892 Strindberg replaced Hansson as his 'Master', to be suc-
ceeded in due course by Munch, who was closer to him in age
and for whom Przybyszewski generated ecstatic adoration.
Przybyszewski and his Norwegian wife Dagny Juel, the Aspasia of

2. Edvard Munch, *Jealousy*, 1895,
OIL ON CANVAS, 67 X 100CM, BERGEN KUNSTMUSEUM.
PHOTO: MUNCH-MUSEET (ANDERSEN/DE JONG) 2001,
© MUNCH-MUSEET/MUNCH-ELLLINGSEN GRUPPEN/
BUS 2001.

the Ferkel circle, crop up in the various versions of Munch's *Sjalousie* (Jealousy). (Fig. 2)

Members of the original circle have been keen to deny that they were pupils of Strindberg's, but he himself maintained he was the spiritual progenitor of the whole group. Both claims are correct in their way; or as Strindberg put it in his novel fragment *Klostret* (The Cloister): "new ideas need two parents, so it would be difficult to say who actually brought them into the world".

All the same, one has to wonder whether Przybyszewski meant more for Strindberg than vice versa. Through his 'apprentice', Strindberg was introduced at an earlier stage to the ideas of the French Symbolists and Decadents. Przybyszewski claimed he tried to involve Strindberg in French Occultism, "Black Magic", which was fashionable among the Symbolists in Paris. However, Strindberg was still sceptical about metaphysical speculations at this time. Strindberg always had both feet on the ground, even in his most fantastic and anti-Naturalistic works. and the abstract, speculative metaphysics of Przybyszewski and the Symbolists were totally alien to him.

Strindberg left the Ferkel circle in May 1893, following his marriage to the Austrian journalist Frida Uhl. After various peregrinations around Europe, the couple settled down on an estate belonging to Frida's maternal grandparents, Dornach, on the Danube. It was here that Strindberg prepared himself for his final conquest of Paris. It is interesting to note that he did not plan his French career primarily as a dramatist – after all, the previous year he had enjoyed a great success with *Fröken Julie* (Miss Julie) at the Théâtre-Libre – but as an essayist, a sort of cultural journalist, and a painter. In Dornach, during his wife's pregnancy, he painted a series of significant pictures, including *Underlandet* (Wonderland), which he sent to Paris in advance.

"I'm now a painter in Paris..."

Shortly after Strindberg arrived in Paris, his new publisher, Albert Langen, introduced him to an eccentric character, the

young Danish-Parisian painter and art dealer Willy Gretor, who offered to launch Strindberg as a painter.

In the 1890s Gretor was a well-known person in the most fashionable art and literature circles of Paris. As an artist he was not a bad portrait-painter, but his main source of income was shady dealings in ancient and modern art, and money he managed to wheedle out of others, mainly woman. He seems to have had the ability to put those around him under a spell, lived in grand style, was totally lacking in scruples and seduced everybody with the myths about his life and adventures he loved to surround himself with. Among those who have depicted him are Knut Hamsun, Th. Th. Heine and Frank Wedekind, who acted as his secretary for a while.

Gretor placed at Strindberg's disposal a luxurious apartment with studio in Hameau Boulainvilliers in Passy. The apartment actually belonged to the artist Rose Pfaeffinger, Gretor's secret wife. Strindberg soon grew suspicious of his landlord and all the unaccustomed luxury, behind which he suspected lurked criminal activities. Nevertheless, he spent some hectic days painting in the apartment, from 7 to 10 September 1894, and produced some of his finest and most sophisticated pictures.

In the middle of September he was reunited with Frida in Paris, and from the moment she arrived there was a marked increase in social activities. They moved together in the circles surrounding Langen and Gretor, which consisted mainly of Scandinavian, German and a few French writers and littérateurs, such as Knut Hamsun, Frank Wedekind and Henri Becque, as well as artists like Strindberg's old friend Fritz Thaulow. Unlike Strindberg's social contacts on previous visits to Paris, the artists he mixed with now were assimilated into French cultural life.

However, Strindberg was not much pleased with the relationship Frida established with Albert Langen, and even less so with her contact with Gretor, which continued when she returned to Austria at the end of August. After she had left, Strindberg began to hear rumours to the effect that Gretor was selling fakes, and he severed all contacts with him for fear of being tarnished with the same brush. It is clear from Strindberg's letters that the first signs of disharmony in his relationship with his wife were

due to her continued contact with Gretor, Langen and company. He worries about the 'pack of fakers', who were quite capable of murder if rumour were to be believed, and the relationships Frida maintained behind his back with the Gretor-Langen circle and Strindberg's former friends in Berlin, which were to play an important role in the onset of his *Inferno* crisis in 1896, resulted in him establishing a new set of social contacts. In the company of his old friend the Swedish painter Allan Österlind, he became a frequent visitor to the Café Napolitain. Österlind also introduced him to contacts in the newspaper and publishing worlds. He took up again with a number of Finnish artists such as Albert Edelfelt and the sculptor Ville Vallgren, who introduced him in turn to the famous astronomer Camille Flammarion.

Mixing with Gauguin and the Symbolists

The late autumn of 1894 seems to be the time when Strindberg was in closest contact with the most modern intellectual and artistic circles in Paris. He now had intimate links with *La Plume* and other Symbolist periodicals such as *Revue Blanche* and *Mercure de France*. The programme for the première of *Fadren* (The Father) at the Théâtre de l'Œuvre, on 13 December 1894, was produced by the Nabi Felix Vallotton, although Strindberg was not personally acquainted with him. (Fig. 3) In its issue dated 15 December, *La Plume* advertised a subscription banquet for "the Master August Strindberg", "le triomphateur de Père et de Créanciers". We know that he was interested in the exhibitions at the Salon de Cent which had links with *La Plume*, and at other galleries connected with the Symbolists.

It is also clear that it was about now that Strindberg started making regular visits to the two Swedish sculptresses Agnes de Frumerie and Ida Ericson-Mollard. Ida Ericson, the 'fallen woman' who, according to *Inferno*, took pity on Strindberg and helped to get him to hospital, was very unconventional in her habits, but renowned for selflessly taking care of people who needed her help. Many young artists, including Ivan Aguéli, had found a home from home in Paris at her house. She lived with her husband, the Norwegian-French state official William

3. Felix Vallotton, Programme sheet for the première of *The Father* at the Théatre de l'Œuvre 13 December 1894,

LITHOGRAPH, 24.5 X 31.8CM, STRINDBERGSMUSEET, STOCKHOLM. PHOTO: HANS THORWID, NATIONALMUSEUM.

Mollard, who was also a radical composer, in a two-storey studio house in the courtyard of rue Vercingétorix 6 in Montparnasse, next to what is now the Gare Montparnasse. Around the turn of 1893–4 Paul Gauguin moved into the studio above the Mollards' on his return from his first trip to Tahiti. They immediately became very good friends, but during the spring Gauguin returned to Pont-Aven and was not back until the end of November.

Gauguin was present at the widely praised Paris première of *The Father* on 13 December, which suggests he had got to know Strindberg quite soon after returning to Paris. It seems that Strindberg and Gauguin were immediately attracted to each other. Naturally enough Gauguin had a lot of Scandinavian contacts through his Danish wife, from whom he was now separ-

ated in circumstances in many ways reminiscent of Strindberg's.

From the start Strindberg and Gauguin most likely met mainly at the Mollards' and then went out with William Mollard for a glass of absinthe. Another member of the group was Gauguin's close friend, the poet Julian Leclercq; he and Mollard translated *Den romantiske klockaren på Rånö* (The Romantic Organist of Rånö) for publication in *Revue de Paris*.

After the successful première of *The Father*, Strindberg received lots of invitations but, hindered by his imperfect command of French, he withdrew from fashionable social intercourse. No doubt another circumstance played an important part: his hands were chapped and bleeding as a result of a severe type of eczema, probably aggravated by the chemical experiments he had started to undertake again. The disease got worse in early January, and his financial situation also became very precarious. Despite all the fame that came his way, the financial rewards from the theatre productions, books and periodicals were very small. The contrast between his literary success and the misery in which he was forced to live made Strindberg very bitter: he considered himself swindled out of the fruits of his labours and humiliated by the collection among Scandinavians resident in Paris, organized by Ida Mollard and Jonas Lie, in order to make it possible for him to seek medical treatment for his hands. That is probably the reason why, on leaving hospital, he avoided the company of other writers and editors, and also his Scandinavian friends.

It was probably at Gauguin's or Mollard's suggestion that he now moved into a *pension de famille* in the rue de la Grande Chaumière, close to where his friends lived in rue Vercingétorix. It was next to Gauguin's former residence and directly opposite Madame Charlotte Caron's crémerie, La Purée Artistique, which was Gauguin's favourite restaurant in Paris: a place where artists could eat on credit and pay with a picture.

In *Inferno*, which presents a markedly fantasized picture of this period, Strindberg writes about the circle of artists:

> In a modestly furnished apartment I had rented I spent the winter conducting my scientific experiments, staying in-doors until the evening when I would go out for dinner at a crémerie where artists of various nationalities had formed a coterie. [...] There was a lot

of talent there, an enormous amount of ready wit, and one of them was an outstandingly gifted genius who has made a name for himself.

It goes without saying that the 'outstandingly gifted genius' was Gauguin. Also in the group were Julien Leclercq, the Polish painter Slewinsky, the Czech painter and poster artist Alphonse Mucha, who has become so popular now, and the English composer Frederick Delius. It is clear from the memoirs written by many of the circle that Strindberg did not play the modest role he claims was his in *Inferno*: on the contrary, he and Gauguin were the life and soul of the group.

The weekly receptions held by Gauguin in his studio, where most of his Tahitian paintings adorned the walls, were frequented by many artists and writers, possibly at times including Degas. We know from a letter and an address in Strindberg's notebook that he also associated with Gauguin's friend and collaborator Charles Morice; nevertheless, the one closest to Strindberg in the Gauguin circle was Julien Leclercq, who became the associate and contact with the outside world that Strindberg needed. Leclercq himself makes no attempt to hide the fact that he played a subordinate role in this company.

The time when Strindberg and Gauguin were the two twin stars of that constellation of artists has been called by Leclercq "our great year". The others also liked to recall that time with fondness, just as members of the Ferkel circle were always harking back to the short period when they used to gather round Strindberg at Zum Schwarzen Ferkel. Delius's recollections are remarkable for their clarity of detail. He writes about the meetings at the crémerie:

> It was a little place of the utmost simplicity, where hardly ten people could sit down at a time and where one's meal generally cost one franc, or one franc-fifty including coffee. [. . .] I lived at that time at Montrouge, Rue Ducouedic, and generally took my meals at home; but I occasionally lunched or dined at Madame Charlotte's to meet Gauguin and Strindberg. Or I would sometime fetch Strindberg for a walk in the afternoon.

Mucha also wrote about going for walks with Strindberg:

> Strindberg and I often used to go for walks along the Boulevard St.

Michel, and then down into the cité, or to watch life go by in the Quartier Latin, or to stroll round the churchyards – those were the excursions he liked best. That was where we would air our inner-most thoughts – about life after death and similarly serious questions. Strindberg had brought with him from Sweden all kinds of scientific problems that he was now working on. What interested him most was the life of atoms and the transmutation of metals into gold. L'Université de Paris had placed a room at his disposal, and he used it as a laboratory. He used to come round to my place and show me glass plates covered in a yellow substance – lead turned into gold.

At this time Strindberg was busy with chemical experiments. Despite their extremely speculative character, his theories were received in France with remarkable respect and interest, even by leading chemists. The Gauguin coterie also believed absolutely in Strindberg's chemical research. Delius writes:

> However, I have to say that I believed implicitly in his chemical discoveries at that time. He had such a convincing way of explaining them, and he really was very keen to be an inventive genius.

A letter to Mollard from Tahiti in December 1895 shows that Gauguin was also interested in Strindberg's chemistry. It was written after Strindberg had published his "Introduction à une chimie unitaire" in the Symbolist periodical *Mercure de France:*

> I see that Strindberg has returned to France – it is after all the country where foreigners are most sympathetically received and where the greatest ideas are produced. I read an article by Strindberg in Mercure, and thought it was very good.

The best-known document about relations between Strindberg and Gauguin is the preface to the catalogue for Gauguin's auction at the Hotel Drouot on 16 February 1895, written when they had only just got to know each other. Gauguin planned to sell the paintings he had made on his first journey to Tahiti in order to fund a return to the south seas, and he evidently thought a preface written by this new friend, who was currently the centre of much discussion, would be excellent publicity. It gives the impression that Strindberg had first intended to decline the invitation; nevertheless, once he picked up his pen the letter of

4. Paul Gauguin, *Aréaréa (Joyeusetés)*, 1892,
OIL ON CANVAS, 75 X 94CM, MUSÉE D'ORSAY, PARIS.
PHOTO: RMN – H. LEWANDOWSKI.
This painting was sold along with a number
of other works by Gauguin at an auction
organized by the artist himself in Paris in
February, 1895. The auction catalogue had a
foreword by Strindberg.

refusal soon turned into an elegantly phrased introduction. Gauguin was delighted by it, and wrote an ostensible reply, intended to be printed in the catalogue together with Strindberg's letter. (Fig. 4) In advance, the newspaper *L'Eclair* printed their letters prominently on 15 and 16 February respectively. The editorial comment was rather odd and does not indicate much in the way of real understanding of Gauguin's painting. Nevertheless, the versions of the letters printed in the newspaper are interesting in that they are noticeably different from the final versions. The biggest changes are in Gauguin's letter.

The preface illustrates how far he identified with Gauguin's situation, despite their varying views about art. Needless to say Gauguin felt the same emotional accord, despite the fact that they

differed on so many things. A letter, long overlooked, to the artist Herman Schlittgen, who was a member of the original Ferkel group, demonstrates Strindberg's high regard for Gauguin's painting, despite the famous ambiguity of the preface. The letter reveals that Strindberg hoped it would be possible to arrange a Gauguin exhibition in Munich.

Strindberg's *Inferno* years 1895–6 have often been referred to as a time of loneliness and isolation. In fact he was never alone during that period, never without friends and social contacts, and any loneliness he sometimes experienced was being "lonely in a crowd". Even after he returned from Sweden in the summer of 1895, he continued to mix with the same coterie despite the absence of Gauguin. Later in his life he liked to think back with pleasure to those rather happy and harmonious days in Paris during the summer and autumn of 1895. However, in Sweden and the Scandinavian circles he abandoned after his spell in hospital, he was regarded as a degenerate and half-crazy person. Later on he himself helped to fuel this myth by the description he gave of the period in his novel *Inferno*.

Even if Delius and Leclercq, unlike Mucha, found it hard to follow Strindberg in his increasingly tangible Occultism, Symbolistic Occultism was nothing unusual for the groups of artists that used to meet at rue Vecingétorix 6. The sculptor Albert von Stockenström, a close friend of Sager-Nelson's and Aguéli's, now became Strindberg's apprentice with regard to his occult visions, as was a newcomer to the crémerie, the German-American artist Paul Herrmann, or Henri Héran as he called himself in France. It is characteristic that both Stockenström and Herrmann were evidently close to the Rose & Croix movement.

At the beginning of 1896 Edvard Munch joined the group at the crémerie. He had evidently known Delius for some time, and associated with him freqently. In Munch's studio Strindberg saw many depictions of the pair Przybyszewski-Juel, including the famous painting *Jealousy*. (Fig. 2)

The period of hypersensitivity and nervousness that began before the turn of the year and caused repeated temporary rifts with his group of friends eventually led to Strindberg leaving the pension in the rue de la Grande Chaumière at the end of Feb-

ruary, and moving into the Orfila Hotel, 60 rue d'Assas, which was a little religious hostel for students, on the western side of the Luxembourg Gardens.

It must have been around this time that Munch started to plan his first French one-man exhibition at the Galerie de L'Art Nouveau. Despite his reputation in Germany, he was just as unknown in France as Gauguin had been in Germany, and it therefore seemed natural for him to place himself under the wing of his famous friend. Before the exhibition Strindberg wrote an introduction in the form of a prose poem, which was published in the Symbolists' and Nabis' *Revue Blanche* on 1 June 1896.

This brief presentation demonstrates how completely he had mastered the Symbolist language by this time. He had at last read the favourite novel of the Symbolist painters, Balzac's *Séraphita*, inspired by Swedenborg, and he starts by quoting a typical motto from the novel: "No matter how incomprehensible your words may be, they have their charm."

5. Edvard Munch, *Strindberg in the Asylum*, 1896,

LITHOGRAPH, C. 33 X 54CM, MUNCH-MUSEET, OSLO.
PHOTO: MUNCH-MUSEET (ANDERSEN/DE JONG) 2001,
© MUNCH-MUSEET/MUNCH-ELLLINGSEN GRUPPEN/
BUS 2001.

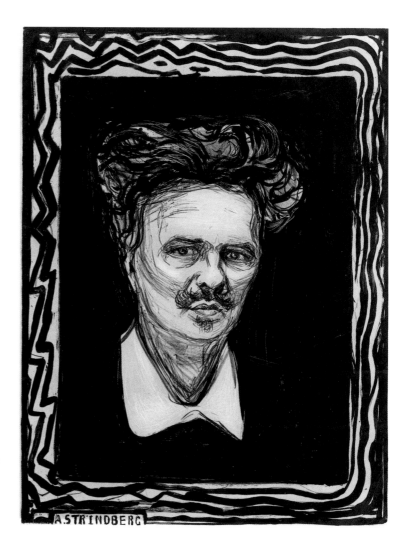

6. Edvard Munch, *August Strindberg*, 1896,
LITHOGRAPH, 61 X 46CM, MUNCH-MUSEET, OSLO.
PHOTO: MUNCH-MUSEET (ANDERSEN/DE JONG) 2001,
© MUNCH-MUSEET/MUNCH-ELLLINGSEN GRUPPEN/
BUS 2001.

The story of Strindberg's unease concerning the assumed
arrival of Popoffsky-Przybyszewski in Paris is well known, as are
Munch's and Strindberg's frenetic plans once Przybyszewski had
been arrested in Berlin at the end of June. As is also well known,
this Berlin episode and Munch's defence of Przybyszewski are
the basis of Strindberg's play *Brott och brott* (There are Crimes
and Crimes), which is set partly in Madame Charlotte's crém-
erie. Delius has recounted how, after a visit he and Munch made
to Strindberg on 18 July, Strindberg came to suspect that Munch
had tried to gas him. This led to his moving out of the Orfila
Hotel, and the start of the first big *Inferno* crisis.

The Last Visit to Paris

Strindberg's last contact with the Parisian artistic world took place about a year later, when he returned to Paris at the end of August 1897. Nearly all his old friends from the crémerie had moved on, apart from the painter Herrmann, who introduced Strindberg to the young doctor and poet Marcel Reja. But as he recorded in his diary, this final visit to Paris turned out to be uneventful, despite the fact that it marked the recommencement of his literary and dramatic writing.

One might well ask how Strindberg was influenced by his contacts with the various artist circles in Paris. There is no doubt that his literary and artistic activities were influenced strongly by the radical tendencies of the time, particularly the medieval-inspired Romantic symbolism of the Rose & Croix movement. On the other hand his exchanges with Gauguin seem to have been at a purely personal level. At the same time it is obvious that Strindberg had a powerful effect on many of his friends from the Paris days, as can be seen from such sources as the autobiographies of Delius and Mucha. It is also clear that Strindberg had a significant influence on Edvard Munch.

To sum up, there is no doubt that Strindberg's new conception of the world, filled as it is with powerful artistic allusions, came about while he was mixing with this group of talented and independent artists from all over Europe, at a time when, especially in Sweden, he was thought to be living the tragic existence of a hermit, in misery and mental confusion.

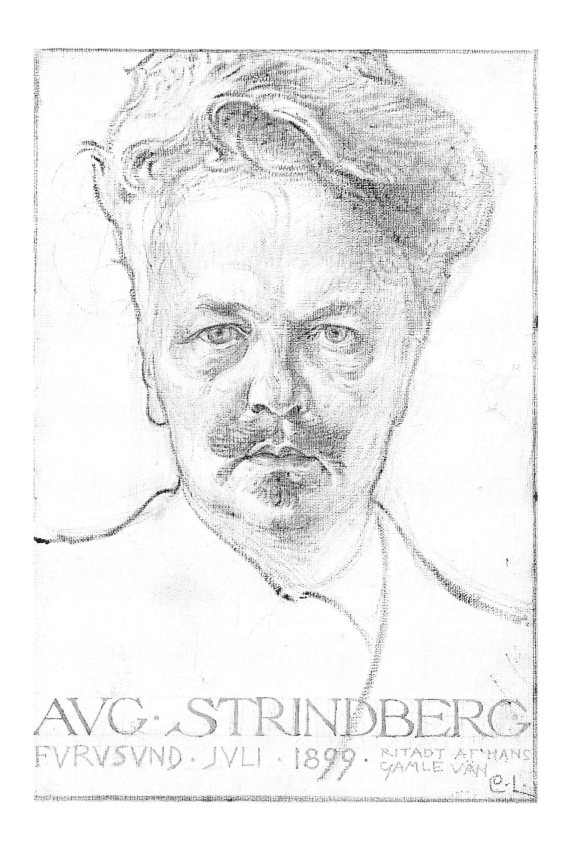

AVG·STRINDBERG
FVRVSVND · JVLI · 1899 · RITADT AF HANS
GAMLE VÄN
C.L.

Strindberg, Carl Larsson and the Frescoes Lining the Main Staircase at the National Museum

Strindberg and Carl Larsson had met as early as the beginning of the 1870s, although they could hardly be described as regular companions until around 1880. In 1872 Strindberg had rooms in a tenement block for the poor at 7, Grev Magnigatan, having quit his university studies in Uppsala and moved to Stockholm in order to try earning a living as a freelance journalist and writer.

One might well ask why Strindberg and Larsson did not see more of each other at a time when they were neighbours, and well aware of what the other was doing. In *En blå bok* (A Blue Book), Strindberg provides a tardy and not especially objective explanation: "I saw him in some pub or other and was immediately scared of him, for his lop-sided, foxy face tried to give the impression of being friendly towards me, but appeared to be interested only in so far as I could be of use to him."

Although he was enthusiastic about unprejudiced radical painting, Strindberg shared with the leading art history professor of the day, Lorentz Dietrichson, an interest in historical painting – matching his interest in historical drama. Dietrichson used to remind his students that ever since its inaugural ceremony in 1866, the main staircase walls at the National Museum were inscribed: "Location for fresco paintings". It seems that Strindberg made up his mind at an early stage that Larsson was to be the one who would supply those paintings. In February 1878 – when Larsson registered historical motifs at the very bottom of his list of priorities – Strindberg the art critic published a review in *Dagens Nyheter* criticizing the exhibition paintings Larsson had sent from Paris which ended thus:

GÖRAN SÖDERSTRÖM

1. Carl Larsson, *August Strindberg*, 1899,
CHARCOAL AND OIL ON CANVAS, 56 X 39CM,
NATIONALMUSEUM, STOCKHOLM, NMB 398, GIFT FROM
THE ARTIST IN 1918. PHOTO: NATIONALMUSEUM.

2. August Strindberg, *Spring Harvest*,
paperback edition, 1880–1,

They are all very pretty and splendid, but what about Swedish history, Peder Sunnanväder, Sturen and all those other great and noble memories? Mr Larsson was always regarded as being in possession of a plus which raised him above the level of drawing room artists; is he really able to learn so much in Paris that he could not pick up at home? Surely not! But as long as he goes on doing so, we shall have to wait for significant contributions to Swedish art, and the walls in the vestibule of the National Museum will evidently have to wait a long time for the man destined to paint them.

In September that same year Larsson took the initiative in establishing closer acquaintance by writing an expansive letter extolling the newly published verse edition of *Mäster Olof*:

> I have just finished reading your unfinished opus "Mäster Olof". I feel an irresistible urge to express my admiration without delay – and to offer you my thanks. You do not know me – that is natural enough as I have not yet indicated which direction my ambitions will lead me. I am convinced we are in agreement that we young lions must do battle. And doing battle kills – destroys.
>
> I do not know why, but I have always felt that you and I have something in common: the urge to ponder and search for what our age really wants . . .

Despite this letter – from a young anarchist draping himself in the red flag – it would be about 1880 before any direct contact was established.

After completing *Röda rummet* (The Red Room), Strindberg collected his research into the cultural history of Stockholm in a book entitled *Gamla Stockholm* (Old Stockholm). The volume was richly illustrated, some pictures being taken from old printed documents, and others made by various artists depicting old objects and buildings. Responsibility for the drawings lay with the painter Wilhelm Dahlblom and the newspaper artist cum book illustrator Robert Haglund. Strindberg was keen to involve Larsson in this publication, and he did in fact contribute two drawings for Chapter four: *Gatmusik och Folknöjen*. He then appears to have withdrawn from the project.

Strindberg was not daunted by Larsson's evident unwillingness to cooperate. By this time Larsson had acquired the repu-

tation of being one of Sweden's foremost illustrators, and Strindberg needed his help. It is true that in October Larsson declined Albert Bonnier's commission to submit an illustration for the short story "Solrök" (Heat Haze) in the annual *Svea*, to be based on Strindberg's own sketches, but he did agree to produce a cover in the form of a portrait of the author for *I vårbrytningen* (Spring Harvest), a collection of early writings. (Fig. 2). Despite misgivings about submitting to Strindberg's directions, Larsson was unable to resist the temptation of putting his own name on the same work as a now famous author.

In November 1880 Larsson travelled to Paris for the second time, accompanied by Ernst Josephson. At the same time Strindberg began to collect his various studies of cultural history in order to publish something completely novel: an anthology of Swedish cultural and historical studies from prehistoric times to the present day, arranged pedagogically for the general reader and richly illustrated. To some extent the illustrations were to be similar in character to those in *Old Stockholm*, while others were to be typological arrangements of objects; in presenting the pictures, however, the emphasis would be on a Strindbergian innovation: the typical historical image – a sort of propagandist depiction of history and ethnological portrayal of culture. For the most important illustrations – the typical historical images – Strindberg turned once more to Larsson, who responded as follows from Paris on 17 February:

> What is certain is that I would not be happy about anyone else supplying what you and the publisher are proposing. . . But working in the manner of some clerk attached to the Academy of Letters, History and Antiques under your supervision – that is something I am afraid would not be a profitable way of proceeding, nor would it be very pleasant for me. Just imagine how you would feel if some higher authority were to criticize your work day by day, page by page, as you were writing.

Larsson returned to Sweden on account of this commission, and ended up by producing a large proportion of the illustrations for *Svenska folket* (The Swedish People) in cooperation with Strindberg. After Larsson returned to Paris in October, Strindberg took to sending his instructions by letter;

3. Carl Larsson, *The Factory Worker*, illustration in August Strindberg's *Svenska folket* (Swedish People), 1882.

PHOTO: HANS THORWID, NATIONALMUSEUM.

some of these are preserved. On 2 March he sent instructions for the seventeenth-century section:

> Now then, Old Man, you have received the manuscript for the 17th-century section, including *Nya samhällstyper* [New Types of Society]. I think you could get three attractive full-page illustrations from there. How about this?
>
> The Factory Worker. A glass works yard; blazing ovens; a sweaty, shattered worker (a future communard!) flings his head back and gulps down some fresh air (Michael Angelo's kip!). One lad is getting a taste of the cat, another is in ankle chains; beyond the wall is a glimpse of the Clara church tower, the old one with the pointed spire; birds flying around, a burnt-down tree next to the wall up which a boy has climbed to look out into the world!
>
> The Priest. In the old palace church; (see Dahlberg's Svecia, it's in the Bibl. Nationale) the priest is babbling on for the assembled court and officers, a piece of Ehrenstahl's Altar Painting can be seen; some ladies are offering one another their sugar boxes behind their fans, but the gentlemen are straining to swallow down every single word the priest utters! The Crown Prince (Karl XII) has his gob wide open, a puffed up little lad, sitting bold upright and gaping at the ceiling or something of the sort.
>
> The Forester. Hello there! The enemy of the people (August Strindberg!) is standing at the edge of the forest, brandishing his fist at a burning village that he's set on fire; his other arm is round the waist of his mistress, a dog, a bow, an axe, – the remains of a wooden hut – fire, cooking pots or something of the sort! [Fig. 5]

Larsson's replies are better preserved. On 19 January 1882, he wrote thanking Strindberg for his suggestions for the illustrations:

> Dear S, thank you for your latest message! I am full of admiration for the way you describe the farmer's cottage: you will have it exactly as you envisage it – and the same applies to the scene in the court room. When you get to see the latest drawings I have posted to you, I don't think you will want to go on asking me to present the Gentleman on horseback surveying his farm: I've sent pictures of both agricultural scenes and gentry on horseback. The male and female costumes have also been completed and dispatched. You will have drinking vessels, furniture suites, water-testing and "greeting" in the very near future.

4. Carl Larsson, *The Factory Worker*, (illustration for August Strindberg's *Svenska folket* [Swedish People], 1882,

PENCIL, PEN-AND-INK DRAWING IN BLACK, WASHED WITH GREY, ENHANCED WITH WHITE ON GREY
PAPER, 18.7 X 11.7CM, NATIONALMUSEUM, STOCKHOLM, NMH 149/1933. PHOTO: ERIK CORNELIUS,
NATIONALMUSEUM.

5. Carl Larsson, *The Prisoner and The Forester,*
ILLUSTRATION IN AUGUST STRINDBERG'S SVENSKA FOLKET (SWEDISH PEOPLE), 1882. PHOTO: HANS THORWID, NATIONALMUSEUM.

It is obvious from the letters that Strindberg not only provided the historical necessities for inclusion in the illustrations, but also went a long way towards laying down the composition of the pictures; he evidently drew his own sketches, to serve as models. There are several similar sketches sent to artists who provided other drawings for the book. (Figs 6 and 7) Despite his initial protests, Larsson tried to follow Strindberg's instructions in detail, meaning there are good reasons for ascribing to him

dom af pinnverk med
stöd för armarne och
lik en utbruten hög-
bänk. Hos borgare
och mindre förmög-
ne tjenstgör pallen,
belagd med kudde,
såsom stol; bonden
har kanske den ur-
hålkade kubben. Äf-
ven kistan begagnas
till samma ändamål.
Stolar synas emeller-
tid hafva varit mera
i bruk än forskare
hafva velat antaga.
Kalmar hade stol-
makare under hela
1400-talet, och sto-
lar upptagas i ett
inventarium af 1410
i Kalmar. I Up-
sala finnas stolmakare
1453.

Kistan begagnas
som byrå och kläd-
skåp samt stundom
som bänk eller stol.
Den prydes ofta med
vackra smidesbeslag
och sniderier.

Skåpet är vägg-
fast och begagnar
stundom byggnads-

87. Hängstäng (Medeltiden).

88. Hängstäng (Dalarne 1600-talet).

89. Ormen i kryddboden (1540-talet).

90. Brödspett.

6. Robert Haglund, illustrations in
August Strindberg's *Svenska folket*
(Swedish People), 1882.

PHOTO: HANS THORWID, NATIONALMUSEUM.

7. Letter from August Strindberg to
Robert Haglund, September 1881,

KUNGLIGA BIBLIOTEKET, STOCKHOLM. PHOTO: MAR-
CUS ANDRÆ, KUNGLIGA BIBLIOTEKET, STOCKHOLM.

The letter shows how Strindberg could give very
detailed instructions for what the illustrations
in Swedish People ought to look like. Carl
Larsson was also provided with similar
instructions, but none of these has been
preserved.

just as much as to Larsson the copyright of the illustrations.

Despite differences in motif, the illustrations reveal clear parallels with Strindberg's contemporary "Impressionistic" narrative style. Many of his depictions of places and countryside can be translated into a complete pictorial composition, in much the same way as his instructions for illustrations for *The Swedish People*. Strindberg's stage directions also frequently displayed the same kind of compositional detail: he saw the

8. Carl Larsson, *Ansgarius and Witmar Disembark*, illustration in August Strindberg's *Svenska folket* (Swedish People), 1882.

image in his mind's eye, and then described it in words.

For Larsson the illustrations for *The Swedish People* were to some extent a turning point as far as composition was concerned. His previous compositions had been characterized by a high degree of confusion with a mass of figures with no compositional centre, or an anecdotal sentimental group. In *The Swedish People* the picture is normally dominated by one or sev-

eral large-scale figures in the foreground, presenting the main action of the picture; in a subordinate role and behind the main characters are various independent sub-plots which nevertheless link up with the main action. This form of composition is especially characteristic of images for which we know Strindberg supplied detailed instructions. An excellent example is *Ansgarius och Witmar landstiga* (Ansgar and Witmar Step Ashore), produced on Kymmendö under Strindberg's direct supervision, and closely corresponding in detail to Strindberg's own drawings from the 1870s and 1880s. (Fig. 8). Larsson's drawings dating from that summer, which he spent with Strindberg on Kymmendö, are pretty consistently influenced by Strindberg's own range of motifs. The drawings Larsson made alone in Paris, on the other hand, are characterized by his tendency to pile up motifs without distinguishing between primary and secondary ones.

Although Larsson had difficulty in breaking old habits in many of his illustrations for *The Swedish People*, it is noticeable that from then on he makes a conscious effort to achieve a firmer composition and greater realism.

Göran Lindblad assumed that Strindberg learnt his impressionistic depiction of nature from Larsson, but one could maintain with some justification that, to adapt Gotthard Johansson's words, far from being an apprentice of Larsson's, Strindberg was in fact his teacher as far as composition was concerned.

In the summer of 1883 Larsson came to Stockholm to get married. He persuaded Strindberg to visit him in Grez-sur-Loing not far from Fontainebleu, the little artists' colony that had been his home since the previous year.

In connection with the planned trip to Grez, Albert Bonnier suggested that Strindberg should write an essay on Carl Larsson for the annual *Svea*. In accepting the commission, Strindberg saw it as an opportunity to attack the Royal Swedish Academy of Fine Arts and the current arguments for an aesthetic idealism of reality. On 7 September Larsson wrote as follows from Grez in reply to a letter from Strindberg that has been lost: "If you could use me as a sort of 'medium' in order to say a few friendly words about the Divine – all-powerful and all-white – Academy of Fine Arts, I would be exceedingly happy."

9. Letter from Carl Larsson to August Strindberg, 7 February 1882,

On 22 September 1883, Strindberg arrived in Grez and booked into the Pension Laurent. Around 1 October he submitted his article for *Svea*, with drawings by Carl Larsson. In the essay he depicts Larsson as an artist representative of the new age:

> . . . his starting point was work, he progressed by means of work, without scholarships and loans, without a patron and in spite of the Academy . . . he has reached the conclusion that it is of less value to be awarded a medal and stay inside the securely locked doors of the rich, than to go out among the people and teach. . .

While Strindberg reiterates his criticism of Larsson's older allegorical paintings, he also attacks the general public's excessively one-sided classification of him as a draughtsman, the

STRINDBERG AND CARL LARSSON

reluctance to classify him as what the man himself actually wants to be: a painter. Just as in Strindberg's other utilitarian manifestos, his attitude is strangely ambiguous. The artist – painter, author – should not create art for art's sake, but should operate as a worker among and for the people. At the same time he regards this as a sacrifice – the artist giving up what he really wants to do – in order to occasionally steal a little time for an activity that can only be of value to himself. For Strindberg drawing is a propaganda medium, along the lines of the illustrations for *The Swedish People*, while painting is regarded as an illegitimate pleasure for the artist, and for the bloated capitalist who hangs the canvas on his wall. His article did not go unchallenged. On 11 December Larsson's future biographer, Carl Nordensvan, opposed Strindberg's presentation in an unsigned article in *Stockholms Dagblad*.

> The author praises Larsson's drawings as the most outstanding work of his life, but those very drawings are so allegorically vague, so strangely and unnaturally put together, and they need long explanations, and hence have precisely the faults the writer ascribes to Larsson's earlier oil paintings.

Nordensvan's analysis is splendidly perceptive, but that did not prevent Larsson from swallowing whole – at least in theory – Strindberg's ideal. Following on from the *Svea* essay, he wrote as follows: "It really is an excellent thing that you – and you of all people – should have presented me to the people back home as a draughtsman: you have done both me and the people a service."

What Strindberg preaches in his utilitarian writings and in his *Svea* essay is a sort of dramatized Social Realism, art not as an end but as a means. His theses did not arouse much in the way of criticism from his artist friends. At least the more radical of the artists in Paris were happy to accept the role of the artist on the barricades. On 24 February 1884, he sent *Sömngångarnätter* (Somnambulistic Nights in Broad Daylight) (Fig. 10) to Carl Larsson, and commented on a postcard: "Here you see the fruits of our labours! No doubt you will no longer wish to know me when I put art in its place in such dastardly fashion; but I don't spare authors either, not even their books!"

Larsson's letter crossed with Strindberg's: "Oh dear, my boy,

10. August Strindberg, *Sömngångarnätter på vakna dagar. En dikt på fri vers* (Somnambulist Nights in Broad Daylight. A Poem in Free Verse), 1884, book cover by Carl Larsson.

Carl Larsson made the drawing for the cover after a proposal by Strindberg which appears to have been rather detailed. Carl Larsson commented on the cover in a letter to Strindberg: "Greatly thrilled, as you can understand, to have been able to smuggle my little C.L. into a corner of your Opus! But I don't deserve any rights to it as you gave me the subject-matter in finished form. – Karin was really surprised by your drawing skills."

11. August Strindberg, *Skärkarlslif: berättelser* (Men of the Skerries: stories), 1888, book cover by Carl Larsson.

12. August Strindberg, *Hemsöborna: Skärgårdsberättelser* (The People of Hemsö: Stories from the Stockholm Archipelago), 1887, book cover by Carl Larsson.

your poems are terrific! My wife and I are cheering you on! You are supreme!. . . You deserve our thanks for putting art in its place: I am fully in agreement with everything you say."

By 1886 the old friends had started to drift apart. At the end of March Larsson set off on a journey to Italy with Klas Fåhraeus, who had come to Grez in order to meet Strindberg. Larsson wrote as follows during the trip:

> He came from London down to Grez purely for Strindberg's sake, but his illusions have all gone. "And mine?" you might well ask. Well, it's strange how Strix and I have drifted apart! His wife is something awful! Nevertheless, she asked me to send you her greetings.

The Insignificant and The Great

On 24 April 1887 Strindberg started in Vienna's *Neue Freie Presse* a series of *Vivisektioner* (Vivisections), studies of real-life models. The first two, "The Insignificant" and "The Great", are portraits of the two artists Carl Skånberg and Ernst Josephson.

The portrayal in "The Great" is mainly restricted to the behaviour of "the Rebels", the Swedish artists who opposed the values of the Royal Academy of the Fine Arts, and the circumstances concerning the Paris-based painters' exhibition in Stockholm in September 1885, when *Strömkarlen* (The Water Sprite) was ridiculed by both the critics and the general public, while paintings by Larsson and many others were enthusiastically received. Ernst Josephson's painting had even aroused disgust among some of his fellow Rebels, and as soon as it was hung Larsson urged Josephson to replace it with another less provocative work. Strindberg depicts the disunity among the Rebels and the withdrawal of the former opposition leader from the Artists' Union. The end of the story is almost prophetic: the hero dies and the "true friends" exclaim: "Poor old Peter, ah well, his restless soul needed to find peace."

On 27 May Strindberg wrote apologetically to Larsson about the vivisection: "Have not The Great (*Die Grossen*) – Josefson – Larsson met a similar fate: being used by the liberal youngsters and then booted up the backside? And then long live Pauli! Did

you understand this pretty little story? And did you realize why I needed to "have a go" at the Exhibition!"

Strindberg was no doubt well aware of Larsson's role in the incident. He is very much the butt of the story.

Carl Larsson and the Nationalmuseum Frescoes

As mentioned above, Strindberg and Larsson had gradually drifted apart. After getting married and returning to Sweden, Larsson had become increasingly bourgeois; his pretty but not especially radical paintings had also been greeted with a volume of approval that few of the other Rebels had managed to attract. When in 1888 a competition was finally announced for frescoes to occupy the main staircase at the Nationalmuseum, Larsson could count on support from several influential members of the Nationalmuseum Murals Committee.

Not having any relevant ideas of his own, he adhered in the main to the detailed programme proposed by committee member Fredrik Sander for the north wall of the lower part of the staircase:

> Interior, room in king Charles XII's house in Bender (alternatively the interior of a tent); the King sitting at a table, perusing architect's plans for the Royal Palace in Stockholm, presented to him by Casten Feif; enter a young officer, evidently a messenger from Sweden, etc.
>
> Exterior, Drottningholm's grounds: on the left a group consisting of Queen Lovisa Ulrika, Count Carl Gustaf Tessin, the philologist Johan Ihre and the entomologist Ch. de Geer, all of them seated; before them is Carl von Linné, holding a flower and evidently delivering a lecture; standing behind the chairs of those seated, several persons, including Olof von Dahlin; on the right a smaller group, also seated: King Adolf Fredrik plus A.J. von Höpken, Jonas Alströmer and Axel von Fersen. In the background: servants, table with best china, fruit etc

This material, eminently suitable for a waxwork exhibition, was adhered to in detail by Larsson in the left-hand and centre sections. His original contribution to the Charles XII tableau comprises the king extending towards the observer his bandaged

right foot, resting on a cushion; his left foot is in an enormous Wellington boot, which becomes the centre of the composition on account of its size – without justification. The central section of this badly constructed composition is arranged around a triangle made of a decidedly irrelevant fully rigged toy sailing boat in a fountain basin, a cypress trimmed to form an obelisk, and a late Gustavian chair-back. In the right-hand section, he has deviated from Sander's plan to some extent: instead of a gallery in the so-called "Stone Museum" in the Royal Palace, he locates the scene in Sergel's studio, with the poet Carl Michael Bellman weeping before a statue of Gustaf III, surrounded by a number of historical personages. This section is dominated by an enormous modelling stand displaying the model for the statue, while the background is filled by living or sculpted figures.

When the mural committee announced its judgement in the middle of January 1889, Larsson was awarded the second prize. The first prize went to Gustaf Cederström for a proposal for one of the locations in the upper hall: *Christianity is introduced into Sweden by Ansgar*. Both Larsson and Cederström were asked by the committee to revise their sketches.

Pontus Fürstenberg was uneasy and asked the painter Georg Pauli to submit a neutral assessment of Larsson's sketches. Pauli was very frank in his response:

> … his use of form and colour, which is so delightful in his smaller-scale works, and is perfectly satisfactory there, is simply not adequate for the larger scale. – Irrespective of the fact that C. L. possesses a lot of qualities necessary for decoration, such as an ease of composition, an ability to decorate effectively etc, he lacks one of the fundamental necessities that would enable him to produce monumental paintings as satisfying as his smaller canvases: his c reation of form is superficial. Add to that his predilection for trying to be funny – and that when he seeks to be profound, he is in fact clever, not to say witty.

Larsson worked on his sketches during the summer, and in October went to Paris for the World Exhibition. His letters to his wife demonstrate his increasing distrust of his former Rebel friends. His disappointment and envy knew no bounds when Bergh, Zorn and Salmson were awarded French orders

for their contributions to the World Exhibition, but not him, despite his first-class medal. He was going to show them a thing or two, however, with his frescoes for the Museum: "I may have failed on this occasion, but you just wait! You shall be proud of me! Just now I suppose you're ashamed of me!"

The new sketches, revised in detail but not exactly to the advantage of the whole, were submitted to the National Museum before the turn of the year. The working party had trouble in reaching a decision and delayed an announcement until the beginning of March, explaining in the end that even after revision, the sketches lacked the monumental dignity considered necessary in such a building. They therefore recommended His Majesty to initiate a new competition.

In March 1890 Larsson met Strindberg in Stockholm. He wrote to Karin:

> I went back home with Strindberg one night. Siri seemed to be so gentle and good. She got up in the middle of the night and made us something to eat and drink, as well as brewing coffee on Strix's chemical retorts. I've just read one of his horrific marriage plays, "Fordringsägare". Bloody Hell!

Larsson continued working on the sketches in Stockholm and at Sundborn, but eventually went to Gothenburg in order to paint a series of murals in a girls' school there. The commission had

13. Carl Larsson, Revised version of the first proposal for fresco for the North wall of the lower staircase in the Nationalmuseum,
OIL ON CANVAS, 61 X 135CM, NATIONALMUSEUM.
PHOTO: NATIONALMUSEUM.

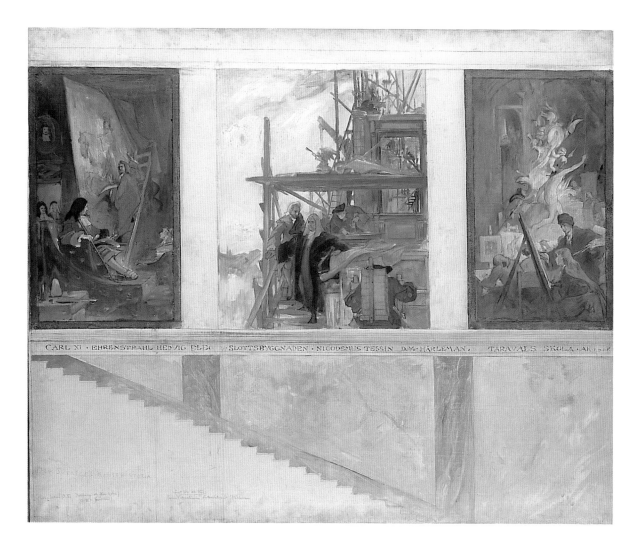

Inside the fresco image:

CARL XI · EHRENSTRAHL HEDVIG ELE· · SLOTTSBYGGNADEN · NICODEMUS TESSIN D·Y· HÅRLEMAN · TARAVALS SKOLA · AR

14. Carl Larsson, Second proposal for fresco for the South wall of the lower staircase in the Nationalmuseum, 1890–1,

OIL ON CANVAS, 110.5 X 134CM, NATIONALMUSEUM.

PHOTO: NATIONALMUSEUM.

come from the patron Pontus Fürstenberg and was intended to increase Larsson's chances of winning the Nationalmuseum competition. For his subject matter he chose one of Strindberg's preliminary sketches for *The Swedish People*, which he hadn't been able to complete at the time: women at various periods and in various situations, from prehistoric times onward.

While in Gothenburg he once again met Strindberg, who was passing through the city on his journey round Sweden. Suddenly, something crucial seems to have happened, and Carl wrote to Karin saying he wanted to go back home in order to produce the new sketches for the Nationalmuseum.

It appears that while with Strindberg, Larsson managed to

STRINDBERG AND CARL LARSSON

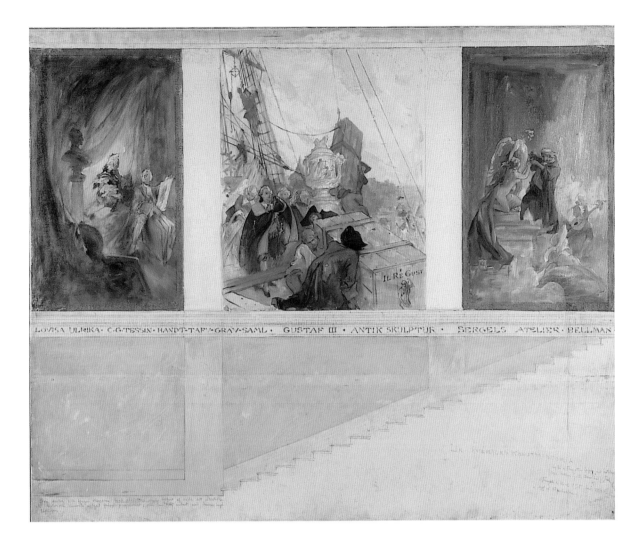

LOVISA ULRIKA · C·G·TESSIN · HANDT·TAF · GRAV·SAML · GUSTAF III · ANTIK SKULPTUR · SERGELS ATELIER · BELLMAN

liberate himself from the outlines drawn up by Sander, and found the inspiration for new compositions. He never refers to the origins of the ideas for the new sketches, which are so unlike his normal style. On the other hand, Strindberg refers to the matter in a reply to a letter from Larsson dated January 1894:

> Things are going well with you, and you have been asked to fill the gaps on the walls of the Nationalmuseum. Is it going to be the Heidenstam "anecdote" (Karl XII's jack-boot), or will it be ours, yours and mine, *The Swedish People*, with a bird's eye view of the ever-so-significant little things?

The last remark refers to Strindberg's dissertation on aesthetics at Uppsala University, in which he discusses Shakespeare's

15. Carl Larsson, Second proposal for fresco for the North wall of the lower staircase in the Nationalmuseum, 1890–1, OIL ON CANVAS, 110.5 X 134CM, NATIONALMUSEUM. PHOTO: NATIONALMUSEUM.

ability to introduce banal realistic irrelevances in order to give a dramatic plot greater reality. In similar fashion Larsson introduced into the new sketches strikingly realistic and everyday secondary figures, which raised what he was portraying from waxworks to a lively depiction of a moment in time.

The new sketches, which were submitted to the Nationalmuseum on 1 May 1891 and awarded their first prize a fortnight later, really do have much of the compositional features characteristic of the typical images in *The Swedish People*. The number of persons depicted has been reduced radically, apart from the left-hand side section of the southern wall – Karl XII is painted by Ehrenstrahl – for which the motif has been taken from Sander's programmatic suggestion. The motifs no longer portray anecdotes from general history, but various forms of Swedish art history: on the southern wall is architecture, with Tessin the Younger and Hårleman holding the architectural drawings and a hod-carrier standing on scaffolding during the building of the Royal Palace in Stockholm, flanked by painting with Ehrenstrahl and drawing with Taraval's Art School; on the north wall are classical antiquities, with Gustav III receiving them in the Stockholm harbour surrounded by seamen and dock workers; all this flanked by engraving, being shown by Carl Gustav Tessin to Lovisa Ulrika, and sculpture, with Sergel sculpting Amor and Psyche while Bellman – alone – plays his lute. It is a brilliant presentation of the Nationalmuseum collections, linked with depictions of some of the most important episodes in the history of Swedish art and art collections.

The depressing result of this programme competition and the – to say the least – unartistic proposals submitted by members of the murals committee themselves, together with the almost complete lack of ideas that characterized Carl Larsson's submissions in the earlier phases, all combine to indicate that the new programme must have come from an outsider. In the Swedish art world there was hardly more than one man who was capable of such a synthesis untrammelled by conventions: Strindberg. As is well known, he also provided the captions for Carl Eldh's reliefs in the main entrance of the Nordic Museum.

Strindberg probably did not make any detailed proposals for

the side sections of the sketches – the Ehrenstrahl picture is also taken from Sander of course, when it was logical to include it in the programme. However, the remarkably realistic portrayals in the middle section are so absolutely typical of Strindberg as he emerges in the instructions for the illustrations in *The Swedish People*, not to mention the stage directions in *Miss Julie*, with their bold reductions and skewed spaces, that one has no alternative but to assume that these sketches were based on detailed discussions between him and Larsson. The frescoes have become apotheoses on work: manual labour on building sites, on board ship and in the docks, but also work in artists' studios and drawing schools. It is a very daring deviation from the work-free, idealized setting in which the murals committee wished to see their great royal personalities operate.

It was only to be expected that these brilliantly composed but unconventional central sections would be subject to strong criticism. Several members of the murals committee objected to the excessively dominant depictions of building workers, scaffolding and packing cases.

There was a delay before the work was actually commissioned and various opinions were expressed, Larsson himself was also prepared to give up the more daring aspects of the sketches. On 10 March 1893 he wrote to Gustaf Upmark, a member of the murals committee, as follows:

> The objections to the two large central sections are that on one of them there is too much building work going on, and that in the other the big packing case in the foreground is too lacking in interest for its significant position. – I find both these objections very much justified. – With regard to the former, I have always had in mind to emphasize some of the marvellous constructional details of the Palace and re-locate most of the scaffolding in the background; and as for the latter, to accept your idea that the unpacking should take place at Logården, thus providing an opportunity to show off the better examples of the antiquities

It is a great loss for realistic monumental art that the middle sections of the frescoes were not finalized in accordance with their original versions. Nevertheless, they were in accordance with Larsson's views at the time. In response to Strindberg's gibe

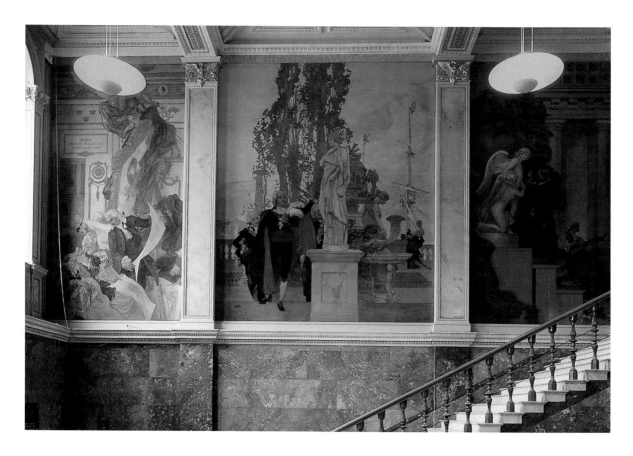

16. Carl Larsson, Frescos on the North
wall of the lower staircase in the
Nationalmuseum, 1896.

PHOTO: PER HEDSTRÖM.

about Karl XII's jack-boot in January 1894, he wrote – no doubt
with an eye to revision of the original – "I like Karl XII (who you
are always getting at) and the ceremonial changing of the guard
and all useless pomp and circumstance." (Fig. 16)

In *En blå bok* (A Blue Book) Strindberg writes as follows
about Larsson, probably referring to their cooperation on the
murals in Gothenburg and Stockholm: "He wanted something
from me; however, he didn't want to learn, but to take." The fact
that there is some truth in his words is demonstrated by the last
of the paintings for the Nationalmuseum: *Midvinterblot* (Mid-
Winter Sacrifice) which was not begun until 1910. This work
contains all the characteristics of the first, rejected sketches for
the walls of the staircase: a lack of genuine monumental com-
position, a conglomeration of similarly sized figures with no
attempt to place motifs in order of importance, witty details
such as the Lappish costume of the magician, the peculiar "folk
dance" on the left of the picture and the strangely stylised sentry

wearing mittens, to the left of the temple door. Similar things can be seen in his *Korum* (Prayers), painted for the secondary school Norra Latin in Stockholm in 1899; as in *Midvinterblot*, this picture shows his increasingly reactionary political stance, an exalted sense of sacrifice on behalf of one's fatherland which is very close to the philosophy of Heidenstam, but far removed from that of Strindberg and his radical artist friends.

Meeting Carl Larsson Again

By the beginning of the century Larsson had become a very popular artist in Sweden and successfully completed the frescoes in the lower main staircase at the Nationalmuseum, admittedly in the face of protests from some members of the murals committee – typically enough, Helgo Zettervall and Carl David af Wirsén. As far as politics were concerned, he had long since left behind the radicalism of his youth and was now quite close to the Heidenstam camp. Nevertheless, he may have felt the need to re-establish contact with the idolized master of his younger days. In the summer of 1899, according to his autobiography at the direct request of Strindberg, he agreed to make a portrait of him for the periodical *Julkvällen* (Christmas Eve). To this end he visited Strindberg at Furusund on 21–3 July. A letter to Prince Eugen shows that he still had misgivings about the meeting:

> In a few days I shall be going to Stockholm in order to sketch Strindberg, who lives out at Furusund. I would give my right arm to get out of it, but I was tricked into promising to do it on the confounded telephone, where I am never myself.

Nevertheless, to judge by the subsequent exchange of letters and some notes made later by Strindberg, it seems to have been a pleasant and merry get-together. In his autobiography *Jag* (I), Larsson describes his work on the portrait (Fig. 1), which he would later present to the Nationalmuseum: "We started in the morning, divided the day into three with meals in between, and the next morning, early, Strindberg was standing by my bed at the hotel exclaiming: 'A masterpiece, do not touch.'"

Thanks to Strindberg interrupting work on the portrait, it has

17. August Strindberg, *Samvetskval* (Remorse), 1899, book cover by Carl Larsson.

PHOTO: MARCUS ANDRÆ, KUNGLIGA BIBLIOTEKET, STOCKHOLM.

almost assumed the character of a preliminary sketch, but at the same time there is a graphic pithiness and an assurance in the composition that is unusual for Larsson. He reproduced the technique in various other portraits, such as those of Sven Hedin (1903) and Selma Lagerlöf; generally speaking his portraits tend to be a *horror vacui*, which often results in the model being reduced to an aspect of the room's interior decoration.

From now on he continued to see quite a lot of Strindberg whenever he was in Stockholm. One thing he now shared with him and which his other artist friends lacked was old-fashioned pious religiosity. In May 1887 he had written from Varberg to Strindberg and joked about how the clergy were dismayed by his refusal to have his children baptized: "The heathen kids are all well and flourishing, and will be brought up in the cult of Strindberg." Subsequent letters written during the 1880s display increasing religious tendencies, growing in proportion to his nationalism and political conservatism.

This nationalism also struck a chord with Strindberg. Having completed *Inferno*, he resumed his series of Swedish historical dramas and revived the interest shown in his younger days in the history of his country. His experience of the uplifting Stockholm archipelago after his years "in exile" deepened his appreciation of his native surroundings, something also seen in his plays. During the summer of 1900, while in Furusund and Stockholm, he wrote the optimistic, popular comedy with a summer setting, *Midsommar* (Midsummer), the final scene of which was set in the open-air Stockholm museum of Skansen. On 5 August he wrote to Larsson:

> I've been taken over by a long play set in Dalarna, and my vision of it is so positive and beautiful! . . . And now the big question. As Grabow's German stage sets are so alien and decrepit, would you be prepared, as a commission from a big Stockholm theatre, to design the Scenery for a very Swedish play set in Dalarna? Just so that we could really see at long last in a Theatre the Swedish countryside, with its red timber cottages, white birch trees and green firs. Please do it: not for my sake, but for Sweden's and Dalarna's and the Swedish Theatre's sakes. The play is set in the present, and you would only need to take some ideas from your

> immortal "A Home". The sketches would not need to be any
> bigger than sets for my little puppet theatre, bought at Leja's.
> There is no rush at all!

Strindberg wrote several versions of the projected play, which
eventually emerged as the folk-song-like, mysterious peasant
tragedy, *Kronbruden* (The Virgin Bride).

However, Larsson was not keen to be Strindberg's artistic me-
dium once again, with the strict limitations on his artistic free-
dom he knew that would involve. Nevertheless he continued to
send Strindberg his picture books with their interiors and every-
day events from his homes in Sundborn and Falun. As can be
seen from the letter quoted and the thank-you letters in res-
ponse to the books, Strindberg was most impressed by this part
of Larsson's life's work. An indication that he was still interested
in Larsson's paintings comes in a remark made in the book
Larssons (1902) concerning an interior at Sundborn on a Sunday,
in which we see a glimpse of Karin alone in the background:

> When Strindberg saw this picture, his imagination was im-
> mediately possessed by a drama whose gloomy outline he in-
> formed me about. Horrific, but brilliant. However, it is his copy-
> right, and hence I am not going to tell you about it.

Carl Larsson and Strindberg shared a trait which complicated
their relationship: ever-present suspicion. In the early years of
the century, however, there are no signs of any actual controv-
ersies, apart from one note in *Ockulta Dagboken* (Occult Diary),
21 April 1900: "Two telephone calls from Karin Larsson." He has
written in, using Greek letters, "Conscience."

The Rift with Carl Larsson

The novel *Götiska rummen* (Gothic Rooms) of 1904 was rec-
eived negatively by both critics and the public. Nevertheless
Larsson congratulated Strindberg on the book and suggested
that he sit for a portrait. On 27 May 1904 Strindberg invited him
to Furusund for a sitting, together with his daughter Anne-
Marie.

No painting was produced in 1904, but Larsson sent him a
panegyrical New Year's greeting:

If there is anybody in this country who deserves a Happy New Year, it is you: you have wielded the divine weapons of genius and the shining swords of honesty ever since you were a boy in your fight against stupidity and bullying, cowardice and the same old routine, and in addition you have created works of art that are genuine masterpieces which will live for ever. All hail!

In 1905 Strindberg repeated his request for his friend to paint Anne-Marie. On 17 October he wrote as follows to Harriet Bosse, who was in Germany at the time:

> Your daughter threw a dinner today for Hervor, in the yellow room; and she'll be going with Daddy to Eld's studio in Narvavägen, where he's doing a bust. Last night all the Beethoven Cronies, even Carl Larsson – to add to Bergh, Nordström, Gyllon and Axel. Uncle Larsson wants to paint the Little One next week; and Bergh is going to paint Daddy.

Again, however, Larsson cancelled. Ten days later Strindberg reported: "Uncle Larsson let us down this time as well, but he'll be coming again, and then she'll have her portrait painted." But Larsson did not come to visit him again; on the other hand, in December he did visit Carl Möller, the architect, and his family (Harriet Bosse's sister and brother-in-law), where Anne-Marie was living at the time. Larsson was a close friend of Möller's – incidentally he actually appears in the introductory chapter to *Svarta Fanor* (Black Banners) as a barely noticed extra. On 6 December Strindberg wrote indignantly to Harriet, now in Vienna:

> I happened to hear today that my daughter was posing at the M's for Carl Larsson! You can see what's going on! I hope you'll allow me to see the portrait when it's finished. Or, if you don't want me to, so be it! After all, M regards her as his child! I don't know on what grounds! But a word in your ear: I've had enough of this, and I want nothing more than to start all over again with a clean sheet, and a home of my own!
> I want a line drawn under all this nonsense!

In a letter to Larsson thanking him for arranging for Ernest Thiel to buy three of Strindberg's own paintings for the former's art collection produced by members of the Konstnärsförbundet (Artists' Association), he expresses himself in strikingly more

moderate tone: "I haven't seen the portrait yet, but no doubt I shall do!"

In his autobiography Larsson cites the autumn of 1905 as the time when the first signs of a rift appear. That is no doubt basically correct, even if the episode just referred to seems highly dubious. When the rift actually came two years later, with the publication of the follow-up to *A Blue Book*, it is clear from the text that what he is accusing Larsson of is his association with the Möllers: he regards Larsson's visits over the last few years as reconnaissance expeditions initiated by the Möllers in order to "see whether he was suffering enough" after divorcing Harriet Bosse.

During 1905 and 1906, however, Strindberg shows no sign of having fallen out with Larsson. At the end of 1906 they had a cordial exchange of letters about such matters as religion versus philosophy. In June of that year Strindberg started to write a sort of modern breviary with texts for every day of the year. It soon developed into a collection of studies on a variety of topics, scientific as well as philosophical and psychological. In connection with this he wrote to Larsson in 1907, asking for assistance with various matters, some of them very speculative in nature. Larsson was annoyed, and his response probably quite brusque.

In early 1907 Strindberg found himself in a state of deep depression, partly due to a recurrence of his severe psoriasis, and an attack of gastritis. His relationship with Harriet was sometimes friendly, but sometimes almost non-existent. Such was his state of mind when he decided to publish the pessimistic contemporary novel *Svarta Fanor* (Black Banners), and found in the young bookseller Karl Börjesson a willing publisher. The indignation caused by the book, with its undisguised attacks on leading figures of Swedish literature and journalism, was enormous.

In the autumn Strindberg withdrew more and more from his normal social life and concentrated on the theatrical project he had set in motion with the young actor and theatre manager August Falck. Notes in his diary reveal his worries about his considerable financial commitments to the success of the theatre.

It was in this mood that he received Larsson's letter dated 11 December 1907, after *Black Banners* and the breviary *En blå bok* (A New Blue Book), now published:

August Strindberg!

Write something really handsome for the human race! You can do it! That is what they are longing for, and they would greet you as a Saviour.

They believe in your genius – you have won them over! – but they don't believe in your good intentions.

I take the liberty of telling you this, as I have not ceased for one moment to be an admirer of yours . . . The last of your works I heard about was *Kronbruden*, and it was beautiful in the true meaning of that word; nevertheless people found it painful on account of its subject matter. They could sense the hatred behind it. What conquers the world, however, is love. That is what you should be devoting yourself to exclusively. And really "great" men love everybody, even the mean and humble.

Larsson wrote another letter, to which Strindberg never replied. Instead, in April–May 1908, at the time of his final divorce settlement with Harriet, he portrayed his old friend in *A New Blue Book* under the heading "Characters Made Up of Lies". He comments on the latest letter: "In this remarkable missive he warns me about certain weaknesses of character, ones I don't possess but which are typical of him." To some extent Strindberg was right: despite a cheerful front, in recent years Larsson's suspicions of his fellow men had sometimes grown into misanthropy bordering on mental illness.

Strindberg's portrayal in *A New Blue Book* was indignant and unfair, but not altogether untrue:

This man progressed through life and achieved his aims, but always with difficulty – and he brought those difficulties upon himself through his unreliability and his intrigues. He pretended to be modest, but under the surface he cherished the most extreme ambitions. For something so simple as carrying out his profession, he set in motion an apparatus that would have been sufficient to conquer a province. He made himself universally visible, marched from luncheons to dinners, made speeches and proposed toasts, delivered thrusts when supported by troops, but when weaponless he crawled; was familiar with every bell-push and every stair-case; he dropped his friends when they caused embarrassment and were unable to strike back, but revered his

friends even so... He cruised from the starboard shore to the port shore, tacked and veered, capsized now and then but righted himself once more, and eventually reached his goal...

But I sometimes imagine him in Swedenborg's undressing room on the other side of death. First coming up to him and peeling off garment after garment; then removing his skin, his muscles, bones, then all the things that are false – and finally there is nothing left of the man at all!

It's all lies! And a lie is a negative quantity: if you take its square root, it becomes even more of a minus, and keeps on until it becomes minus to the power of infinity.

In the conclusion he makes a soul-searching reservation:

Perhaps people in this life, searching for happiness, are all like that? Perhaps he has regarded me as being equally false and lacking in character? Just think if I myself were like I have depicted him? Let's be honest, there are many who generally do portray me like that in fact, and hence it is possible that I really am. That would be fatal.

When Larsson read this depiction of himself in *En ny blå bok*, his reaction was deep-seated and protracted, perhaps not least because of the truth that lay in Strindberg's severe judgement: the whole basis of his life had been blown away. He was not unaware of the duplicity of his life: in the remarkable self-portrait *Självrannskan* (Soul-Searching) from 1906, he depicted himself holding a grotesque clown-doll with a false smile. In his autobiography, however, he writes about how upset he was:

I must say I was very angry, and felt like a saint. My friendship for him was so loyal, and that was all the thanks I got for it! A repulsive skunk like that has forfeited the right to live! And in fact, armed with an expensive knife I'd been given by Zorn – because it had to be elegantly done in this case, despite everything – I went to Stockholm on the hunt for my prey: but, like the cowardly scribbler he is, he was no doubt cowering in his rooms for the next few weeks...

"'Revenge is mine,' saith the Lord." And not long afterwards Strindberg died, in terrible pain. This desecrator of everything that is noble and holy is said to have been thumbing through a Bible in the last days of his life... No doubt he intended to fool his Creator...

Carl Larsson's rift with the Artists' Association now became final. Three years later, when his sketch for *Midwinter Sacrifice* was severely criticized, Gustaf Fjæstad, who also considered himself to have been unfairly treated by the Association, wrote a newspaper article accusing the union leaders of having cast out Larsson and plotted against him. He accused them of being a coterie fighting against "the three greats", Larsson, Liljefors and Zorn. Bergh sent Fjæstad a furious reprimand in postcard form, and forwarded a copy to Larsson. Larsson's response, full of suspicion, led him to write a new letter dated 5 November 1911:

> If only I could temper your distrust somehow or other! I have been suffering on account of it for years. . . But it wouldn't help, I can feel that. There is a murky barrier between us: Strindberg! As far as he is concerned, you share naturally enough Ellen Key's opinion. For you he is the Great "Vilifier", the only one worthy of that title: but I cannot see him in that light, I just can't! For me his is still the enormously unhappy man, the most unhappy I have ever known, and moreover something different and more important: the great poet who attacks the material round about him like the Cyclone attacks people and homes and whisks them away in whichever direction the wind is blowing, never pausing to ask what will become of the objects that are sucked into the confusion. In other words I do not believe he made any conscious attempts to wreak vengeance on others. What he wrote should be read as poetry, and seen in the context of his own dark soul.

New Directions in Art!

Or the Role of Chance in Artistic Creation

AUGUST STRINDBERG

I've been told that the Malays drill holes in the bamboo stalks that grow in their forests. When the wind blows, they lie on the ground to listen to the symphonies produced by these gigantic Aeolian harps. The strange thing is that each listener hears a unique tune and a unique harmony, all according to the whim of the wind.

It is a fact that weavers use a kaleidoscope to discover new patterns, leaving it to chance to arrange the bits of coloured glass.

At Marlotte, the well-known artists' colony, the first thing I do is to go to the dining room to look at the famous panels. Actually, what I see there are portraits of women; a) young b) old, etc. Three crows on a branch. Very well executed. You can tell right away what it is.

Moonlight. A rather bright moon; six trees; quiet, reflecting water. Moonlight – certainly!

But what is it? It is this initial question that provides the first thrill. You are forced to search, to conquer; and nothing is more pleasant than having your imagination set in motion.

What is it? Painters call it "palette scrapings"; in other words, when his work is finished, the artist scrapes together the colours that are left and, if he feels so inclined, makes some sort of sketch. I stopped in delight in front of this panel at Marlotte. The colours have a harmony, a harmony that is easily explained since they have all been part of the same painting. Once freed from the problem of composing the colours, the soul of the artist is inclined to concentrate all its energy on the outline. Since his hand keeps moving the palette knife at random, never losing sight of the model provided by nature, the whole reveals itself

as a wonderful mixture of the conscious and unconscious. This is natural art, where the artist works in the same capricious way as nature, without a set goal.

I have sometimes passed these panels of scrapings after some time has passed, and have always found something new there; all according to my frame of mind.

I was looking for a melody for a one-act play called *Samoum*, which is set in Arabia. I therefore tuned my guitar at random, loosening the screws haphazardly, until I found a chord that conveyed the impression of something extremely singular without surpassing the boundaries of beauty.

The actor playing the part accepted my melody. But the director, every inch the realist, demanded an authentic melody when he learned that mine was not genuine. So I found a collection of Arabian tunes and showed them to the director – but he rejected them all and, in the end, found my little tune more "Arabian" than the genuine ones.

The song was performed and brought me a certain measure of success. The composer then in vogue came to ask my permission to write the music for my little play, all based on my "Arabian" tune, which had made an impression on him.

Here is my tune, as created by chance: G. C sharp. G sharp. B flat. E.

I knew a musician (Przybyszewski) who amused himself by tuning his piano every which way, without rhyme or reason. He then played Beethoven's *Pathétique* from memory. It was an incredible delight to hear an old piece come to life again. For twenty years I had heard this sonata played, always without hope of ever seeing it develop: fixed, unable to get anywhere. This is the way I have treated its worn melodies on my guitar ever since. Guitarists envy me and ask me where I found this music; I tell them I don't know. They think I am a composer.

Here is an idea for the manufacturers of the barrel organs now so much in vogue! Have some holes drilled at random in the round melody disc, in any old way and you will have a musical kaleidoscope.

Brehm maintains in *The Life of the Animals* that a starling imitates all the sounds he has ever heard: the noise of a door

closing, the wheel of the knifegrinder, a millstone, a weather vane, etc. Not true. I have heard starlings in most European countries, and they all sing the same mishmash of remembered impressions of the nuthatch, thrush, swallows, and other relatives – and in such a way that every listener can interpret it as he will. The starling actually has the musical kaleidoscope.

The same thing is true of parrots. Why do we call the gray parrots with the scarlet tails Jacob? Because it is their natural sound; their mating call is Jaco. And their owners are convinced that they have taught their parrot how to talk and to start by saying its own name.

And the cockatoos! And the macaws! It is amusing to listen to an old lady teach her parrot, as she will insist that that is what she is doing. The bird babbles his disjointed screeching sounds; the lady translates, in that she compares the sounds to what they most closely resemble. Or rather, she supplies the words for this infernal music. It is thus not possible for a stranger to understand what the parrot is "saying", until he has been told the words by the owner.

I once had the notion to make a clay model of a supplicant, patterned on a model from antiquity. There he stood, arms raised, but I became dissatisfied with him and, in a fit of pique, I brought my hand down on the poor wretch's head. And lo! A metamorphosis that Ovid could not have envisioned. His Greek locks were flattened by the blow, made into a kind of Scottish tam-o'-shanter covering his face; his head and neck were pushed down between his shoulders; his arms fell until his hands were level with his eyes under the beret; his legs gave way; his knees were brought together; and the whole thing was transformed into a weeping nine-year-old boy, hiding his tears behind his hands. Just a few additional touches, and the statue was perfect – that is to say, the viewer was given the intended impression. Afterward, in the studios of my friends, I improvised a theory on automatic art:

Gentlemen, you recall the boy of the fairy tale who wanders into the forest and catches sight of the siren of the woods. She is as beautiful as the day, with emerald green hair, etc. As he draws near she turns her back, which resembles a tree trunk.

Clearly, the boy saw nothing but a tree trunk, and his lively imagination supplied the rest.

This often happened to me.

One beautiful morning, as I walked in the woods, I came to a fallow field surrounded by a fence. My thoughts were far off, but my eyes spotted an unfamiliar, strange object on the ground.

One moment it was a cow; shortly thereafter two farmers embracing; then a tree trunk, then. . . The changing sensory impressions appeal to me … my will is engaged, and I want to know more … I know that the curtain of consciousness is about to rise … but I don't want it to … now it is a breakfast party in the open air, they are eating . . . but the figures are as still as at the waxworks … ah … that's what it is … it is a deserted plough on which the farmer has tossed his coat and hung his lunch packet! That's all! Nothing more to be seen! The fun is over!

Is this not an analogy to the modernist paintings that the philistines find so difficult to understand? At first, you see nothing but a chaos of colours; then it begins to look like something, it resembles – no, it does not look like anything. All of a sudden, a point detaches itself; like the nucleus of a cell, it grows, the colours are clustered around it, heaped; rays develop, shooting forth branches and twigs like ice crystals on the window panes . . . and the picture reveals itself to the viewer, who has assisted at the birth of the painting. And, what is more: the painting is ever new; it changes with the light, never growing tired, springing to life anew, endowed with the gift of life.

I paint in my spare time. To master my material, I select a medium sized canvas of preferably a board, so that I am able to complete the picture in two or three hours, while my inspiration lasts.

I am possessed by a vague desire. I imagine a shaded forest interior from which you see the sea at sunset. So: with the palette knife that I use for this purpose – I do not own any brushes! – I distribute the paints across the panel, mixing them there so as to achieve a rough sketch. The opening in the middle of the canvas represents the horizon of the sea; now the forest interior unfolds, the branches, the tree crowns in groups of colours, fourteen, fifteen, helter-skelter – but always in harmony. The canvas is covered. I step back and take a look!

Well, I'll be damned! There is no sea to be seen. The illuminated opening shows an endless perspective of rose-coloured, bluish light in which airy, disembodied and undefined beings float like fairies, trailing clouds behind them. The forest has turned into a dark subterranean cave, obstructed by brambles: and in the foreground – let's see what it could be – rocks covered with lichens, the likes of which are not to be found – and there, on the right, the knife has glossed over the paint too much, so that it resembles reflections in water – well, look! It's a pond. Wonderful!

What next? Above the water, there is a white and pink spot whose origin and significance I cannot explain. Wait a moment! – a rose! – The knife goes to work for two seconds, and the pond has been framed in roses, roses, what a lot of roses!

A slight touch here and there with my finger, blending the resisting colours, fusing and banishing any jarring tones, thinning, dissolving, and there's the painting!

My wife, at the moment my friend, comes up to take a look, falls into ecstacy before the "Tannhäuser cave" from which the large serpent (my hovering fairies) slithers out into the wonderland; and the mallows (my roses!) are mirrored in the sulphurous spring (my pond), etc.

For a whole week she admires my "masterpiece", values it at thousands of francs, assures me that it belongs in a museum, etc.

Eight days later we are once more in a period of hateful antipathy; she sees my masterpiece as pure garbage!

And there are those who claim that art exists in and of itself!

Have you ever worked with rhyme? I thought so! You have noticed that it is nasty work. Rhymes fetter your spirit, but they also liberate. The sounds become the transmitters of notions, images, and ideas.

That fellow, Maeterlinck, what is he doing? He uses rhyme in the midst of prose.

And this miserable stupid critic accused him of feeble-mindedness because of that, referring to his illness by the "scientific" name of echolalia.

Echolaliacs – all true poets since the earth began! With one exception: Max Nordau, who uses rhyme without being a poet.

Hinc illae lacrimae!

The art of the future (which will disappear, like everything else!): Imitate nature in an approximate way, imitate in particular nature's way of creating!

Written in French in 1894, and published in *Revue des Revues* on November 15 of the same year.

Chronology

Compiled by Greger Bergvall and based principally on the biographical data compiled by Hans Levander for the catalogue of the exhibition Strindberg at the Stockholm Cultural Centre in 1981.

1849 Johan August Strindberg was born on 22 January in Stockholm. His father, Carl Oscar Strindberg, was a steamship agent and his mother, Ulrika Eleonora Norling, the daughter of a Södertälje tailor.

1862–67 His mother died of tuberculosis in 1862, and his father made the housekeeper, Emilia Petersson, his second wife. Strindberg matriculated. Moving to Uppsala in the autumn, he studied aesthetics and modern languages at the University.

1867 He was unhappy in Uppsala, plagued by money trouble, and eventually he moved back to Stockholm.

1869 He wrote his first play, *En namnsdagsgåva* (A Name Day Gift), now lost.

1870 More play writing. *I Rom* (In Rome) was performed at the Royal Dramatic Theatre (Dramaten), Stockholm.

1871 Travelled for the first time to the island of Kymmendö in the Stockholm Archipelago. *Den fredlöse* (The Outlaw) was produced at Dramaten, attracting the interest of King Karl XV, who awarded him a scholarship.

1872 Strindberg's first period of painting 1872–4. He rubbed shoulders with journalists, painters and others in a circle frequenting "The Red Room" at the Berns Rooms in Stockholm. He wrote the first version of *Mäster Olof* (Master Olof), the prose edition, which was rejected by the Royal Theatre as an "immature piece".

1873 Edited *Svensk Försäkringstidning* (Swedish Insurance News), later transferring to *Dagens Nyheter*.

1876 Lived with Siri von Essen, who divorced her first husband, Carl Gustaf Wrangel, the same year and trained as an actress. Travelled to Paris.

1877 Strindberg worked as an administrative assistant at the Royal Library. *Från Fjärdingen till Svartbäcken* (From Fjärdingen to

Svartbäcken), a collection of short stories set in Uppsala, was published. Married Siri von Essen.

1879 Strindberg went bankrupt on *Svensk Försäkringstidning*. He wrote *Röda rummet* (The Red Room), which was published and quickly became a success.

1880 *Gillets hemlighet* (The Secret of the Guild) was produced at Dramaten, with Siri playing Margaretha. August and Siri had a daughter, Karin.

1881 Resigned his post at the Royal Library and did archive research for his historical works *Gamla Stockholm* (Old Stockholm) and *Svenska folket* (Swedish People). *Mäster Olof* (Master Olof) was successfully performed at Nya Teatern, Stockholm.

1883 Travelled by way of Paris to Grèz-sur-Loing, a Scandinavian artist colony.

1884 *Giftas I* (Getting Married) was published. It was confiscated and a blasphemy indictment followed. Strindberg travelled to Stockholm, was acclaimed by sympathisers, conducted his own defence in the City Court and was acquitted by the jury.

1886 Began writing *Tjänstekvinnans son* (Son of a Servant). Photographed in Gersau in Switzerland. Travelled in France with the sociologist Gustaf Steffen, working on the social reportage entitled *Bland franska bönder* (Among French Peasants).

1887 Wrote *Fadren* (The Father) and *Hemsöborna* (The People of Hemsö) and started *Le plaidoyer d'un fou* (The Confession of a Fool).

1888 Strindberg founded a "Scandinavian Experimental Theatre" in Copenhagen with Siri as its Manager and wrote *Fröken Julie* (Miss Julie).

1889–91 *Fordringsägare* (Creditors), *Den starkare* (The Stronger) and *Paria* were performed at the Experimental Theatre. Travelled in central and southern Sweden for a work on the natural history of Sweden. Divorce proceedings in the City Court, separation order made.

1892 Strindberg's begins second period of painting at Dalarö in Stockholm Archipelago, continuing until the end of 1894.

1893 Strindberg lived in Berlin, associating with a crowd of German and Scandinavian writers and artists at the tavern known as Zum Schwarzen Ferkel (The Black Pig). Married Frida Uhl.

184 CHRONOLOGY

1894	*Fordringsägare* (Creditors) and *Fadren* (The Father) were performed by Lugné-Poë at Théâtre de l'Œuvre in Paris. Indecency proceedings against the German edition of *En dåres försvarstal* (The Confession of a Fool). Strindberg was acquitted but the remaining edition was destroyed.
1895	Probably went through a succession of psychoses, "inferno crises", 1894–6. In Paris he engaged in chemical experiments and attempts to make gold, corresponded with alchemists, occultists and theosophists and moved in a generally religious direction.
1896	Strindberg began keeping his *Ockulta dagbok* (Occult Diary), concluded in 1908.
1897	Wrote *Inferno* in French. Returned to Paris and while there wrote *Legender* (Legends).
1898	Wrote *Till Damaskus* (To Damascus). Left Paris and returned to Lund.
1899	Returned to Stockholm for good.
1901–02	Married Harriet Bosse. Their daughter Anne-Marie was born. Resumed painting, and this final period of painting in his life extends from 1901 to the end of 1905. Wrote *Ett drömspel* (A Dreamplay).
1903	Wrote the autobiographical tale *Ensam* (Alone).
1904	Strindberg's marriage was officially dissolved but the couple still lived together for several years. Wrote *Götiska rummen* (The Gothic Rooms) and *Svarta fanor* (Black Banners).
1906	Began writing *En blå bok* (A Blue Book), published 1907–8.
1907	*Svarta fanor* (Black Banners) was published. Strindberg's Intima Teater at Norra Bantorget, Stockholm, opened with the chamber play *Pelikanen* (The Pelican). He photographed cloud formations, 1907–8.
1908–11	Strindberg moved to his last home Blå Tornet (The Blue Tower) in Drottninggatan, Stockholm. Fell in love with Fanny Falkner. The Strindberg feud – political and literary polemic about Strindberg in the press. Caught pneumonia.
1912	On Strindberg's 63rd birthday, he was greeted by a torchlight procession of students and workers. In March he received 45,000 crowns from a national appeal which was intended among other things to make up for the Nobel Prize which he never received. He developed cancer of the stomach and died on 14 May. He is buried in the Northern Cemetery, Stockholm.

Exhibited Items

PAINTINGS

1. August Strindberg, *Rock and Sea*, 1873,
OIL ON CARDBOARD, 16 X 17 CM, NORDISKA MUSEET, STOCKHOLM.

2. August Strindberg, *Shore, Kymmendö II*, 1873,
OIL ON PANEL, 17,5 X 24,5 CM, ÖREBRO STADS- OCH LÄNSBIBLIOTEK, ÖREBRO.

3. August Strindberg, *Shore*, 1873,
OIL ON PANEL, 15,5 X 18,5 CM, NORDISKA MUSEET, STOCKHOLM.

4. August Strindberg, *Polar Light*, 1891,
OIL ON CARDBOARD, 11 X 16,5 CM, KUNGLIGA BIBLIOTEKET, STOCKHOLM.

5. August Strindberg, *Eclipse*, 1891,
OIL ON CARDBOARD, 11 X 17 CM, KUNGLIGA BIBLIOTEKET, STOCKHOLM.

6. August Strindberg, *Flower on the Shore*, 1892,
OIL ON ZINK, 24,7 X 43,5 CM, MALMÖ KONSTMUSEUM.

7. August Strindberg, *Lighthouse*, 1892,
OIL ON PANEL, 6,5 X 18 CM, KUNGLIGA BIBLIOTEKET, STOCKHOLM

8. August Strindberg, *The Solitary Thistle*, 1892,
OIL ON PANEL, 19 X 30 CM, PRIVATE COLLECTION.

9. August Strindberg, *Storm in the Archipelago* (The Flying Dutchman), 1892,
OIL ON PANEL, 62 X 98 CM, STATENS MUSEUM FOR KUNST, KÖPENHAMN.

10. August Strindberg, *Double Picture*, 1892,
OIL ON PANEL, 40 X 34 CM, PRIVATE COLLECTION.

11. August Strindberg, *Purple Loosestrife*, 1892,
OIL ON CANVAS, 35 X 56 CM, PRIVATE COLLECTION.

12. August Strindberg, *Little Water, Dalarö*, 1892,
OIL ON CARDBOARD, 22 X 33 CM, NATIONALMUSEUM, STOCKHOLM, NM 6633.

13. August Strindberg, *Mysingen*, 1892,
OIL ON CARDBOARD, 45 X 36,5 CM, BONNIERS PORTRÄTTSAMLING, NEDRE MANILLA, STOCKHOLM.

14. August Strindberg, *Blizzard*, 1892,
OIL ON PANEL, 24 X 33 CM, PRINS EUGENS WALDEMARSUDDE, STOCKHOLM.

15. August Strindberg, *Sunset*, 1892,
OIL ON CARDBOARD, 23,5 X 32 CM, NATIONALMUSEUM, STOCKHOLM, NM 6168.

16. August Strindberg, *Stormy Sea, Broom Buoy*, 1892,
OIL ON CARDBOARD, 31 X 19,5 CM, NATIONALMUSEUM, STOCKHOLM, NM 6175.

17. August Strindberg, *Stormy Sea, Buoy without Top Mark*, 1892,
OIL ON CARDBOARD, 31 X 19 CM, NATIONALMUSEUM, STOCKHOLM, NM 6174.

19. August Strindberg, *Burn-Beaten Land*, 1892,
OIL ON ZINC, 35,7 X 27,2 CM, PRIVATE COLLECTION.

20. August Strindberg, *The Vita Märrn Seamark II*, 1892,
OIL ON CARDBOARD, 60 X 47 CM, NATIONALMUSEUM, STOCKHOLM. NM 6980.

21. August Strindberg, *Palette with Solitary Flower on the Shore*, 1893,
OIL ON PANEL, C. 38 X 34 CM, PRIVATE COLLECTION.

22. August Strindberg, *Night of Jealousy*, 1893,
OIL ON CARDBOARD, 41 X 32 CM, STRINDBERGMUSEET, STOCKHOLM.

23. August Strindberg, *Alpine Landscape I*, 1894,
OIL ON PANEL, 72 X 51 CM, PRIVATE COLLECTION.

24. August Strindberg, *The Verdant Island II*, 1894,
OIL ON CARDBOARD, 39 X 25 CM, STRINDBERGMUSEET, STOCKHOLM.

25. August Strindberg, *Golgotha*, 1894,
OIL ON CANVAS, 91 X 65 CM, PRIVATE COLLECTION.

26. August Strindberg, *High Seas*, 1894,
OIL ON PANEL, 96 X 68 CM, FOLKHEM.

27. August Strindberg, *Marine*, 1894, OIL ON CARDBOARD, 46,5 X 31,5 CM, NATIONALMUSEUM, STOCKHOLM NM 6968.

28. August Strindberg, *Seascape with Rock*, 1894,
OIL ON PANEL, 40 X 30 CM, PRIVATE COLLECTION.

29. August Strindberg, *Shore Scene*, 1894,
OIL ON CARDBOARD, 26 X 39 CM, STRINDBERGMUSEET, STOCKHOLM.

30. August Strindberg, *Wonderland*, 1894,
OIL ON CARDBOARD, 72,5 X 52 CM, NATIONALMUSEUM, STOCKHOLM, NM 6877, GIFT FROM KARL OTTO, ELISABETH, PONTUS, EVA OCH ÅKE BONNIER 1992.

31. August Strindberg, *Danube in Flood*, 1894,
OIL ON PANEL, 44 X 33 CM, PRIVATE COLLECTION

32. August Strindberg, *Inferno*, 1901, OIL ON CANVAS, 100 X 70 CM, PRIVATE COLLECTION.

33. August Strindberg, *The Yellow Autumn Painting*, 1901, OIL ON CANVAS, 54 X 35 CM, PRIVATE COLLECTION.

34. August Strindberg, *The Lighthouse III*, 1901, OIL ON CANVAS, 99 X 69 CM, UPPSALA UNIVERSITETSBIBLIOTEK, UPPSALA.

35. August Strindberg, *The Vita Märrn Seamark IV*, 1901, OIL ON PANEL, 51 X 30 CM, ÖREBRO STADS- OCH LÄNSBIBLIOTEK, ÖREBRO.

36. August Strindberg, *The Wave VII*, 1901, OIL ON CANVAS, 57 X 36 CM, MUSÉE D'ORSAY, PARIS.

37. August Strindberg, *The Wave VI and VIII*, 1901/1902, OIL ON CANVAS, 100 X 70 CM, NORDISKA MUSEET, STOCKHOLM.

38. August Strindberg, *The Birch Tree I*, 1902, OIL ON PANEL, 33 X 23 CM, PRIVATE COLLECTION.

39. August Strindberg, *Falaise I*, 1902, OIL ON CANVAS, 20 X 11 CM, NORDISKA MUSEET, STOCKHOLM.

40. August Strindberg, *Falaise III*, 1902, OIL ON CARDBOARD, 96 X 62 CM, NORDISKA MUSEET, STOCKHOLM.

41. August Strindberg, *The Cave (Inferno II)*, 1902, OIL ON CANVAS, 21 X 17 CM, NORDISKA MUSEET, STOCKHOLM.

42. August Strindberg, *Landscape with Tobacco Flowers*, 1902, OIL ON CANVAS, 12 X 23 CM, NORDISKA MUSEET, STOCKHOLM.

43. August Strindberg, *Sunset*, 1902, OIL ON CANVAS, 12,5 X 20,5 CM, PRIVATE COLLECTION.

44. August Strindberg, *A Coast*, 1903, OIL ON CANVAS, 76 X 55 CM, NATIONALMUSEUM, STOCKHOLM, NM 2722.

45. August Strindberg, *The Sun Sets over the Sea*, 1903, OIL ON CANVAS, 95 X 53 CM, PRIVATE COLLECTION.

46. August Strindberg, *The Town*, 1903, OIL ON CANVAS, 94,5 X 53 CM, NATIONALMUSEUM, STOCKHOLM, NM 4516.

47. August Strindberg, *The Avenue*, 1905, OIL ON CANVAS, 94 X 53 CM, THIELSKA GALLERIET, STOCKHOLM.

48. August Strindberg, *The Spruce Forest*, 1905, OIL ON CARDBOARD, 27 X 21 CM, NORDISKA MUSEET, STOCKHOLM.

49. August Strindberg, *Alpine Landscape II*, 1905, OIL ON CANVAS, 60 X 40 CM, THIELSKA GALLERIET, STOCKHOLM.

50. August Strindberg, *The Moor*, 1905, OIL ON CANVAS, 50 X 35 CM, THIELSKA GALLERIET, STOCKHOLM.

51. August Strindberg, *Rosendal Gardens II*, 1905, OIL ON CANVAS, 36 X 54 CM, GÖTEBORGS KONSTMUSEUM.

SCULPTURE

52. August Strindberg, *The Weeping Boy*, 1891, PLASTER, HIGHT 20 CM, PRIVATE COLLECTION.

53. August Strindberg, *The Weeping Boy*, 1891, PLASTER, HIGHT 20 CM, PRIVATE COLLECTION.

54. August Strindberg, *Hanna Palme von Born*, 1891, PLASTER, HIGHT 18,5 CM, PRIVATE COLLECTION.

DRAWINGS

55. August Strindberg, *Landscape Study*, 1872, PENCIL, 27 X 22 CM, GÖTEBORGS UNIVERSITETSBIBLIOTEK, GÖTEBORG.

56. August Strindberg, *Twin Pines*, 1873, PENCIL, 10 X 15,6 CM, NORDISKA MUSEET, STOCKHOLM.

57. August Strindberg, *Pine*, 1873, PENCIL, 16 X 23,2 CM, NORDISKA MUSEET, STOCKHOLM.

58. August Strindberg, *Cottage with Turf Roof*, 1873, PENCIL, 7,2 X 16 CM, NORDISKA MUSEET, STOCKHOLM.

59. August Strindberg, *Fur*, 1873, PENCIL, 23,2 X 16 CM, NORDISKA MUSEET, STOCKHOLM.

60. August Strindberg, *Head Librarian Gustaf Edvard Klemming*, 1880, WATERCOLOUR AND INK, 23,8 X 20,7 CM, KUNGLIGA BIBLIOTEKET, STOCKHOLM.

61. August Strindberg, *Rönnkläppan*, 1890, PENCIL, 27 X 19,5 CM, KUNGLIGA BIBLIOTEKET, STOCKHOLM.

62. August Strindberg, *Tree Study*, 1890, PENCIL, 27 X 19,3 CM, KUNGLIGA BIBLIOTEKET, STOCKHOLM.

63. August Strindberg, *Valerian, Chorn Chamomile and Sea Aster*, 1890, PENCIL, 19,5 X 27 CM, KUNGLIGA BIBLIOTEKET, STOCKHOLM.

64. August Strindberg, *Tree Study*, 1890, PENCIL, 27 X 19,3 CM, KUNGLIGA BIBLIOTEKET, STOCKHOLM.

65. August Strindberg, *Yxhammarskubben*, 1890, PENCIL, 27 X 19,3 CM, KUNGLIGA BIBLIOTEKET, STOCKHOLM.

66. August Strindberg, *Landscape Study from Dalarö Udde*, 1892, PENCIL, 27 X 19,3 CM, KUNGLIGA BIBLIOTEKET, STOCKHOLM.

67. August Strindberg, *Three Charcoal Sketches Depicting Partially Burnt Lumps of Coal*, 1896, 8,9 X 12 CM, ALBERT BONNIERS FÖRLAG, STOCKHOLM.

68. August Strindberg, *Frottage made from a Shell of a Crab*, 1896,
PENCIL, ALBERT BONNIERS FÖRLAG, STOCKHOLM.

69. August Strindberg, *Sketch for the Title Page of Master Olof*,
WATERCOLOUR, 13,5 X 10 CM, KUNGLIGA BIBLIOTEKET, STOCKHOLM.

70. August Strindberg, *Crayon from Draft of the Saga of the Folkungs*, 1899,
33 X 25 CM, KUNGLIGA BIBLIOTEKET, STOCKHOLM.

71. August Strindberg, *Original Drawings for Swedish Nature*, 1900,
INK, 8,5 X 11,5 CM EACH, KUNGLIGA BIBLIOTEKET, STOCKHOLM.

72. August Strindberg, *Cloud Formations*, 1907,
SIX SHEETS, PENCIL, 11 X 19 CM EACH, KUNGLIGA BIBLIOTEKET, STOCKHOLM.

PHOTOGRAPHS

73-84. August Strindberg, *Photgraphs from Gersau*, 1886,
TWELVE COPIES MADE FROM ORIGINALS IN NORDISKA MUSEET, BONNIERS FÖRLAGSARKIV AND STRINDBERGSMUSEET.

85. August Strindberg, *Photo Album with Photographs from Gersau*, 1886,
STRINDBERGMUSEET, STOCKHOLM.

86. August Strindberg, *Photo Album. "Twelve Impressionist-Images"*, 1886,
ALBERT BONNIERS FÖRLAG.

87. August Strindberg, *Photogram of Crystallization, 1890-talet*,
FOUR COPIES MADE FROM ORIGINALS IN KUNGLIGA BIBLIOTEKET, STOCKHOLM.

88. August Strindberg, *Self-portrait*, 1892-3,
12 X 9 CM, KUNGLIGA BIBLIOTEKET, STOCKHOLM.

89. August Strindberg, *Celestographs*, 1893-4,
FOUR COPIES MADE FROM ORIGINALS IN KUNGLIGA BIBLIOTEKET, STOCKHOLM.

90. August Strindberg, *Self-portrait taken with the "Wunderkamera"*, 1906,
30 X 24 CM, NORDISKA MUSEET, STOCKHOLM.

91. August Strindberg, *Self-portrait*, c.1906, NORDISKA MUSEET, STOCKHOLM.

92. Herman Anderson, *Portrait of Bruno Liljefors*, 1906,
30 X 24 CM, STRINDBERGSMUSEET, STOCKHOLM.

93. Herman Anderson, *Portait of Karl Nordström*, 1906,
30 X 24 CM, STRINDBERGSMUSEET, STOCKHOLM.

94. Herman Anderson, *Portait of August Strindberg, c.1906-8*,
30 X 23 CM, STRINDBERGSMUSEET, STOCKHOLM.

95. Herman Anderson, *Four Portraits of August Falck*, 1908,
34 X 28 CM AND 31 X 25 CM, STRINDBERGSMUSEET, STOCKHOLM.

MANUSCRIPTS

96. August Strindberg, *Manuscript of The Secret of the Guild*, ink and watercolour, 1879-80,
ÖREBRO STADS- OCH LÄNSBIBLIOTEK, ÖREBRO.

97. August Strindberg, *Note-book from the French Journey*, 1886,
TWO VOLUMES, 12 X 7,5 CM, KUNGLIGA BIBLIOTEKET, STOCKHOLM.

98. August Strindberg, *Cover for Drawings*, 1890,
KUNGLIGA BIBLIOTEKET, STOCKHOLM.

99. August Strindberg, *Inferno*, 1897,
INK, C. 25 X 20 CM, GÖTEBORGS UNIVERSITETSBIBLIOTEK, GÖTEBORG.

100. August Strindberg, *Cover for the Manuscript of To Damascus*, 1898,
32 X 23,5 CM, KUNGLIGA BIBLIOTEKET, STOCKHOLM.

101. August Strindberg, *Lillies on Gold* (from the manuscript to *To Damascus*), 1901,
22,5 X 18,5 CM, KUNGLIGA BIBLIOTEKET, STOCKHOLM.

102. August Strindberg, *Kleksografi* (Ink Blot Picture), Enclosure to the *Occult Diary*, 1904,
18 X 22 CM, KUNGLIGA BIBLIOTEKET, STOCKHOLM.

103. August Strindberg, *Copy-book for the Ghost Sonata*, 1907,
37,6 X 22,7 CM, STRINDBERGSMUSEET, STOCKHOLM.

104. August Strindberg, *Proposal for a Stage Set for To Damascus I*, 1909,
ANILINE ON BLOTTING PAPER, 15 X 28,5 CM, KUNGLIGA BIBLIOTEKET, STOCKHOLM.

105. August Strindberg, *Cover for the Manuscript to Stora landsvägen* (The Great Highway), 1909,
29 X 22 CM, KUNGLIGA BIBLIOTEKET, STOCKHOLM (DEPOSITION FROM STRINDBERGSSÄLLSKAPET).

106. August Strindberg, *Draft Manuscript for The Secret of the Guild, c.1879-80*,
WATERCOLOUR AND INK, ÖREBRO STADS- OCH LÄNSBIBLIOTEK, ÖREBRO.

107. August Strindberg, *Proposal for a Stage Set for Ett Drömspel* (A Dream Play), 1909,
ANILINE ON BLOTTING PAPER, 14,5 X 28,4 CM, KUNGLIGA BIBLIOTEKET, STOCKHOLM.

108. August Strindberg, *Cover for the Manuscript to Mausoléen* (Advent),
32 X 25 CM, KUNGLIGA BIBLIOTEKET, STOCKHOLM.

109. August Strindberg, *Manuscript for Des arts nouveaux! Ou le hasard dans la production artistique* (New Arts! or On Chance in Artistic Creation), 1894, 23 X 18,5 CM, KUNGLIGA BIBLIOTEKET, STOCKHOLM.

110. August Strindberg, *Draft for the Secret of the Guild*, c.1879–80, ÖREBRO STADS- OCH LÄNSBIBLIOTEK

LETTERS

111. *Letter from Carl Larsson to August Strindberg*, 1881, STRINDBERGSMUSEET, STOCKHOLM.

112. *Letter from August Strindberg to Carl Larsson*, 23 November 1881, UPPSALA UNIVERSITETSBIBLIOTEK, UPPSALA.

113. *Letter from August Strindberg to Carl Larsson*, 13 April 1882, UPPSALA UNIVERSITETSBIBLIOTEK, UPPSALA.

114. *Letter from Carl Larsson to August Strindberg*, 7 February 1882, KUNGLIGA BIBLIOTEKET, STOCKHOLM.

115. *Letter from August Strindberg to Pehr Staaf*, 16 May 1882, KUNGLIGA BIBLIOTEKET, STOCKHOLM.

116. *Letter from August Strindberg to Pehr Staaf*, 21 May 1882, KUNGLIGA BIBLIOTEKET, STOCKHOLM.

117. *Letter from August Strindberg to Carl Larsson*, 29 January 1884, UPPSALA UNIVERSITETSBIBLIOTEK, UPPSALA.

118. *Letter from August Strindberg to Carl Larsson*, 29 February 1884, UPPSALA UNIVERSITETSBIBLIOTEK, UPPSALA.

119. *Letter from August Strindberg to Carl Larsson*, 26 July 1884, UPPSALA UNIVERSITETSBIBLIOTEK, UPPSALA.

120. *Letter from August Strindberg to Leopold Littmansson*, 31 July 1894, KUNGLIGA BIBLIOTEKET, STOCKHOLM.

121. *Letter from August Strindberg to Richard Bergh*, 12 October 1903, KUNGLIGA BIBLIOTEKET, STOCKHOLM.

WORK BY OTHER ARTISTS

122. Gösta Adrian-Nilsson, *August Strindberg*, 1915, OIL ON CANVAS, 72 X 57 CM, MODERNA MUSEET, STOCKHOLM.

123. Richard Bergh, *Portait of August Strindberg*, PENCIL, 181X154 MM, NATIONALMUSEUM, STOCKHOLM, NMH 368/1954, GIFT FROM CAROLA CEDERSTRÖM 1954.

124. Per Ekström, *Landscape after Sunset*, 1869, OIL ON CANVAS, 36 X 45 CM, NATIONALMUSEUM, STOCKHOLM, NM 3319.

125. Per Ekström, *French Landscape in Spring. Scene from St. Germain-en-Laye*, 1887–8, OIL ON CANVAS, 33 X 46 CM, KALMAR KONSTMUSEUM, KALMAR.

126. Carl Eldh, *Strindberg Out Walking*, 1904, BRONZE, HEIGHT 40,5 CM, MODERNA MUSEET, STOCKHOLM.

127. Carl Eldh, *Portrait of the Writer August Strindberg*, 1905, BRONZE, HEIGHT 64 CM, MODERNA MUSEET, STOCKHOLM.

128. Carl Eldh, *The Young Strindberg in the Archipelago*, 1908, PLASTER, HEIGHT 41 CM, CARL ELDHS ATELJÉMUSEUM, STOCKHOLM.

129. Carl Eldh, *The Titan, Study for the Strindberg Monument*, c.1912–16, PLASTER, HEIGHT 81 CM, CARL ELDHS ATELJÉMUSEUM, STOCKHOLM.

130. Carl Eldh, *The Fighter (Strindberg)*, 1914, PLASTER, HEIGHT 124 CM, CARL ELDHS ATELJÉMUSEUM, STOCKHOLM.

131. Carl Eldh, *Strindberg*, PLASTER, HEIGHT 27 CM, CARL ELDHS ATELJÉMUSEUM, STOCKHOLM.

132. Agnes de Frumerie, *August Strindberg*, 1895, BRONZE, HEIGHT 178 CM, NATIONALMUSEUM, STOCKHOLM, NMSK 2021.

133. Carl Grabow, *Sketch for Stage Set for To Damascus*, 1900, WATERCOLOUR AND INK, 33,5 X 54,5 CM, NORDISKA MUSEET, STOCKHOLM.

134. Eric Hallström, *Strindberg Fantasy*, c.1919, OIL ON CANVAS, 48,5 X 61 CM, MODERNA MUSEET, STOCKHOLM.

135. Sofie Holten, *August Strindberg*, 1885, OIL ON CANVAS, 148 X 85 CM, NATIONALMUSEUM, STOCKHOLM, NMGRH 2136.

136. Knut Jern, *Portrait of August Strindberg*, 1909, PLASTER, HEIGHT 34,5 CM, NATIONALMUSEUM, STOCKHOLM, NMGRH 3259.

137. Knut Jern, *Project for Strindberg Monument*, 1911–12, PEN AND CHALK, 67 X 47,8 CM, NORDISKA MUSEET, STOCKHOLM.

138. Christian Krogh, *August Strindberg*, 1893, OIL ON CANVAS, 126 X 127 CM, NORSK FOLKEMUSEUM, OSLO.

139. Nils Kreuger, *Poster for the Strindberg Exhibition at Hallins konsthandel*, 1911, LITHOGRAPH, 41 X 74 CM, STRINDBERGMUSEET, STOCKHOLM.

140. Carl Larsson, *Schoolboys and Students,* Illustration for *Swedish People*, 1881 PENCIL, 30,2 X 17,6 CM, NATIONALMUSEUM, STOCKHOLM, NMH 147/1933.

141. Carl Larsson, *The Trip to the Bride's Bath*, Illustration for *Swedish People*, 1881 PEN AND WASH, 25,8 X 15,3 CM, NATIONALMUSEUM, STOCKHOLM, NMH 148/1933.

142. Carl Larsson, *The Factory Worker,* Illustration for *Swedish People,*
PEN, PENCIL AND WASH, 18,7 X 11,7 CM, NATIONALMUSEUM, STOCKHOLM, NMH 149/1933.

143. Carl Larsson, *August Strindberg,* 1899, CHARCOAL AND OIL ON CANVAS, 56 X 39 CM, NATIONALMUSEUM, STOCKHOLM, NMB 398, GIFT FROM THE ARTIST 1918.

144. Edvard Munch, *The Author August Strindberg,* 1895,
OIL ON CANVAS, 120 X 90 CM, MODERNA MUSEET, STOCKHOLM.

145. Edvard Munch, *August Strindberg,* 1896,
LITHOGRAPH, 61 X 46 CM, MUNCH-MUSEET, OSLO.

146. Edvard Munch, *Strindberg at the Asylum,* 1896,
LITHOGRAPH, CA 33 X 54 CM, MUNCH-MUSEET, OSLO.

147. Karl Nordström, *Portait of August Strindberg,* 1911,
PENCIL, 9 X 7 CM, STRINDBERGMUSEET, STOCKHOLM.

148. Arthur Sjögren, *Model Scenery for Swanwhite,* 1901,
WATERCOLOUR, 32 X 47,5 CM, NORDISKA MUSEET, STOCKHOLM.

149. Arthur Sjögren, *Sketch for Book Cover for Påsk* (Easter),
WATERCOLOUR, 25 X 17 CM, NORDISKA MUSEET, STOCKHOLM.

150. Arthur Sjögren, *Book Cover for Legender* (Legends), 1909,
WATERCOLOUR, 18,5 X 12 CM, NATIONALMUSEUM, STOCKHOLM, NMH 123/1944.

151. Arthur Sjögren, *Book Cover for Jäsningstiden* (Time of Ferment), 1909,
WATERCOLOUR, 18,3 X 12,4 CM, NATIONALMUSEUM, STOCKHOLM, NMH 122/1944.

152. Arthur Sjögren, *Book Cover for Inferno,* 1909,
WATERCOLOUR, 18,5 X 12 CM, NATIONALMUSEUM, STOCKHOLM, NMH 124/1944.

153. Felix Vallotton, *Programme Sheet for the Première of The Father at Théatre de l'Œuvre in Paris,* 14/12 1894,
LITHOGRAPH, 24,5 X 31,8 CM, STRINDBERGMUSEET, STOCKHOLM.

154. Anders Zorn, *August Strindberg,* 1910, ETCHING, 29,8 X 19,8 CM, NATIONALMUSEUM, STOCKHOLM, NMH 12/1912.

BOOKS, CATALOGUES AND OTHER MATERIAL

155. *Catalogue for the Paul Gauguin Auction,* Paris, February 1895, with Foreword by August Strindberg,
KUNGLIGA BIBLIOTEKET, STOCKHOLM.

156. August Strindberg, *Röda rummet* (The Red Room), 1879,
PRIVATE COLLECTION.

157. August Strindberg, *I vårbrytningen* (Spring Harvest), 1880–1, cover by Carl Larsson,
PRIVATE COLLECTION.

158. August Strindberg, *Svenska öden och äfventyr* (Swedish Destinies and Adventures), 1881,
COVER BY VICKE ANDRÉN, PRIVATE COLLECTION.

159. August Strindberg, *Svenska folket i helg och söcken, i krig och fred, hemma och ute eller ett tusen år af svenska bildningens och sedernas historia,* (Swedish People), vols I–II, 1881–2, PRIVATE COLLECTION.

160. August Strindberg, *Svenska folket i helg och söcken, i krig och fred, hemma och ute eller ett tusen år af svenska bildningens och sedernas historia,* (Swedish People), 1882,
STRINDBERGMUSEET, STOCKHOLM.

161. *Kalendern Svea,* 1884, including August Strindberg's article on Carl Larsson,
PRIVATE COLLECTION.

162. August Strindberg, *Sömngångarnätter på vakna dagar. En dikt på fri vers,* (Somnambulistic Nights in Broad Daylight), 1884, cover by Carl Larsson,
PRIVATE COLLECTION.

163. August Strindberg, *Hemsöborna: Skärgårdsberättelse* (The People of Hemsö), 1887, cover by Carl Larsson,
PRIVATE COLLECTION.

164. August Strindberg, *Blomstermålningar och djurstycken ungdomen tillegnade,* (Flower Paintings and Animal Pieces), 1888, cover by Axel Sjöberg,
PRIVATE COLLECTION.

165. August Strindberg, *Skärkarlslif: berättelser,* (Men of the Skerries), 1888, cover by Carl Larsson,
PRIVATE COLLECTION.

166. August Strindberg, *Bland franska bönder,* (Among French Peasants), 1889, cover by Nils Kreuger,
PRIVATE COLLECTION.

167. August Strindberg, *I hafsbandet,* (By the Open Sea), 1890, cover by Carl Larsson,
PRIVATE COLLECTION.

168. *Quickborn,* 1899, text by August Strindberg, illustrations by Edvard Munch,
PRIVATE COLLECTION.

169. August Strindberg, *Samvetskval* (Remorse), 1899, cover by Carl Larsson, private collection.

170. August Strindberg, *Sömngångarnätter på vakna dagar. En dikt på fri vers* (Somnambulistic Nights in Broad Daylight), second edition, 1900, cover and decorations by Nils Kreuger,
PRIVATE COLLECTION.

171. August Strindberg,
Sömngångarnätter på vakna dagar.
En dikt på fri vers (Somnambulistic
Nights in Broad Daylight), second
edition, 1900, cover and decorations
by Nils Kreuger,
PRIVATE COLLECTION.

172. August Strindberg, *Midsommar*
(Midsummer), 1900, cover
by Arthur Sjögren,
PRIVATE COLLECTION.

173. August Strindberg, *Påsk* (Easter),
1901, cover by Arthur Sjögren,
PRIVATE COLLECTION.

174. August Strindberg with Arthur
Sjögren, *Sveriges natur*, (Sweden's
Countyside), 1901,
PRIVATE COLLECTION.

175. August Strindberg, *Ensam* (Alone),
1903, illustrations by Arthur Sjögren,
PRIVATE COLLECTION.

176. August Strindberg, *Historiska
miniatyrer* (Historical Miniatures),
1905, decorations by Arthur Sjögren,
PRIVATE COLLECTION.

177. August Strindberg, *Ordalek
och småkonst* (Word Play and
Minor Art), 1905, illustrations
by Arthur Sjögren,
PRIVATE COLLECTION.

178. August Strindberg, *Antibarbarus I*,
1906, cover and decorations by
Arthur Sjögren,
PRIVATE COLLECTION.

179. August Strindberg, *En blå bok*
(A Blue Book), 1907,
PRIVATE COLLECTION.

180. August Strindberg, *Svarta fanor*
(Black Banners), 1907,
PRIVATE COLLECTION.

181. *Theater Programme for The Ghost
Sonata at Intima Teatern in
Stockholm*, 1908,
PRIVATE COLLECTION.

182. August Strindberg, *Stora landsvägen*
(The Great Highway), 1909,
PRIVATE COLLECTION.

183. Paint-box and Palette used by
Strindberg in 1894,
36,5 X 27 X 7 CM, STRINDBERGMUSEET,
STOCKHOLM.

184. E. Von Schlicht's Camera for 9x12 cm
plates, the camera used by
Strindberg for the Gersau
Photographs,
STRINDBERGSMUSEET, STOCKHOLM.

NOTES

1 Jan Myrdal, *Johan August Strindberg*, 2000, pp. 229–30.
2 Francisco Calvo Serraller, "The Sunken Bell", *Strindberg* (exhibition catalogue), IVAM Centre Julio Gonzáles, 1993, pp. 175–6
3 Robert Rosenblum, *The Paintings of August Strindberg*, 1995, pp. 14–18.
4 Göran Söderström, *Strindbergs måleri*, Torsten Måtte Schmidt (ed.), 1972, p. 239.
5 Harry G. Carlson, *Out of Inferno : Strindberg's reawakening as an artist*, 1996, p. 333
6 Douglas Feuk, *August Strindberg. Paradisbilder – Infernomåleri*, 1991, pp. 24–9.
7 Johan Cullberg, *Skaparkriser, Strindbergs inferno och Dagermans*, 1992.
8 Catherine C. Fraser, *Ensam och Allén. Ord och bild hos Strindberg*, 1994, chapter 4.
9 Gunnar Brandell, *Strindberg. Ett författarliv*, vol 1, 1983, p. 168.
10 Per Hemmingsson, *August Strindberg som fotograf*, 1989, p. 13.
11 Harry G. Carlson, *Out of Inferno : Strindberg's reawakening as an artist*, p. 179
12 Göran Söderström, *Strindberg och bildkonsten*, 1972, p. 129.

BIBLIOGRAPHY

August Strindberg. Underlandet (exhibition catalogue), Malmö Konsthall, Malmö 1989

August Strindberg. Carl Kylberg. Max Book (exhibition catalogue), Liljevalchs Konsthall, Stockholm 1992

August Strindberg som målare och kritiker. Ett urval (exhibition catalogue), Nationalmuseum, Stockholm 1994

Carlson, Harry G., *Out of Inferno : Strindberg's reawakening as an artist*, Washington 1996

Feuk, Douglas, *Strindberg. Paradisbilder – Infernomåleri*, Hellerup 1991

Feuk, Douglas, "August Strindberg, peintre et photographe", *Lumière du monde, Lumière du ciel* (exhibition catalogue), Musée d´art moderne de la ville de Paris, Paris 1998

Fraser, Catherine C., *Ensam och Allen. Ord och bild hos Strindberg*, Stockholm 1994

Frizot, Michel, "L´âme, au fond. L´activité photographique de Munch et Strindberg", *Lumière du monde, Lumière du ciel* (exhibition catalogue), Musée d´art moderne de la ville de Paris, Paris 1998

Goethe, Hugo, *Strindberg: diktare, bildkonstnärer* (exhibition catalogue), Nationalmuseum, Stockholm 1974

Hemmingsson, Per, *August Strindberg som fotograf*, Åhus 1989 (1963)

Immagini dal Pianeta Strindberg. Images from the Strindberg Planet (exhibition catalogue), The Swedish Pavillion, Venice 1980

Lilja, Gösta, *Strindberg som konstkritiker*, Malmö 1957

Petri, Grischka, *Der Bildprozeß bei August Strindberg*, (Artes et Litterae Septentrionales, vol 1, ed. by Knut Brynhildsvoll), Köln 1999

Rosenblum, Robert, *The Paintings of August Strindberg. The Structure of Chaos*, Hellerup 1995

Strindberg (exhibition catalogue), IVAM Centre Julio Gonzáles, Valencia 1993

Strindberg och fotokonsten (exhibition catalogue), Strindbergsmuseet, Stockholm 1995

Sylvan, Gunnel, "August Strindberg som målare", *Dikt och konst. Tidskrift för konstvetenskap*, 1948, nr 27, s 63-125

Söderberg, Rolf, *Edvard Munch. August Strindberg. Fotografi som verktyg och experiment. Photography as a tool and an Experiment*, (Lucida-serien, 7) Stockholm 1989

Söderström, Göran, "Strindbergs måleri", *Strindbergs måleri. En monografi*, ed. by Torsten Måtte Schmidt, Malmö 1972

Söderström, Göran, "Fantasies of a Visual Poet", *August Strindberg* (exhibition catalogue), Rijksmuseum Vincent van Gogh, Amsterdam 1987

Söderström, Göran, *Strindberg och bildkonsten*, Stockholm 1990 (1972)